To my mother and my children

Thank you for sharing the hundred memories in this book!
Cordially, Mary Lawrence

100 Works of Art with

A BALANCE HOUSE BOOK

PRODUCED AND DIRECTED BY Marshall Lee

Mother and Child

❧ COMPILED BY *Mary Lawrence*

commentaries by 106 distinguished people

❧ PREFACE BY HELEN HAYES

❧ Thomas Y. Crowell Company NEW YORK

Established 1834

Copyright © 1975 by Balance House Ltd., New York
All rights reserved. No part of this publication may be
reproduced or transmitted in any form or by any means,
electronic or mechanical, including photocopy, recording,
or any information storage and retrieval system, without
permission in writing from the publisher.
Grateful acknowledgment is hereby given the copyright owner
for permission to adapt excerpts from *The Agony and the Ecstasy*
by Irving Stone. Copyright © 1961 by Doubleday & Company, Inc.
Printed in the United States of America
CIP information is on last page

Wᴇ ʜᴀᴠᴇ all experienced in one way or the other, and been profoundly affected by, that very special relationship of mother to child, but I suppose that mothers, having been *both* parts of this equation, are particularly responsive to it. In her great capacity for love my mother was a singular inspiration to me; when I became a mother, I found a new awareness of that mystical bond between the mother and her child that transcends everything. The strength of this bond was impressed upon me when I had the pleasure of playing Queen Victoria in the theater. Victoria was a great queen, but essentially she was a woman, for whom family and motherhood outweighed an empire; and by emphasizing the virtues of motherhood and home, Victoria created the manners and morals of an age.

As a subject of artistic concern mother-and-child has *always* occupied an important place. In museums around the world I have found delight in images of mother and child from primitive and ancient cultures as well as the most sophisticated and recent. In these images one finds— almost always—purity, tenderness, protectiveness, the finest of human qualities.

The richly varied works of art in these pages have been conceived very differently—reflecting sometimes earthiness, sometimes majesty, sometimes that spiritual radiance so sublimely personified in the medieval and renaissance Madonna and Child. But, whatever the form, whatever the period, whatever the style, all of these works celebrate the same ideal.

Mother and Child is not only a delight to the senses—it is an affirmation of the timeless, unchanging wonder and glory in the entwining love of mother and child.

ʜᴇʟᴇɴ ʜᴀʏᴇꜱ

CONTENTS

IN THE course of thirty years of travel I have spent very many days exploring museums, galleries, and churches. As most people do, I bought reproductions of my favorite works of art in each place. One day four years ago, while searching for a lost letter, I came across this collection of pictures and was startled to find that most of these reproductions were on the same theme — mother and child. It hardly seemed possible, but I could not recall ever having seen a book on this most universal and appealing subject, so I decided it would be a wonderful idea to put the mother-and-child pictures together and make a book celebrating that beautiful relationship. My enthusiasm carried me far into the night, pasting and labeling. That was the beginning of a long labor of love that grew into *Mother and Child*.

It was clear from the outset that there should be commentaries on each of the works. Since the theme of all the pictures was the same, it seemed necessary to have comments by different people to get a variety of viewpoints. If variety is good, I reasoned, let there be *maximum* variety. So I decided to invite commentaries by distinguished people of varied backgrounds.

Tolstoy called art "an activity in which the artist transmits his emotions by means of consciously constructed external signs to other persons who may experience the same feelings". Great artists succeed in transmitting their emotions in a general way, but surely each viewer gets an individual image of the work of art filtered through his or her particular mix of personality, experience, professional interest, national and family background, and instinct. I believe, then, that when the viewer is a layman but an exceptional person his or her response to the work may be as interesting as that of a specialist, even though the comments of an art scholar are certain to be more informative.

Many of the commentaries are by distinguished art historians, museum directors, and curators — professionals who generally address themselves to the work and the artist with a minimum of personal involvement. However, a large number of the essays are based on the commentator's personal interaction with the work, and these have been written by a broad spectrum of interesting and accomplished personalities whose relations to the works vary as much as do their own backgrounds. Some are collectors and patrons of the arts; others are artists themselves in theater, music, and literature; others are members

of families having personal associations with the great artists of the past; still others have a close personal tie to the work. Some of their commentaries are deeply felt and moving, others veer to lighthearted observation. All are interesting in their own way and, most important, all reveal something about the nature of art as it affects people.

For *Mother and Child* I chose what seemed to me the most interesting and beautiful works I could find. Many are classics familiar to all, some are from private collections and are published here for the first time. Considerations of history and style were secondary, although I did make a special effort to find examples from places and cultures not represented. Many of my favorites had to be left out, and every reader will probably feel that this or that work should have been included, but in the search for variety some works had to be dropped, regardless of their quality.

Since there was no attempt to make a scholarly point in the selection, I decided to follow the visual criterion in the arrangement, also. Therefore, the works are in what seems the most interesting order to see them, rather than in any historical or geographical sequence.

Although the mother-child relationship is a single theme, it has different aspects and a variety of forms. The works shown in these pages reflect that diversity, as well as the diverse personalities and styles of the artists. Yet, these hundred works, ranging in time from nearly three thousand years ago to the present and through almost every culture in the world, together project a view of motherhood that is one with love and loyalty, sacrifice, tenderness, happiness. The mother-and-child image is an emblem of humanity and spirit that we can look to as a citadel against the forces that are tearing at our civilization. Here we celebrate the continuity of life—our fragile link to immortality.

Compiling *Mother and Child* has brought me large portions of pleasure, and some disappointment. The latter because I was not always able to get a picture or a contributor I had hoped for, the former because, almost without exception, the people with whom I spoke and corresponded were richly warm and helpful. This includes those who have contributed and those who declined. It includes also the many people in museums, galleries, libraries, and publishing houses for whose help in arranging for photographs and permissions I will always be appreciative. I owe much to my secretary, Pat Anderson, who has helped with my correspondence from the beginning. Mostly, I am deeply grateful to those who wrote the commentaries in *Mother and Child*. They not only gave generously of their time, but shared their joy and special knowledge, and I give them my heartfelt thanks. A special word of gratitude is due to Marshall Lee, whose guidance and support were indispensable.

MARY LAWRENCE

Auguste Renoir (1841–1919)

LA MATERNITÉ

1885, oil on canvas, 30x23½" (76x60cm)

Collection Maurice Gangnat, Paris

THIS woman breast-feeding a baby is my mother. The baby is my older brother, Pierre. He is dead now, and so is my mother, and the bushes of hawthorn which covered the yard of the Château des Brouillards, where I was born, have gone. Big buildings have replaced wild flowers. Children now play on the cement of sidewalks. They don't know that this woman once existed in real life. Renoir, while painting her, did not intend to make history: he only sought the sensuous pleasure to caress with his brush the flesh of his flesh, and today, by the magic of his brush, we can participate in the voluptuousness of this swollen breast, this eternal symbol of maternity and pleasure.

JEAN RENOIR

RENOIR—eternal continuity—this flesh remains bound to this flesh; monument to hope and love created by your genius.

STELLA MERTENS

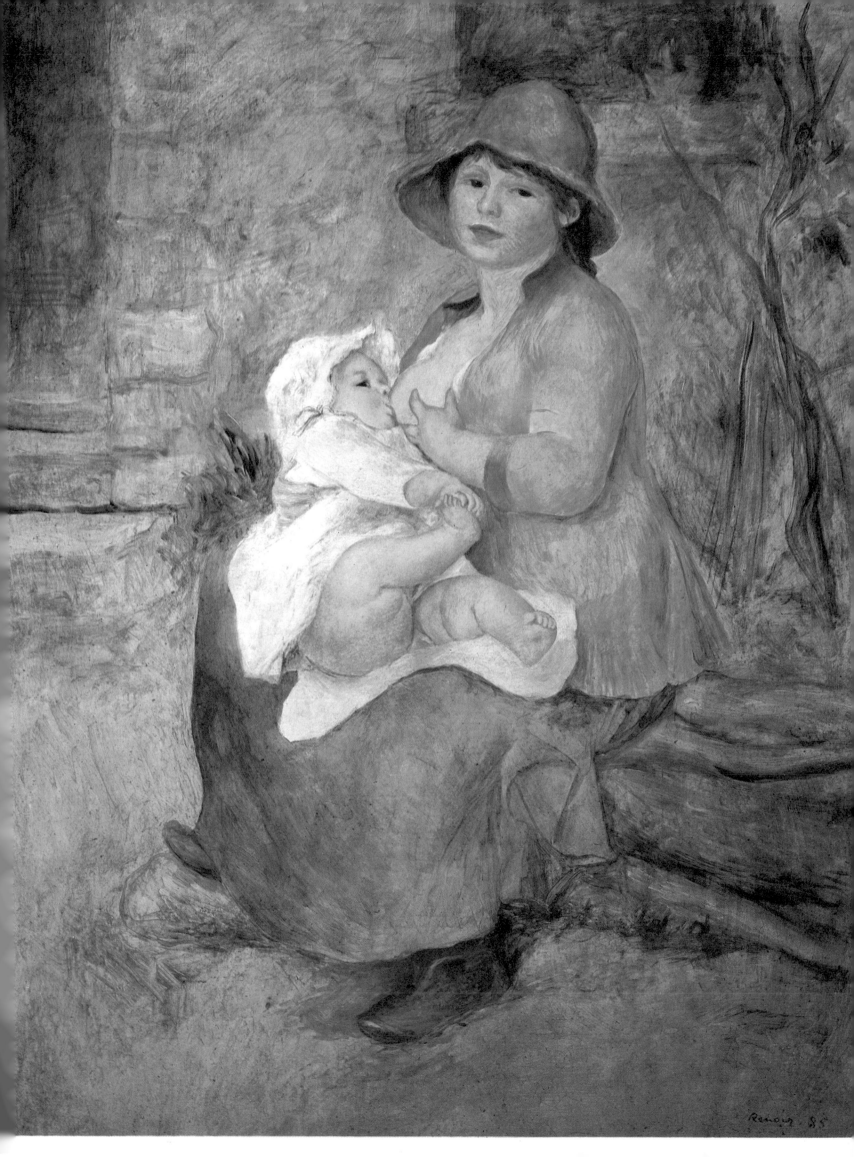

Michelangelo (1475–1564)

THE HOLY FAMILY (THE DONI MADONNA)

1503, resin and tempera on panel, diam. 48" (122cm)

Uffizi, Florence

THIS painting was commissioned by Doni Strozzi on the occasion of his marriage to Maddalena Strozzi, about 1503. It is the only certain easel painting ever done by Michelangelo. After much haggling over the commission, 70 gold florins was agreed upon.

Michelangelo had dozens of drawings for a Madonna and Child. They were intensely spiritual, removed from the mundane world. For a Holy Family, however, the concept should be the opposite in spirit: earthy, a family of simple people.

During the hot summer days he tramped the roads of Tuscany looking for models. He found a strong-limbed, healthy young girl from one household, a plump, red-cheeked, curly haired child from another, a bald-headed, bearded grandfather from a third, and put them together in an affectionate grouping on the grass. The flesh tones of the arms, faces, feet, the naked bambino, he had no trouble with, but the robes of the Mother and Joseph, the blanket of the Child, eluded him. In the end he did a series of monotones, as though they were colored marble. The Mother's dress he painted pale rose and blue; the Child's blanket light to burnt orange; Joseph, showing only a shoulder and arm of faded blue. In the foreground he painted a few simple clusters of flowers in the grass.

The background was bare except for the impish face of John looking upward. To amuse himself, he painted a sea on one side of the family, mountains on the other; before the sea and the mountains he drew five nude youths sitting on a wall, glorious bronze figures with the sun on them, creating the effect of a Greek frieze.

Doni's face flushed when he answered Michelangelo's summons to see the finished picture. "Show me one thing that is holy about this picture of peasants! One sentiment that is religious!"
"I want a Holy Family in a palace. I cannot give this picnic on the grass to my delicate bride."

"Holiness has nothing to do with surroundings. It is an inner spiritual quality."

Florence enjoyed the contest, with bets on who would win. Maddalena Strozzi wanted the painting; no other wedding gift would please her more. Michelangelo raised the price to 140 florins and Doni finally paid.

IRVING STONE

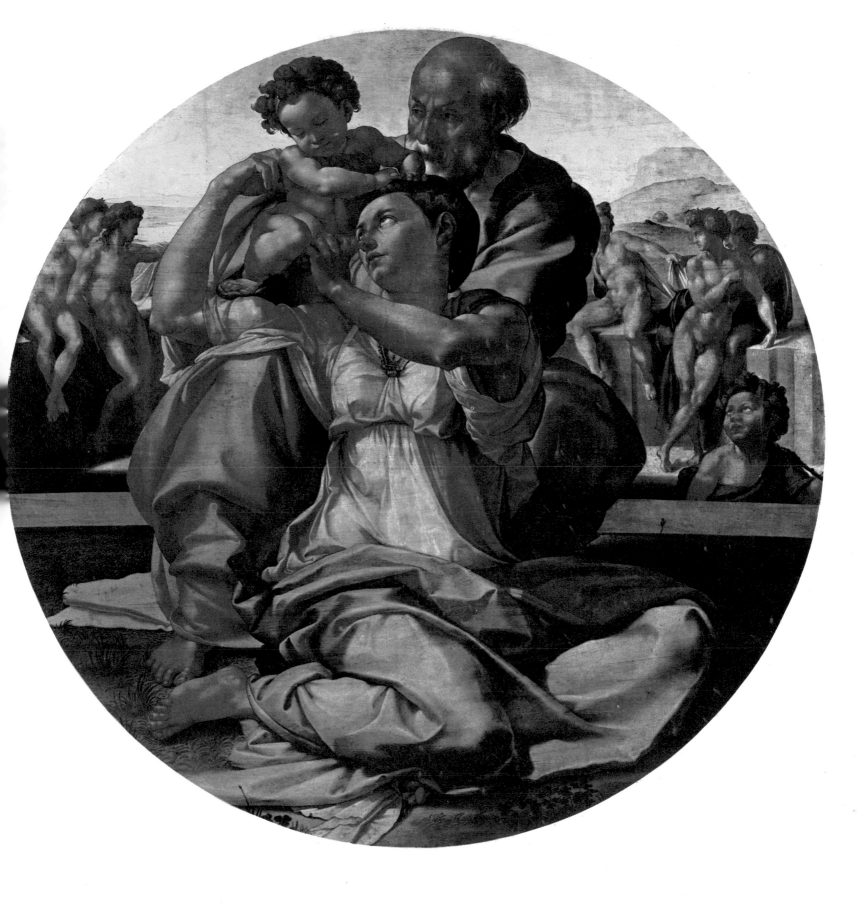

Marisol (b. 1930)

THE FAMILY

1969, wood, plastic, terracotta, neon, 88x56" (223.5x142cm)

Brooks Memorial Art Gallery, Memphis, Tenn.

THE FAMILY was made especially for the Brooks Memorial Art Gallery. The figures are depicted in forms constructed of wood, plastic, and terracotta, adorned with neon. The Madonna is draped with a carved wooden robe (painted with bright blue acrylic) and bejeweled with glass marbles.

The Madonna's terracotta face seems to be a self-portrait of the Venezuelan artist. Both of her hands, each bearing a wedding ring, are left hands. Perhaps the two rings connote her marriage to Joseph and to God. Her hands hold her robe back, exposing a protruding womb which, when opened, reveals a mirrored interior that reflects the onlooker and seems to suggest a kinship between the viewer and the Madonna. Although Joseph is planted firmly on earth, Mary's feet do not touch the ground; instead, they point downward and seem to allude to her uniqueness. Mary's eyes are mystifying in a disconcerting way and present an interesting puzzle. Her left eye is concave and the right convex!

Joseph calmly kneels before the crying, newborn child. The folded hands of Joseph, with thumbs outward, cannot be his, but instead seemingly represent the praying hands of all mankind. Joseph's bare feet protrude from the back of his bright orange "body".

The carved wooden Child, on his plastic and neon bed, evokes an image of Fra Filippo Lippi's depiction of the infant Christ in his *Madonna enthroned* in the National Gallery, Rome. The same pudgy limbs and face can be seen in both works.

One senses Marisol's theological roots and perhaps a manifestation of her self-worth in this sculpture of the Holy Family.

JOHN J. WHITLOCK

MARISOL'S *The Family* has the intensity of expression that Pater must have had in mind when he referred to this characteristic ("rare in poetry, rarer still in art, rarest of all in the abstract art of sculpture") as the one "which alone makes works in the imaginative and moral order really worth having at all".

ELSIE LEIGH

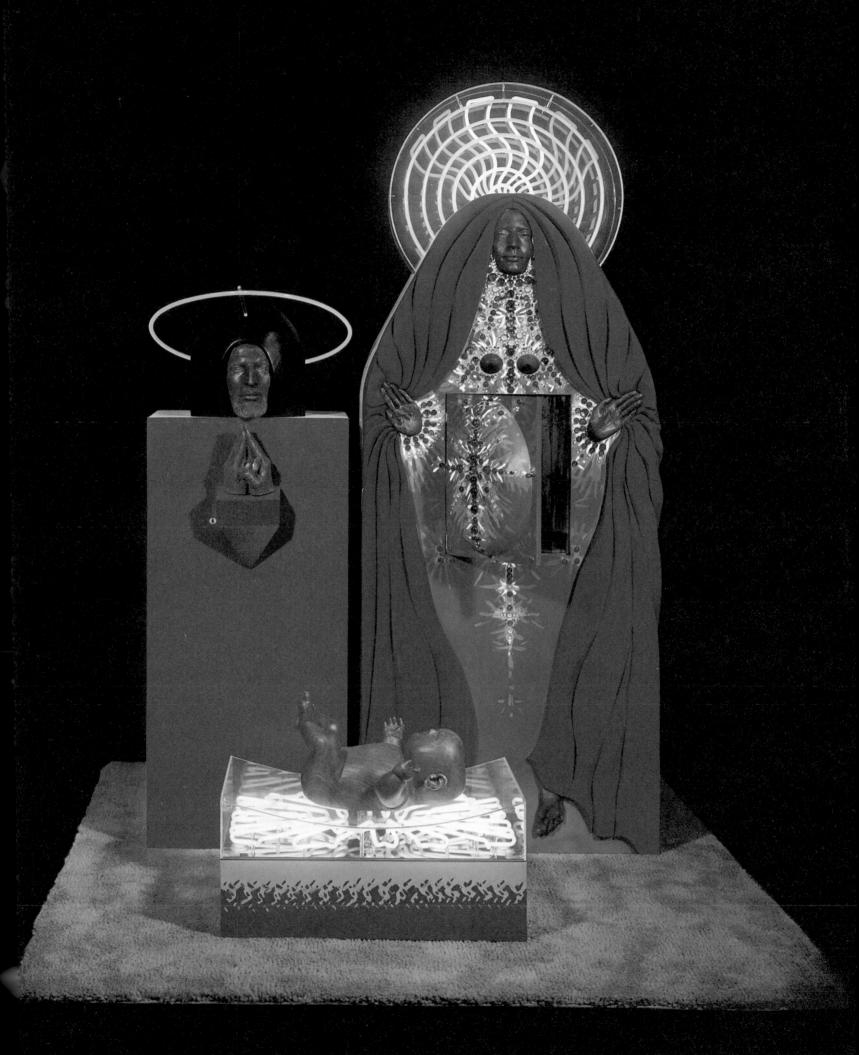

Paul Gauguin (1848 – 1903)

NATIVITY

1896, oil on canvas, 37³/₄x50³/₄″ (96x129cm)

Bavarian State Galleries, Munich

POOR Gauguin! To reach the land of his heart's desire, he was forced to create it with his own hands. Still in France, waiting for a ship, he had already improvised a naked Tahitian Eve, sloe-eyed and poetic. But alas, when he landed on his dream island he found Papeete, the capital, ugly and middle class. The quaint thatched roofs had by 1890 given way to rusty corrugated iron.

Those langourous pagan girls with golden flesh he had heard described were swallowed up in missionary ankle-length sacks. The young, god-like men had affected straw boaters and resembled French music hall performers who had forgotten their pants. When he took a young mistress, he felt the wrath of the priests, who harassed him constantly.

And no one bought or even liked his paintings. One man who commissioned a picture to be "comprehensible and recognizable" and was submitted the now-famous *White horse*, refused to pay for it because "no horse is green."

"Everything is green in the afternoon shade," said Gauguin.

"I want a horse I can appreciate all day long," was the reply.

Money was scarce then, as was family news. Also, Gauguin suffered from various illnesses. Finally, he tried to commit suicide, but his body's violent reaction to the poison forced him back to miserable life.

However, he painted his life, holding fast to wisps of dreams. Pictured here is Pauura, his fifteen-year-old mistress, who has just given birth to a baby who was to die in a few days. Gauguin bore this pain with artistic resilience. He put halos on the sad mother and child, making them the Holy Family, and presto! Tahiti was the head of the spiritual universe.

The picture shows clearly Gauguin's belief in the basic unity of all holy creeds, so he must have gleaned some reward while painting it. Certainly we are happy while looking at it. We can easily slide into the fantasy that Tahiti is as pastoral and pure as Gauguin painted it. He lets us see a world he never saw. But his inner wish was so strong, the island in his mind so vividly painted, that it has become the Tahiti the whole world believes in, ignoring the real but slightly tawdry one.

JOSHUA LOGAN

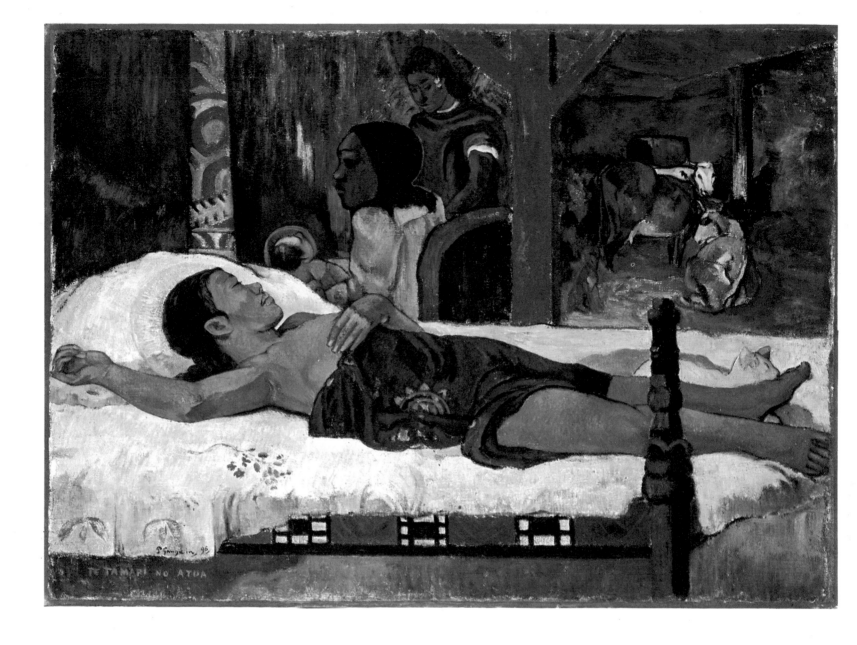

Anon.

MADONNA AND CHILD: Detail

986–994 (Byzantine), mosaic, detail height 119" (302cm)

St. Sophia Museum, Istanbul

ST. SOPHIA in Istanbul is said to be the oldest functioning building in the world and is regarded by many as the most enthralling example of architecture in existence. St. Sophia was ordered in A.D. 532 by Justinian. It was built in the remarkably short time of five years and has miraculously survived in a city much given to earthquakes. The glorious mosaics had been covered with thick plaster by order of Mohammed the Conqueror because the Islamic religion forbids any kind of human representation, but they were again revealed when the mosque became a museum.

Under the Roman Empire the ancient art of mosaics reached perfection. During a period of great prosperity, from the late ninth through the eleventh century, the brightest and most exquisite mosaics were produced. This particular masterpiece was done in the tenth century, probably between 986 and 994. It is a detail from the lunette over the south portal, showing the Madonna and Child between Justinian and Constantine.

In mosaic art one often finds designs composed of various kinds of colored stones, including pieces of plain marble or alabaster as well as more precious stones. But as early as the Imperial Age glass appears beside the natural stones, for it was found that with glass it was much easier to produce patterns in all colors, even the gold and silver found in full glory in the mosaics of St. Sophia. To make these gleaming cubes, little plates of precious metal were placed on one side of the transparent glass, then covered with a new layer of glass and welded between the two glass plates. Designs for the mosaics were drawn in advance, then the colored cubes were pressed down piece by piece in a bed of mortar and kept at equal height by means of a board with a straight or curved edge to match the shape of the wall or ceiling.

The Christian mosaics differed little from their predecessors except for a new spirituality with a negation of the earthly and an aspiration toward the supernatural. There is something sad, and yet inspiring, when one reads that a work of art is by "artists unknown". There was a time when anonymous artists worked only for the glory of God and not their own immortality, yet they often achieved it, as here, with this masterpiece.

DELMER DAVES

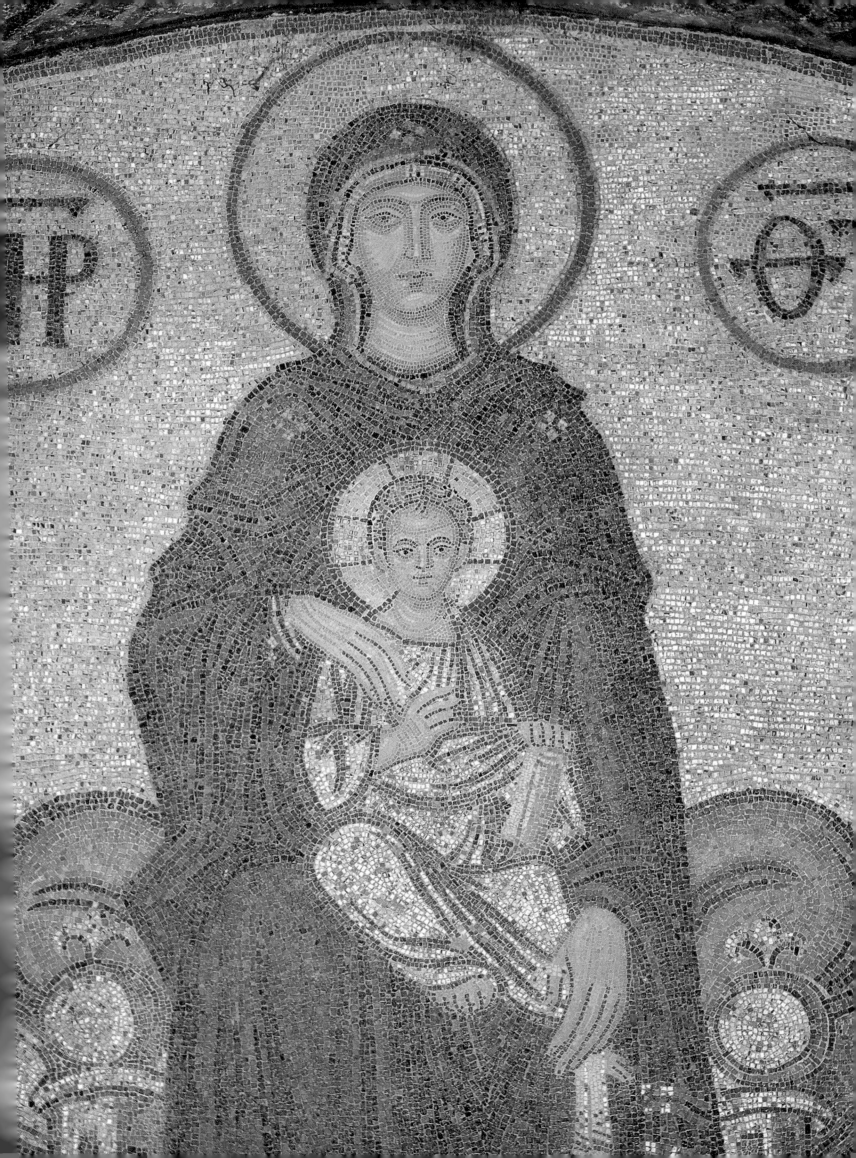

Norman Rockwell (b. 1894)

MOTHER AND DAUGHTER

Illustration from the *Saturday Evening Post,* Dec. 18, 1937, oil on canvas

I THINK it is the mood of mystery and drama that appeals so much to me in this picture by Norman Rockwell. Although painted realistically, down to the wedding ring on the mother's finger, there is an underlying sense of apprehension—of not knowing. The little girl in her white camisole and white stockings stands out rather starkly against the muted background of her mother's dress. Her face is grave. The whole focus of the picture is on her. It is an unforgettable moment in the child's life that Rockwell has dramatized—the day that a little girl first stepped down from the misty clouds of simple childhood onto the solid concrete of adult life. This child is suddenly faced with the fact that instead of being a fairy-tale princess in disguise she is only a little girl with very straight yellow hair. Her crown and her scepter, which had given her such pleasure, lie at her feet. Even the kitten emerging from the shadows seems a little fearful of what lies ahead. But as she gazes into the mirror with such round eyes (I take it for granted that we are the mirror into which she is looking) she sees the reassuring presence of her patient mother who will always be there to help her grow up.

Is part of this picture's appeal a nostalgia for an American past when life was simpler and family life more solid? I think so.

JANE WYATT

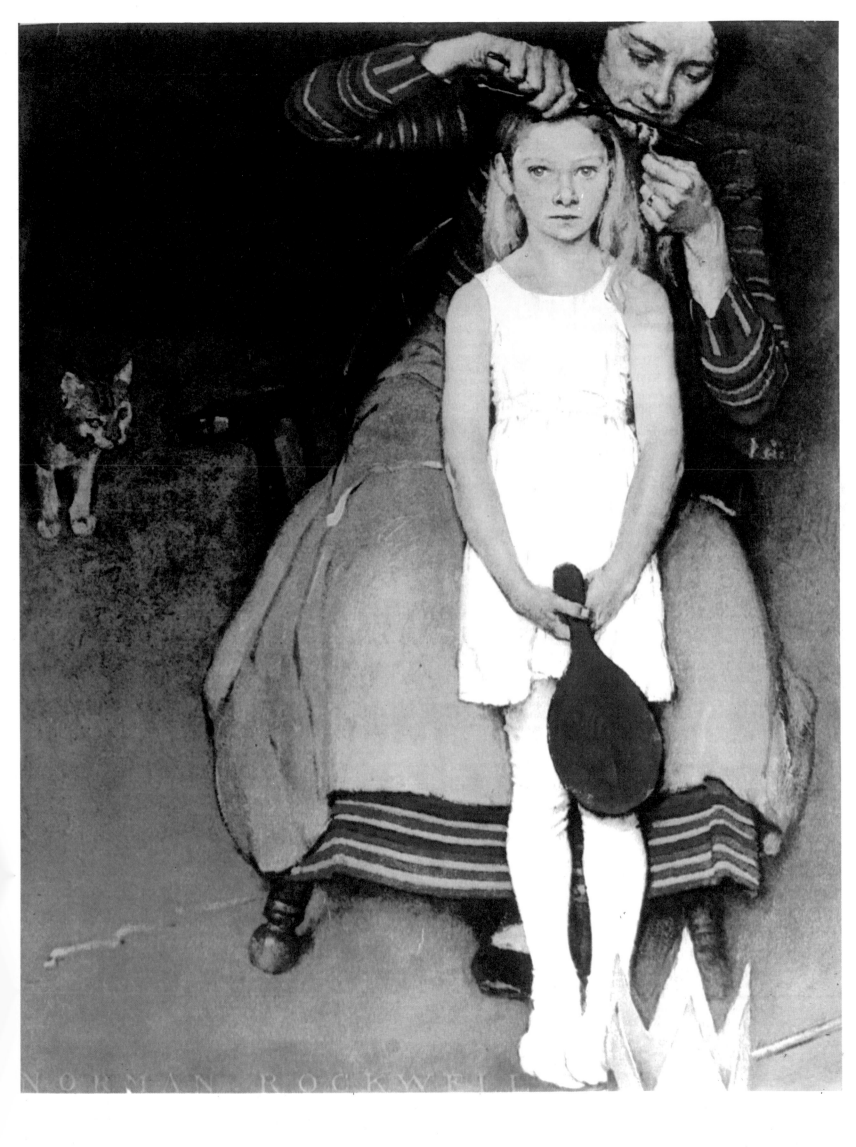

Marc Chagall (b. 1889)

BANKS OF THE SEINE

1953, oil on canvas, 31⅛x26¾" (79x68cm)

Collection Vava Chagall, Vence, France

MARC CHAGALL calls his painting *Banks of the Seine,* but by the images he employs one can see that he is trying to express a far more comprehensive idea than the title would suggest. He differentiates the two aspects of the river with a mother holding a young child to her breasts on one bank, while on the other bank is typified some sort of amphibious beast. I believe that by selecting these two diverse images he is suggesting a universal completeness about the river and its banks. The connotations of the graphic substance of the painting are unlimited. Someone has said that if there were no such being as God, man would have invented one. It is the same with the idea of "mother". Here the mother-child image stands for all of Paris that lives, or for that matter, all of France.

The color composition suggests the color spectrum progressing counterclockwise from red-orange through yellow, green, blue, and violet for the mother's hair. The mother symbolizes the fecundity of one bank, expressed in earth-red color, which at the same time proclaims the spiritual power and infinitude of Mother Paris enfolding the innocence and purity of its newborn, to whom it gives succor and life. For the child, Chagall chose white.

The opposite bank suggests bestiality, remote yet connected by the Seine bridges. The artist himself, or at least the artist image, is included in the painting. He faces the mother and child as if to show wherein his subjective convictions lie. Paris, the mother, holding her people—depicted by the babe in arms—to her breast is the artist's inspiration.

KING VIDOR

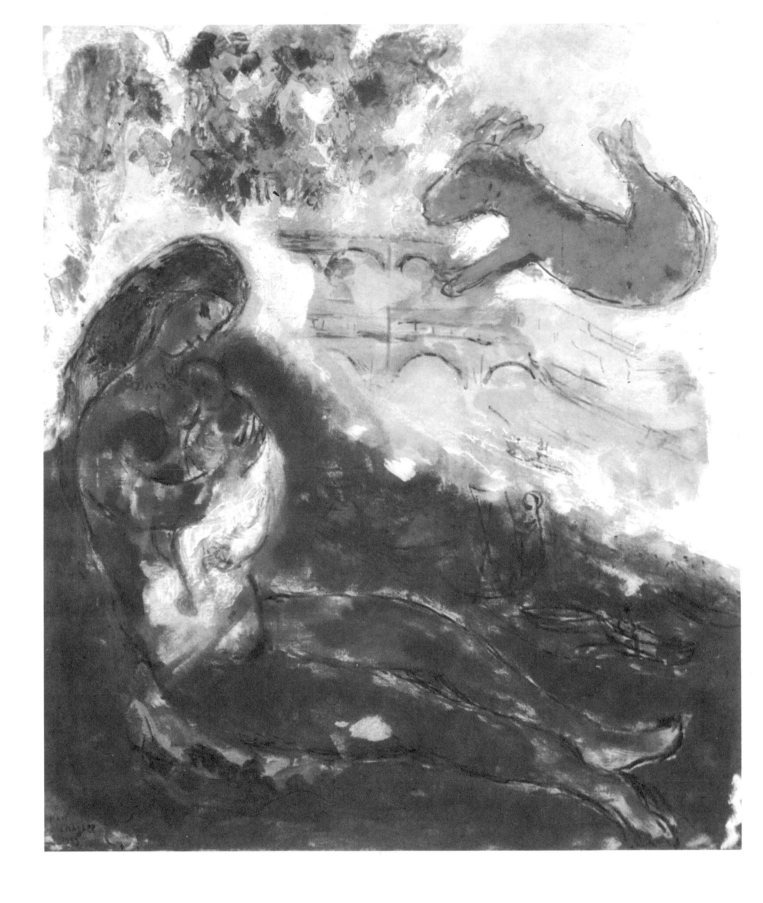

Hans Memling (1433 – 1494)

MADONNA OF THE APPLE

1487, oil on wood, left panel of diptych, 17½x13" (44x33cm)

St. John's Hospital, Bruges, Belgium

THE Art of Serenity! No artist so serenely captures and defines it as does Memling. This supreme Madonna and Child, perhaps as perfect as any work of art, reflects the composure of certain love, of divine knowledge in a setting of worldly tranquillity.

Memling lets nothing disturb our contemplation of fulfillment of the ultimate mystery of life: the secret between Mother and Child. The fruit with which she tempts his worldly appetite is an orb they both know will be conquered. It is the fruit that tempted Eve, but that sin of frantic, too human curiosity is here atoned by the selfless one who accepts it in the spirit of benign forgiveness.

Memling's composition has the peace of a pyramid, the simplicity of an "S", the assurance of the cross. It attains the sophistication of simplicity by the most controlled use of detail. That so much is happening in every area of the picture would seem to belie the overall feeling of calm . . . but there is the respect that makes Memling a great artist—he sees much to make us see only what he wants us to feel.

VINCENT PRICE

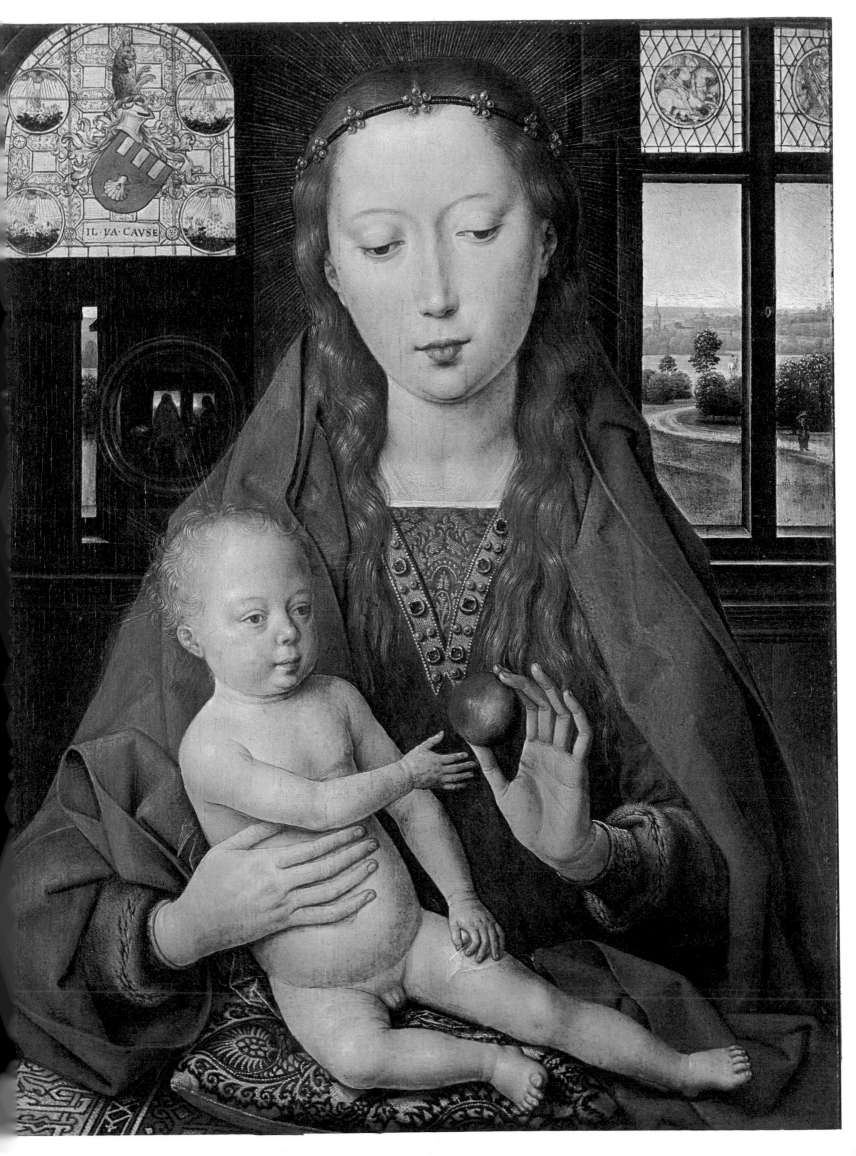

IL·VA·CAVSE

Henry Guerriero (b. 1929)

MOTHER AND FIRST BORN

1969/1971, bronze, height 20" (51cm) and 3½" (9cm)

Mother: Collection Arthur Spitzer, Beverly Hills, Calif.

First born: Collection Dr. James Teague, Los Angeles

IN THE Bible it is written, "to everything there is a season and a time to every purpose under the heaven". Six long years ago it was time for me to create the child, a *first born.* The mother, with all the intricately balanced mother-child relationships implied, was created two years later. Like human mother and child, they stand independently of each other though totally connected.

The complex development and unfolding of the child, interlocked by a million tensions and emotions with the simple serenity of the mother, has been a subject haunting, obsessing artists since the beginning of time. Many years of work I spent in Europe, Mexico, and the United States before daring to attempt this historically great subject. Once the work was begun, I often thought, during countless days and late nights, of my mother and my own childhood.

The two abstract bronzes, *Mother* and *First born,* embody, I feel, the essence of the eternally beautiful relationship between a mother and her child. They represent my emotional reaction to this most common, yet most miraculous and most mysterious, of life's bonds. "Mysteries are not necessarily miracles," Goethe has said, yet the glory of a mother and child is both mysterious and miraculous—the love and birth symbols of the universe.

HENRY GUERRIERO

Claude Monet (1840–1926)

MME. MONET AND CHILD

1875, oil on canvas, 22x25¾" (56x65cm)

Private collection

ALTHOUGH my family left Paris to settle in New York when I was only three, my bringing-up was strictly French. Mother chose to believe we were still in Paris and remained completely oblivious to anything American! Thus Central Park was the Luxembourg and the Tuileries, and the Metropolitan Museum was the Louvre, where every good French child must be taken regularly on non-school days.

Mother was a great admirer of *"les impressionistes"*, so I learned very early to know and to love the paintings of Renoir, Degas, Cézanne, Manet, and van Gogh. But my favorite of all was Claude Monet. I dreamed of being able someday to paint as he did, catching sunbeams on his brush. I read all I could find about him and wept over his constant struggle to make ends meet, his fight to take care of his wife and child, while painting incessantly. For all this misery, he was driven to put on canvas not the sad, ugly side of their poverty, but the richness and the brilliance of the sea and sky, the peace and beauty of the Seine and its lush green banks. And always the sun, casting its exciting shadows over everything!

This particular painting of his beloved Camille, who was to die not long after the painting was made, is so poignant to me. There is such tranquillity, beauty, and love shown here. What more ideal setting could there be for a mother and child than this fantastic garden!

CLAUDETTE COLBERT

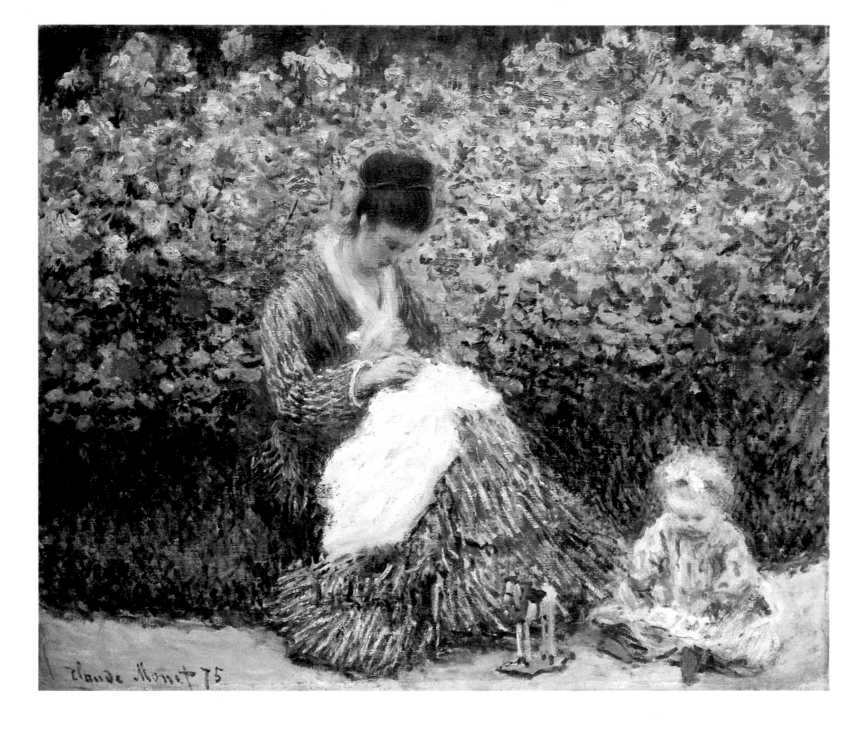

Antonio Correggio (1494 – 1534)

MADONNA OF THE BASKET

1522, oil on wood, 13¼x9⅞" (34x25cm)

The National Gallery, London

IN THIS little painting the Madonna is putting a shirt on the Christ Child, whose attention is caught by something outside the picture to the left. It is possible that the Madonna's action may have a symbolic meaning, though the early critics of the picture do not enlighten us.

The group of the mother and child is as compact as a piece of sculpture. The Christ Child's head is allowed to project above the outline of the Madonna's garments, but all the other portions of his body—even his outstretched hands—are enveloped by her. Though sculptural in concept, and therefore monumental, the group also has enormous dynamism. The Christ Child kicks vigorously with his right leg (his right foot is the focal point, the most distinctly painted part of the whole picture), and the draperies of both figures are extremely agitated.

The main group slants diagonally across the picture space from just below the top left corner to a point just to the left of the bottom right corner. This leaves spaces in the lower left and upper right corners—the first filled by the Madonna's workbasket and shears, the second by a distant view of St. Joseph, planing at his carpenter's bench. He is deliberately painted slightly out of focus and in dull colors so as not to detract from the Madonna group. The elegantly rustic surroundings—steps and ruined buildings—look ahead by as much as two centuries after Correggio's time toward the eighteenth century.

CECIL GOULD

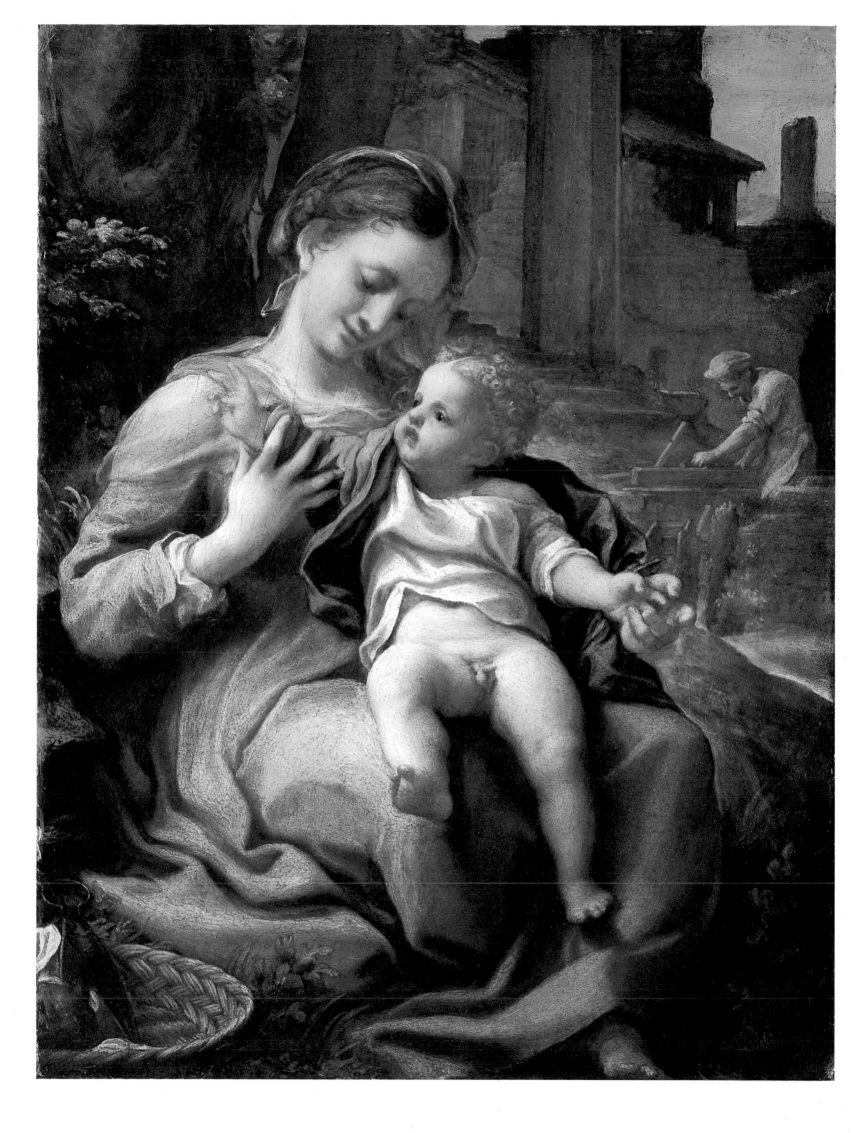

Jacques Lipchitz (1891–1973)

MOTHER AND CHILD II

1941–1945, bronze, 50x51" (127x129.5cm)

The Museum of Modern Art, New York, Simon Guggenheim Fund

IN FRANCE in 1929 Lipchitz completed the plaster for a large bronze *Mother and child.* The mother kneels on the ground, her head and one arm raised to protect and comfort the child who, playfully if clumsily, rides upon her back. A decade later Lipchitz returned to the same theme. On paper, in a series of sketches, he drew the mother's torso, this time with both arms raised. As the studies progressed, another image emerged—the head of a bull.

After the fall of Paris in 1940, Lipchitz fled to Marseille and then to New York. In the United States, the first large sculpture he completed was a second *Mother and child,* developed from the sketches begun in France. In 1942, almost immediately after this sculpture had been cast in bronze, he started another version which is reproduced here.

Lipchitz, a great storyteller, mentioned to his friend Alfred H. Barr, Jr., that while working he realized the possible source of the mother figure. He remembered that once in Moscow on a rainy night he had heard the loud, hoarse voice of a woman singing. As he walked nearer he saw the woman under the light of a streetlamp. She was legless and her torso rose abruptly from a little cart. She sang with her arms outstretched, her face raised to the light, and her long hair hanging wet in the rain.

Lipchitz's *Mother and child* is no conventional variation on the universal theme. He himself interpreted the multiple images of mother, child, and bull's head as an expression of a conquered Europe's despair and hope. Very likely Lipchitz also remembered the same images which had appeared in another allegory, Picasso's heroic mural *Guernica,* which he had seen in Paris in 1937.

WILLIAM S. LIEBERMAN

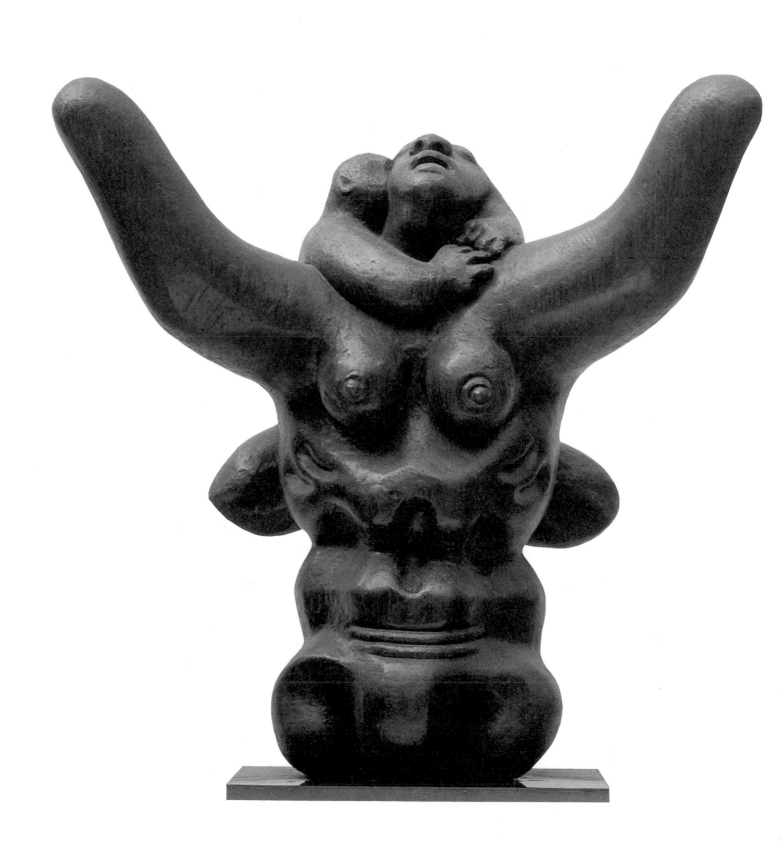

Anon.

THE CHOLMONDELEY SISTERS

1600–1610 (British School), oil on panel, 35x68" (89x173cm)

The Tate Gallery, London

How neat they are and how turned out they are. This is a very charming picture—carefully painted and carefully conceived. The scarlet of the babies' wraps gives dash to the painting of two young mothers, so obviously aristocratic and obviously luxurious, so smartly arranged in the same bed—against identical white linen pillowcases, only their jewelry and the patterns of the lace differing.

Do we know what their lives were? They could be twins but are not identical twins. One feels that they are very close in age, married at almost the same time, and were delivered of their babies at exactly the same time.

Or, are we romancing? Is this all a *trompe-l'oeil?*

Are they two *vieilles filles,* never desired by any man and holding in their arms, swaddled in brocade, their own babyhood and innocence, and dreams of what could have been?

DIANA VREELAND

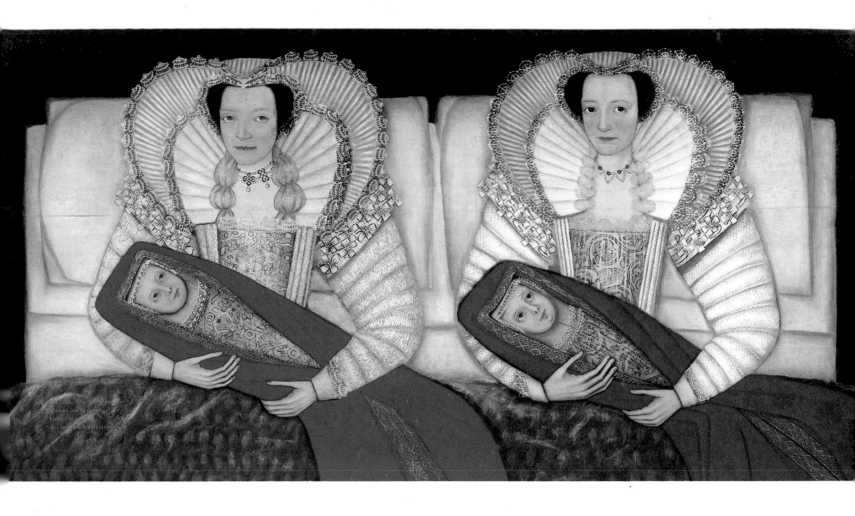

Pisanello (1395—1450)

MADONNA OF THE QUAIL

1426, fresco, 19¾x13" (48x33cm)

Castelvecchio, Verona, Italy

WHEN I was a child living in Italy, "Madonna" was a word we heard as often as *"buon giorno"*.

Sometimes the Madonna made mysterious appearances. One time the *contadini* (peasants) who worked on the farm next to ours, on a hillside above Florence, came running over to our villa. Breathless and dragging children by the hand, they said, *"Si, si, signori*—last night we saw the Madonna . . . she appeared at dusk, on our way home"*. At the top of a hill, close to where we lived, she had emerged from a cluster of laurel branches. After a few seconds she had vanished in the amber rays of sunset. "We must return there tonight," they urged. "We feel sure she will not disappoint us." So compelling was their conviction that my mother and father led all eight of us up the narrow, dusty road, up to the spot where the vision had appeared. The *contadini* were waiting there, bunched together in an expectant embrace. We stood motionless beside them until the sun had completely settled behind the cypresses and laurel bushes. The Madonna did not come back, but she left a permanent spell in what became a sacred spot to the peasants and to us children.

As I look upon Pisanello's *Madonna of the quail* I recall that provocative evening in Florence when we waited for the Madonna to appear before us. Similarly, Pisanello's Madonna is rising from a cluster of green foliage, floating skyward, ready to disappear at any moment. She is the acme of youthful beauty, with features so fine and sensitive that she looks more childlike and innocent than the infant Christ. His expression, so charged with prophetic responsibility, senses the burdens he is to face and the infinite messages he will pass on to humanity. The fold of the Madonna's robe curves into a semicircle of motherly protection and, like a shell, opens up to deliver the infant Jesus to the world, while modestly and unpossessively she holds him lightly, barely touching him. The wise quail is standing by the Madonna's feet like a guardian, while the baby birds rejoice and sing in the verdant background and two angels crown the Madonna in a burst of golden light.

GLORIA BRAGGIOTTI ETTING

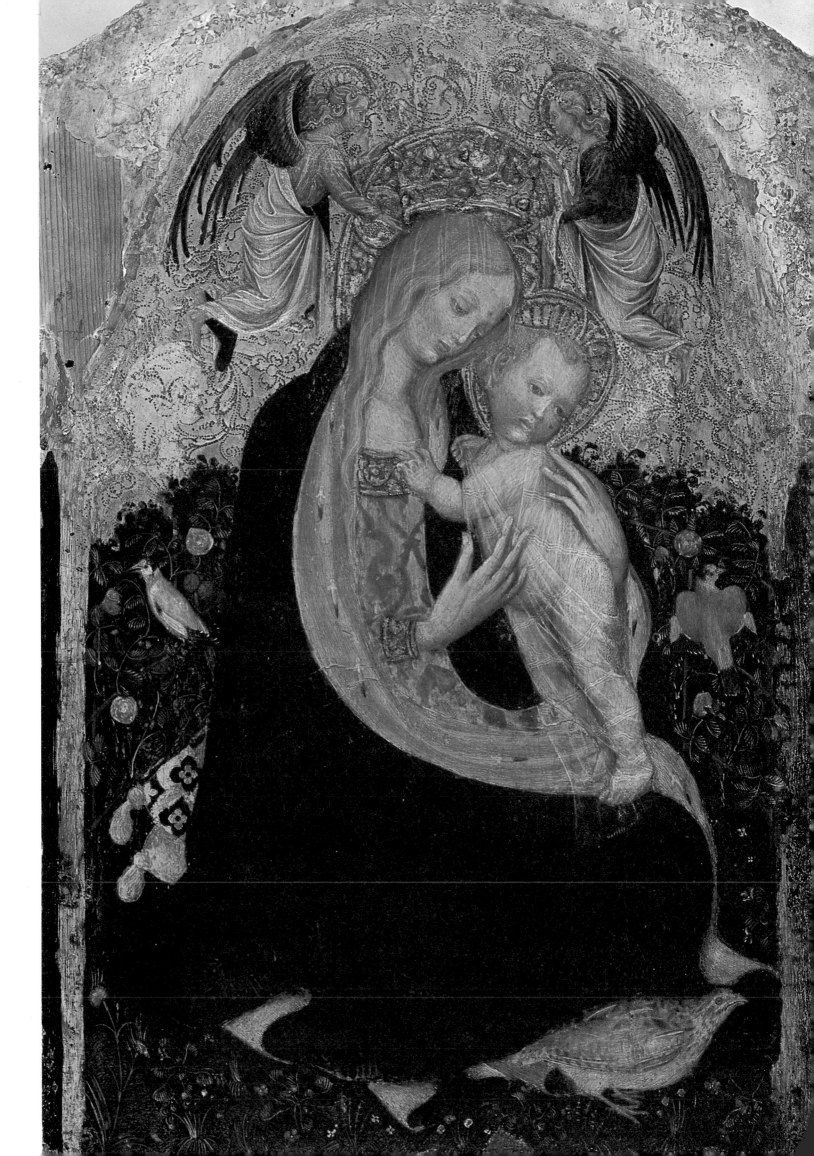

Henri Matisse (1869 – 1954)

MADONNA AND CHILD

1946, glazed ceramic tiles, 12x22½' (3.6x6.8m)

Dominican Chapel of the Rosary, Vence, France

THE dream of every great artist is to erect a complete monument, architecture and decoration, that will be both the highest expression of his personal style and the receptacle of universal values—a sacred dwelling, a sanctuary. Exceptional circumstances allowed Matisse to realize during the last years of his life, in an outburst of offering and talent, the Chapel of the Rosary (Sainte Marie du Rosaire) at Vence, which he considered his masterpiece and his testament. "This chapel is for me the outcome of a lifetime of work and the flowering of an enormous effort, sincere and difficult. This is not a task that I have chosen, but rather a task for which I have been chosen by destiny at the end of my journey."

Set down with ease and discreetness, as though having always been there, in its Mediterranean surroundings of plants and sun, the little white chapel with blue tiles reveals the miracle of its harmony, the solemn purity and simplicity of contrasting elements. "My principal aim," said Matisse, "was to balance a surface of light and color with a simple wall, with a drawing of black on white." Stained-glass windows with a design of leaves fashioned of three clear and united colors—transparent green and blue, translucent yellow—distill the supernatural light that reflects itself on the panels of white ceramic, where religious compositions are drawn with black lines. Upon entering, we discover near the altar the high and serene statue of Sainte Dominique, founder of the order to which the chapel is consecrated, and on the long wall at the right, radiant from the light of the stained-glass windows, the *Madonna and Child,* raised majestically among the great celestial flowers blooming around her. She holds against her slender body the standing body of the Jesus Child, spreading her arms in the form of a cross, in a premonitory gesture of the sacrifice that is carried out dramatically on the back wall. The transparency of the light and the perfection of the design bring down to the essential, sublimely, the nudity of the Madonna with her trembling bosom and make of her the ideal image of the human life and the divine life, joined inseparably by the Christian enigma.

JEAN LEYMARIE

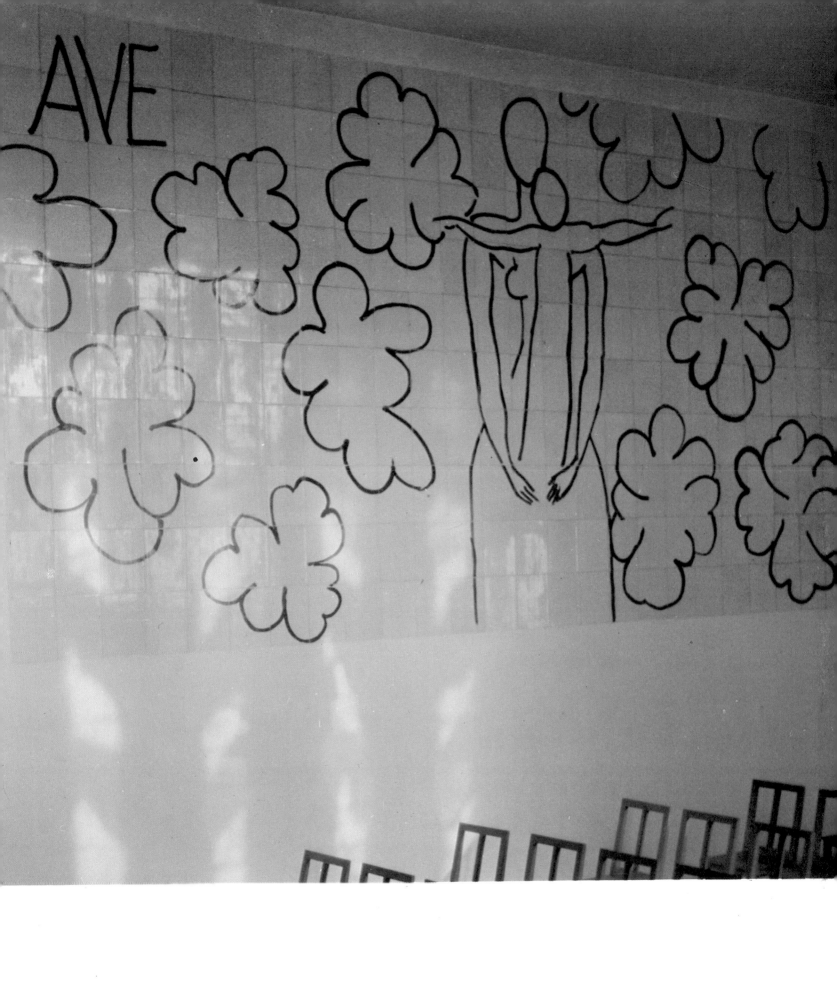

Anon.

MOTHER AND CHILD

c. 1900 (Ashanti), painted wood, height 18" (46cm)

Collection Katherine Coryton White, Los Angeles

THIS African madonna emerges from the medieval life of the ancient Ghanian court. She is part of the paraphernalia, the hieratic structure of an empire. Those governments are elaborate guilds of various handcrafts and carving and are closely controlled by court dictates. Works are commissioned for specific purposes, from didactic pieces for ritual use to sculptures merely for the king's pleasure. Highly trained artists are skilled in producing several art styles, moving from simple, deeply traditional figurines to more recent forms, which reveal the Ghanians' alert perception of European realism. Osei Bonsu, who lived before the turn of the century, is still remembered as one of the great masters of this system. He took the artistic tradition and, without disturbing its equilibrium, raised the art to an innovative level, teaching those around him and those that followed him.

This royal mother is in his style. She sits on a silver *asipim* chair, of the kind used for ritual exhibition of sacred people and objects. *She* is ritual. Her every posture is rooted in the centuries. She sits completely in balance, silent and alive, contained and yet aware. Her feet are even, carefully placed. Her head is raised in calm, her eyes are wide open and inward gazing. Her mouth is contemplative. Her neck is creased with rings of heavy fat, the sign of prosperity. The child resting on her lap is offered milk, with her simple serene gesture. It is the mother-queen sustaining the nation. She is fertility—she is life. She is continuity and ancestor, feeding the generations. Few things are so revered in Africa. Royal power, sacred magnetism, the breath of semidivine initiative are not the sole prerogative of kings. The deep, hot mother function is the central core of the queen's authority; she rules the domestic equanimity with careful wisdom. As she is honored with a silver throne, the gleam of moon, so she and her precious child are anointed with fine gold, the glowing dust of sun.

KATHERINE CORYTON WHITE

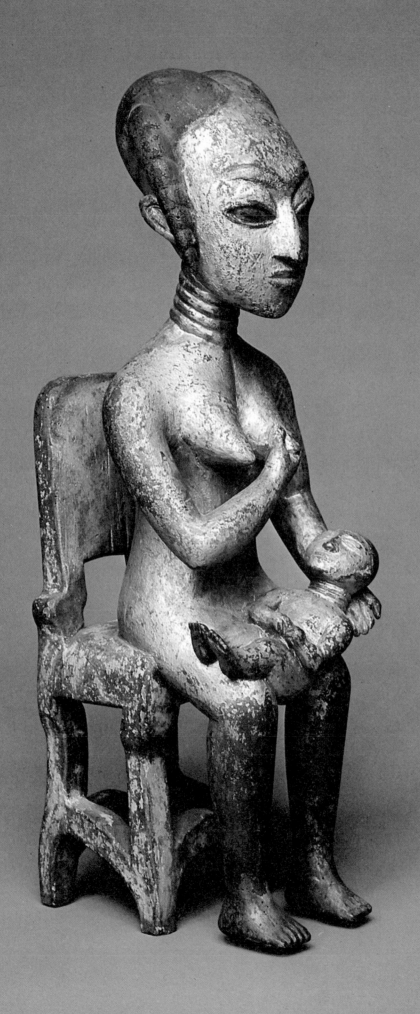

Paul Schutzer (1930–1967)

KHURDISTAN MOTHER AND CHILD

Photograph, negative 35mm

Time/Life Picture Agency

ETERNITY'S SUNRISE" is the message this photograph suggests to me: the eternal triumph of life forever new.

Nothing could mar the exultation of the mother or perturb the communication between the mother and child. Were they standing on a raging battlefield, no clamor could interrupt the tender murmur of her flowing milk. Death and destruction would be a passing event in the face of life's timeless triumph.

This triumphal quality is intrinsic to the nature of motherhood. Why, then, is it not given to all mothers and children? Part of the answer is a question: How many babies are consciously and willingly conceived?

The seed of loneliness, one of the major maladies in our age, is sown early in life. Seeing the feeling of organic unity emanating from this mother and child, one can hardly imagine that this baby will ever be lonely, for he is drinking his milk with the sense of solidarity with another human being. It is to be expected that when all babies are wanted and blissfully nourished, our menacing present polarization will be dispelled. Consciously and happily conceived babies and triumphant mothers may give our race its best chance for survival—for a worthwhile survival in which our basic need to love and to be loved is fulfilled.

LAURA HUXLEY

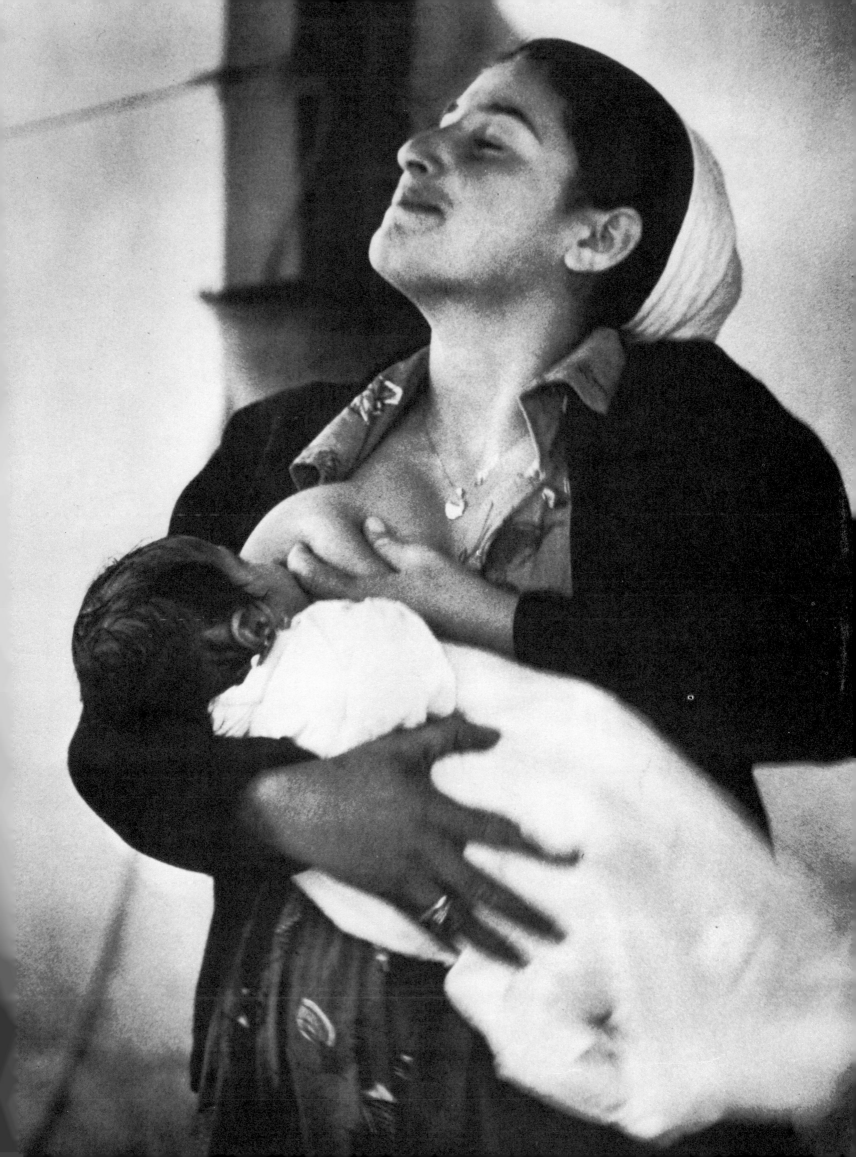

Gerard David (c. 1450 – 1523)

REST ON THE FLIGHT INTO EGYPT

c. 1510, oil on panel, 17³⁄₄x17¹⁄₂″ (45x44cm)

National Gallery of Art, Washington D.C., Collection Andrew W. Mellon

IT SOMEHOW goes against one's puritan grain, the idea of a pretty young mother on a picnic having anything to do with the enduring cultural and religious values of art. Advertisers in our harassed society have capitalized on the imagery of relaxation, and in their case it is a safe rule that more instantaneous appeal equals less artistic significance. The ads of only ten years ago seem hopelessly out of date, not to mention the quaint hilarity of the Victorians. But Gerard David's image, which at first glance might be only the charming depiction of a grape-and-nut break, has managed to cast its inescapable spell for more than four and a half centuries.

The secret of David's picture lies partially, of course, in the deeply human evocation of the tenderness of motherhood. A mother is offering sustenance to her child, and in the process holds him on her knee with a delicacy of touch in her right hand that transmits a wealth of human tenderness.

But much more is going on here. Those grapes foreshadow the wine this Child will offer at his last supper, and thus the blood that he will shed in making the sacrifice of his own life for all mankind. Through this act he will gain for us eternal life, which is symbolized at the far-right corner by a bubbling spring.

No wonder, then, that the expressions on the faces of both Mother and Child are tinged with introspection and a hint of sadness.

But the painting does more than reach back into centuries of Christian tradition. It reached out to the audience of its day by taking the scene away from the road to Egypt and putting it into the immediately recognizable ambience of the Flemish countryside.

Subtly organized, with a giant zigzag going back into space, and gloriously orchestrated in the harmony of its color and the subordination of myriad details into an atmospherically fused whole, David's picture reaches forward to touch us, in our time, with its overall mood. Into that, every element—religion, art history, color, composition—is fused. He has, quintessentially, gotten it all together. Herod may have sent out search parties to murder every child, but even the pursued need to pause; and the refreshment offered us, as vicarious participants, by this pictorially integrated and totally beguiling scene should last us for many more centuries.

J. CARTER BROWN

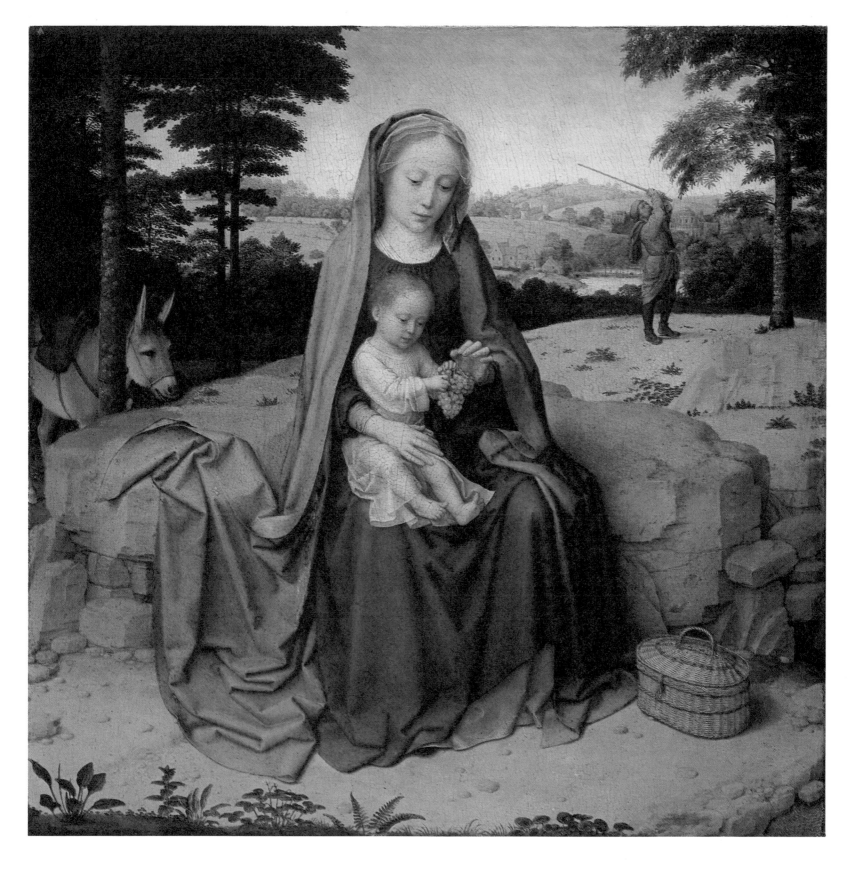

Henry Moore (b. 1898)

MADONNA AND CHILD

1943–1944, Hornton stone, height 59" (150cm)

St. Matthew's Church, Northampton, England

WHEN I was first asked to carve a Madonna and Child for St. Matthew's, although I was very interested, I wasn't sure whether I could do it, or whether I even wanted to do it. One knows that religion has been the inspiration of most of Europe's greatest painting and sculpture, and that the Church has in the past encouraged and employed the greatest artists; but the great tradition of religious art seems to have got lost completely in the present day, and the general level of church art has fallen very low. Therefore, I felt it was not a commission straightaway and lightheartedly to agree to undertake, and I could only promise to make notebook drawings from which I would do small clay models, and only then should I be able to say whether I could produce something which would be satisfactory as sculpture and also satisfy my idea of the Madonna-and-Child theme as well.

I began thinking of the Madonna and Child for St. Matthew's by considering in what ways a Madonna and Child differs from a carving of just a mother and child—that is, by considering how in my opinion religious art differs from secular art.

It is not easy to describe in words what this difference is, except by saying in general terms that the Madonna and Child should have an austerity and a nobility and some touch of grandeur (even hieratic aloofness) which is missing in the everyday mother-and-child idea.

HENRY MOORE

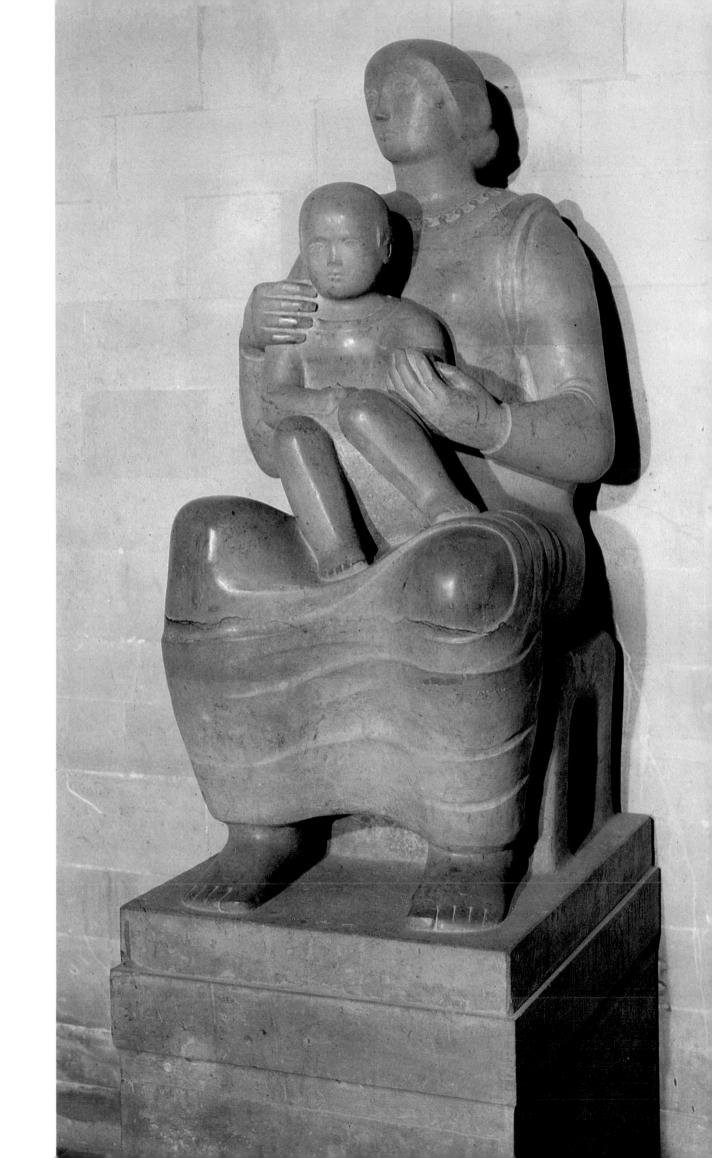

Bronzino (1503 – 1572)

ELEONORA OF TOLEDO AND SON

c. 1550, oil on panel, 46x38³⁄₈" (117x97cm)

Uffizi, Florence

BRONZINO has influenced my life more than I realized when I was growing up in Florence. I was fascinated with the details and the splendor of the clothes in this painting, which I visited often in the Uffizi. I did not know it then, but the inspiration for a career in clothing design was sparked by Bronzino's beautiful portrait of Eleonora of Toledo and her little boy.

Bronzino was not only one of the master painters of the renaissance, but a truly first-class designer. In those days, artists were generally much more versatile than today. Living in Florence, I fully realized the meaning of the term "renaissance man", and Bronzino was exactly that. The way he treats the clothes and the exquisite details certainly shows that he was more than just a painter. In renaissance Italy, it was not unusual for the painter and the subject to work together to create a unique "look" for the coming masterpiece—a practice, I might say, not unlike the teamwork that existed between the then Mrs. John Kennedy and myself.

It seems to me that Bronzino attempted to accentuate the close bond between the mother and her child in this picture by his use of complementary colors and details in the design of their clothes; note the brown pattern in the little boy's collar and cuffs which echoes the brown panels on his mother's dress.

The noble appearance of the two figures combined with the warmly protective arm of the mother and the little boy's gently clutching fingers makes this a quite perfect mother-and-child portrait.

OLEG CASSINI

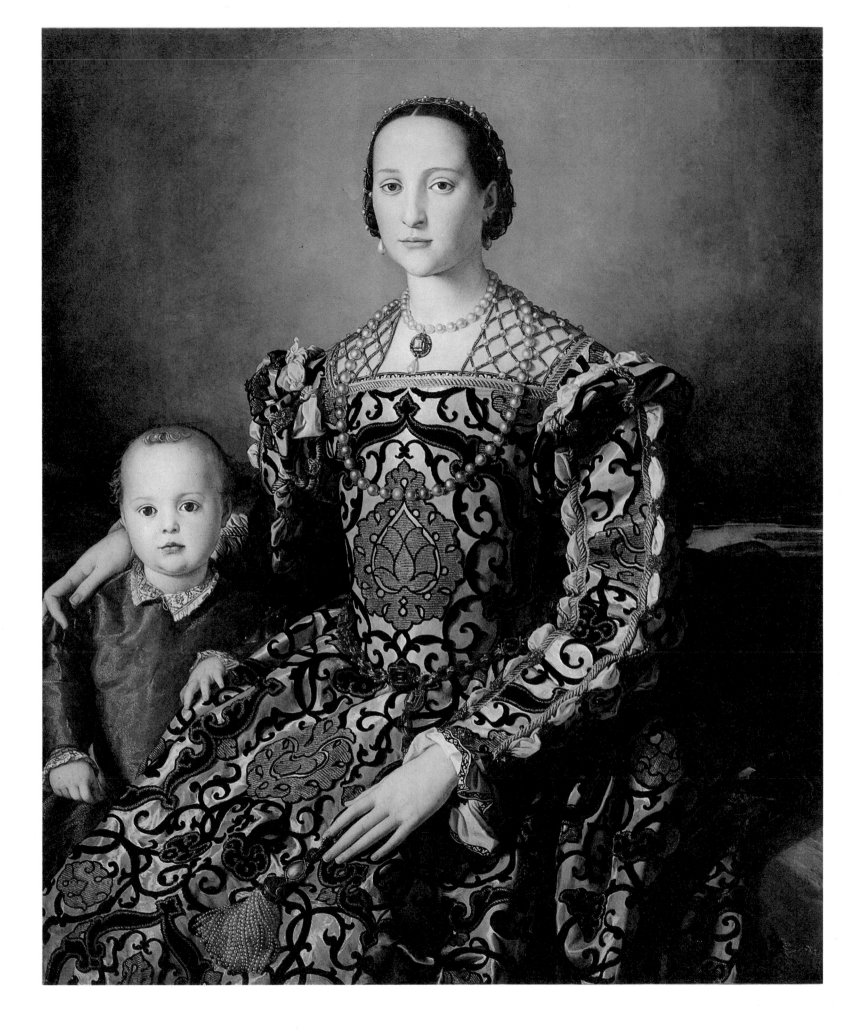

David Siqueiros (1896 – 1974)

PEASANT MOTHER

1929, oil on jute, 88⅝x70″ (226x178cm)

Instituto Nacional de Bellas Artes, Mexico City

I PAINTED *Peasant mother* in 1929 in Taxco, Guerrero. It is oil on canvas. This painting belongs to the period of my work which shows the influence of national archaeology. It was a retrospective period of the search for the prehistoric roots of the ancestral culture of Mexico—a period of the first militant politics in the area of the worker. I have used very solid forms, with a severe, limited palette, and a tendency to darker tones to emphasize the mood of this mother and child.

DAVID SIQUEIROS

THE world of art best knows David Alfaro Siqueiros as a dynamic painter of social commentary; his many murals, begun immediately following Mexico's revolution of 1910–1920, reflect his deep concern for his country and most especially for the workers and agrarians for whom the revolution was a promise of better things to come.

Nowhere is this concern for the *campesino* better shown than in Siqueiros' occasional easel paintings. Here, in this beautifully handled mother and child, he has caught the feeling of strength in adversity and maternal affection so typical of farm workers as a group. It is a scene that one might see in rural Mexico today, a thousand times—and it reveals Siqueiros' warm humanity toward his fellow Mexicans.

JAMES PINTO

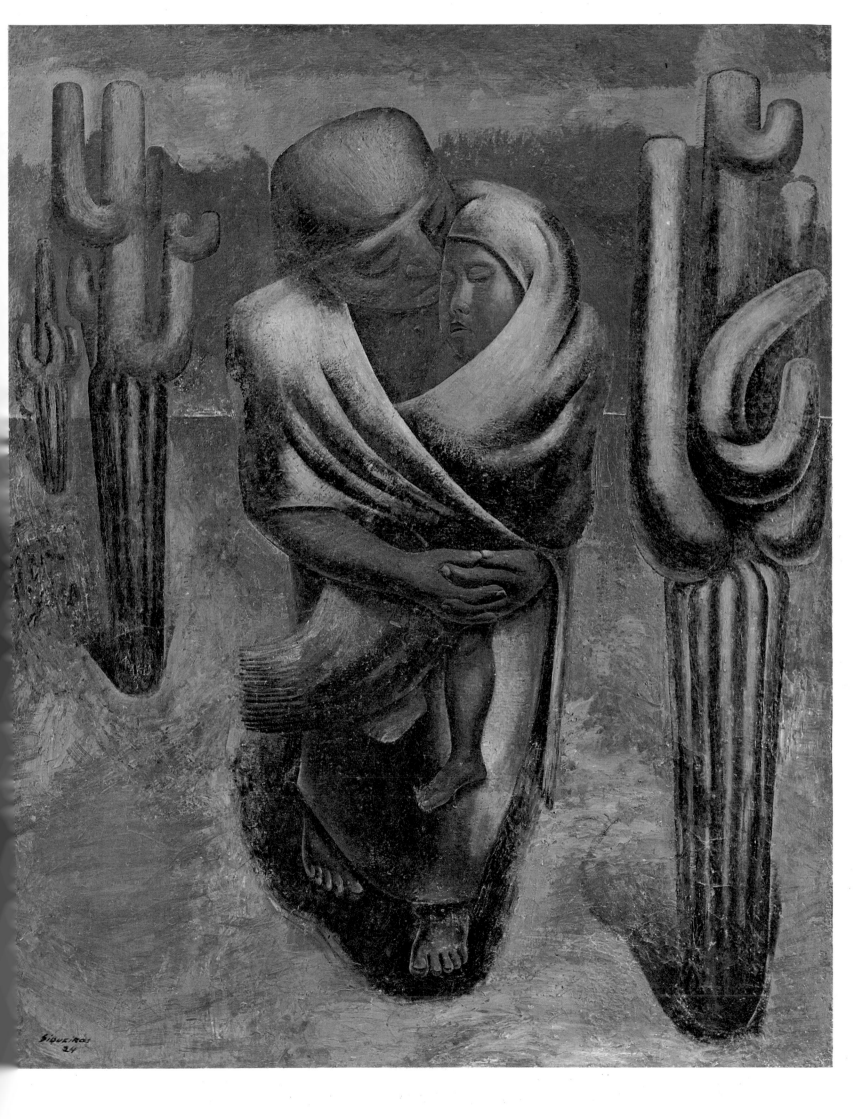

Botticini (1446 – 1497)

MADONNA AND CHILD WITH ST. JOHN AND ANGELS

c. 1482, oil on panel, diam. 48½" (123cm)

Pitti Palace, Florence

THE title could continue "with two goldfinches, two lizards, a finch eyeing an insect, grazing animals, and a flight of birds". Botticini, painting in a lifelike manner, has filled this picture with a richness of detail, an awareness of nature, and a meaningful symbolism. Attention is focused on the reverent gathering in the enclosed garden (symbolic of the Madonna) which is defined by the embrace of a garden wall. One can almost sense the future cross as the balustrade meets the kneeling figure of the Virgin Mother. Her reverence and serenity are deeply felt. The radiance of the young Mother and her preoccupation with the miracle in her life direct attention to the Child. The incandescent and winsome appearance of the Infant Jesus is appealing for its human quality.

From the hand of the angel above, a spill of pink petals far more effectively illustrates the glory of the Infant than the usual halo of light. Flowers abound. Wild flowers bloom throughout the enclosed garden. Carefully picked roses are held by an angel, and blossoms are strewn on the ground by the Child. The bank of full-blown roses, separating the immediate scene from the landscape, clearly shows Botticini's love for the subject. Each rose is painted at the height of its perfection. Punctuating the drama of the foreground are four cypresses, creating a grille through which the distant landscape is seen.

In expressing the tenderness of the moment, the artist pointedly bestows not one but two goldfinches, seen amid the flowers in the foreground. For centuries, the goldfinch depicted several facets of Christian belief, among them the resurrection after death and the immortality of the soul. To the left a finch eyes an insect, a symbol of evil. To represent an earthly aspect, Botticini includes two wall lizards, symbolic of man's need to seek the radiant light of the spirit.

The grace of the figures and the intimate appreciation of nature, framed in a circle—the ancient form of wholeness and eternity—express Truth, Beauty, and Love.

JANE DART

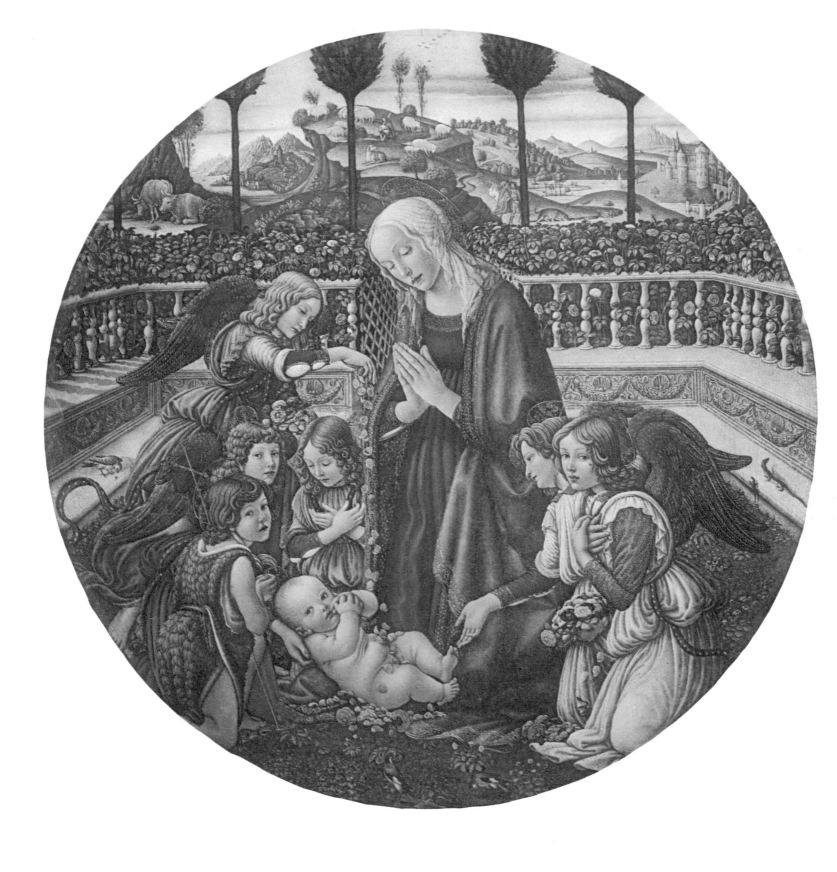

Pablo Picasso (1881 – 1973)

MOTHER AND CHILD

1921, oil on canvas, 40x32" (102x81cm)

Collection Hadassah and Josef Rosensaft, New York

No ARTIST, be he sculptor, musician, painter, or poet, is free from humanity and nature. He is an artist first; not a German, Frenchman, Englishman, Catholic, Buddhist, or Jew. No art is isolated from other arts; all have form, harmony, movement, emotion, heart, and wisdom. A great artist can be a mother and a child even if he is a man, and an old one at that. Centuries apart, all art has much in common. A Madonna and Child of the fifteenth century and this mother and child by Picasso equally prompt me to take my cello and play a saraband by Bach.

GREGOR PIATIGORSKY

This mother and child was painted during Picasso's classical period. The sculptural and almost architectural treatment of the subject give it a stoic quality that is typical of his work from this time. The solid strength of the mother's arm and the balanced rigidity of the chair arms tend to heighten the softness of the child as it looks innocently into its mother's face. The mother kissing the child's hand becomes the focal point of the composition. Picasso has used a blend of sculptural solidity, as represented in the figure of the mother, a softness in the curves of the child, and a tenderness of gesture to depict the universal symbolism of mother and child.

RONALD D. HICKMAN

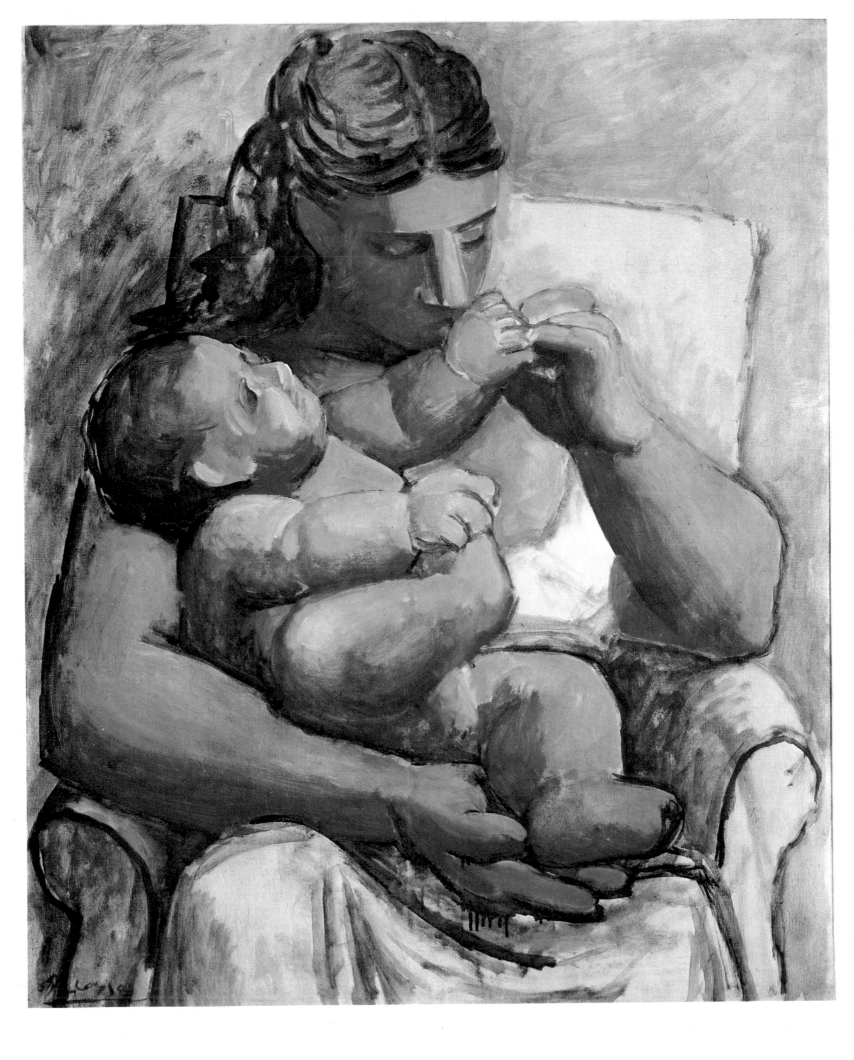

Piero della Francesca (1410/20 — 1492)

THE NATIVITY

c. 1470–1475, tempera and oil on panel, 49x48¼" (124x122.5cm)

The National Gallery, London

OF all Piero's works, this is the one whose voice we hear first. Not only the angels but the colors seem to sing, and with a note so celestially pure that we feel as if he had discovered some new instrument. To combine the fleeting with the permanent, the intimate with the divine, is one of the most lovable achievements in art, the achievement of Mozart, Vermeer, and certain epitaphs in the Greek anthology.

There can be no reasonable doubt that it is a late work, and its beauty prevents us from doubting its authenticity, but it is exceptional and can be explained only by an effort of imagination. *The Nativity* is generally referred to as unfinished. But a recent examination has proved beyond reasonable doubt that the two shepherds on the right are the victims of an earlier restorer. Unfinished to a lesser degree the picture may have been, and the fact that it comes from the family of the painter suggests that it was an experiment, or something done for his own satisfaction without thought of a patron or of a special architectural setting. It embodies, more than any other work, Piero's long-standing interest in Flemish art. This is most obvious in the Child, who is the pathetic newborn Babe of Hugo van der Goes. The iconographical motive by which the Child lies on his Mother's cloak is from the same source.

The landscape of *The Nativity* has Piero's beautiful contrast of light and dark, but the darks are the tight, round trees and bushes of Rogier, with their leaves carefully described and their trunks growing neatly straight down from their centers. Piero has been faced with the problems of combining these Flemish ways of seeing with his own sense of spatial construction, and this has led him to adopt a design less strictly architectural.

What induced in Piero, at a time when painting was beginning to lose its interest for him, this mood of intimacy and lyrical freedom we cannot tell; but we can hardly resist the old fable of the silver-throated swan, invented by poets to symbolize the moment when their gift of poetry was leaving them, and their last notes seemed to have an unprecedented beauty.

LORD CLARK

Kenneth Clark

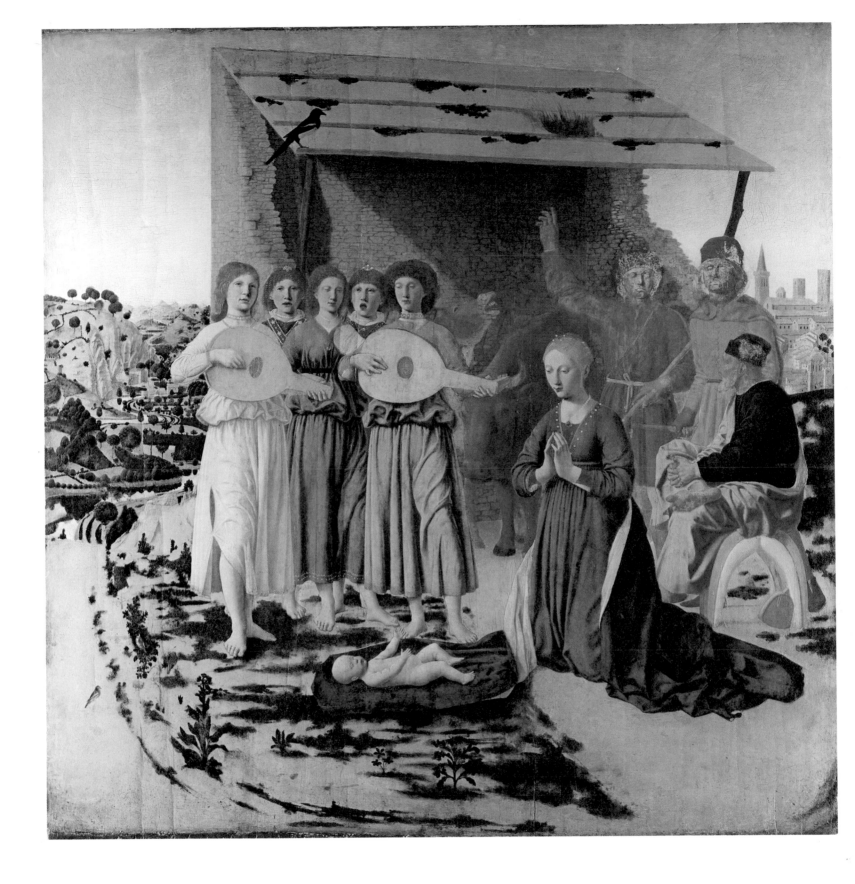

Käthe Kollwitz (1867 – 1945)

MOTHER AND CHILDREN

1920, crayon drawing, 24x18" (61x46cm)

Collection Mr. and Mrs. Jacob Zeitlin, Los Angeles

So POWERFUL is the art of Käthe Kollwitz that no one can react indifferently to it. Those whose conscience is full of guilt for human misery and suffering cannot bear to face her silent women and imploring children; they must suppress her. Kaiser Wilhelm II in 1906 vetoed the award of a gold medal for her Weavers Series. Hitler and his fellows prohibited the exhibition of her works lest they be a too poignant reminder of the cruelties they had inflicted on the helpless.

To the sensitive ones of our world she speaks a moving language, the language of Goya and Daumier and, too, something of the language of Rembrandt with his love of old faces and beggars. Not any of these others, however, have dealt so tenderly with women and children. If there is little happiness in her art, surely there is much love.

But concern with the dark side of life was only part of her personality. In 1948 her niece, Mrs. Fritz Kortner, spoke to a small group gathered to honor her. She told us that Käthe Kollwitz could be gay and witty in company, and that she could remember her dancing with one of her sons at a family party.

Among the artists of all time, she alone speaks as a woman for the women of all the ages who have felt the heights and the depths of emotion in the way that is special to women.

JAKE ZEITLIN

Man Ray (b. 1890)

MADONNA

1914, oil on canvas, 20⅛x16⅛″ (51x41cm)

Columbus Gallery of Fine Arts, Columbus, Ohio, Collection Ferdinand Howald

IN 1914 I was hoping to be able to leave for France, but the war broke out in Europe upsetting my plans. I had been visiting museums to look at primitive paintings, studying techniques as well as more modern works in galleries, in preparation for the trip.

A feeling of frustration and despair overcame me. However, I continued to paint more than ever. The result was a large painting titled simply *MCMXIV*. Then the *Madonna*, a more symbolic work, the dress in mourning black, the arm holding the Child, like a cannon from which smoke issues, forming the halos.

Perhaps the idea was to express my desire for peace as against war. There were no religious intentions. The technique is modern, which at the time was quite out of keeping with the spirit. Now the church is one of the most avid patrons of contemporary work!

MAN RAY

MAN RAY has painted a moving and tender modern Madonna, very different from the women he photographed. Quite a few good painters were lost to photography, such as Steichen and, for years, Charles Sheeler. This is a flat and hieratic image, with a hint of the icon, a hint of the cubists, and a whole science of design in the placing of the figure. Man Ray is a very clever artist, and he could paint a religious picture better than the next man. There is no deep natural piety or strong belief here, but a fine sense of style and an outline that carries for miles. For a man of the world and a scoffer, making this popular devotional object was quite a feat. Painted in 1914, while Man Ray was still in New York, this is a Paris and Hollywood Madonna. She is not thinking about much, but she is highly decorative, and she makes a grand effect.

MAHONRI SHARP YOUNG

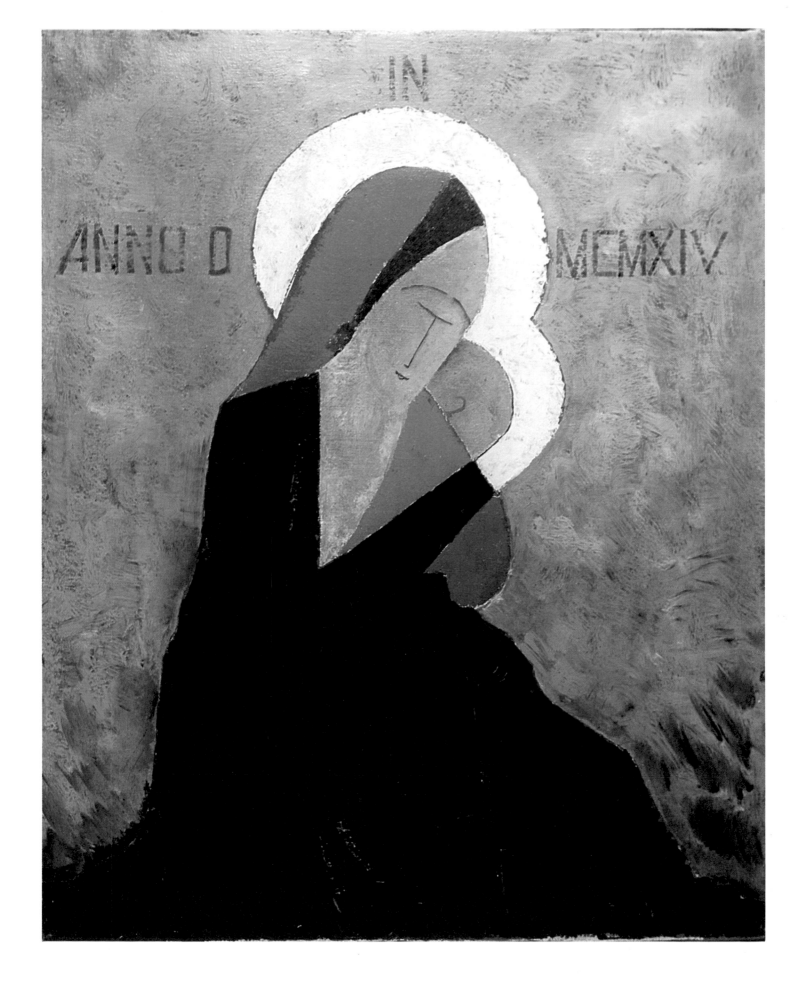

Gustav Vigeland (1869–1943)

MOTHER AND CHILD

c. 1928, bronze, height 79½" (202cm)

Vigeland Park, Oslo

YOU will find this happy young woman running with her child in the Vigeland sculpture park in Oslo, Norway. There are several hundred figures, groups, and reliefs in bronze, stone, and wrought iron made by the sculptor Gustav Vigeland. This statue belongs to one of a series of fifty-eight sculptures in bronze placed on both parapets of a bridge crossing the river.

The uniting theme may be called "the cycle of life" and is the artist's vision of man's journey through life, starting with the fetus and ending with death and decay, from which spring new generations. Vigeland has tried to capture typical human situations and emotions of different stages of life, such as the relationship between man and woman, children and adults. Among the sculptures on the bridge there are seven groups representing different situations and moods between mother and child and, what is perhaps more original, just as many depicting father and child.

In the group represented here we sense an exuberantly happy young woman running with a baby in her outstretched arms, both of them enjoying the speed and the movement through space. A happy vitality emanates from the group—the radiation is so strong that it makes us participate for a moment in their joy of life.

Typical of most of Vigeland's sculptures is that the figure is not self-contained, not an ideal in itself. It radiates life and expresses an emotional content, in this case happiness and joy. The group belongs to a late phase in Vigeland's art, modeled around 1928. The emotional content as well as the rendering of the body is far removed from the melancholy, emaciated figures of his youth. The woman has a rounded fullness, which reminds one of Maillol's sculptures. The surface is seemingly smooth, but there are tiny patches all over it so as to distribute light evenly. The form is extremely simple, with no stress on anatomy such as bone structure or protruding muscles; yet looking more closely, the inner build of the body can be discerned in some fine, almost hidden anatomical details. The main features are the harmonious form and the continuous flow of outline of the group as seen in profile against the sky. In spite of the simplification of forms there is a tremendous vitality, resulting from the exterior movement and the interior feeling, mirrored by the radiant expression on the mother's face.

TONE WIKBORG

Tone Wikborg

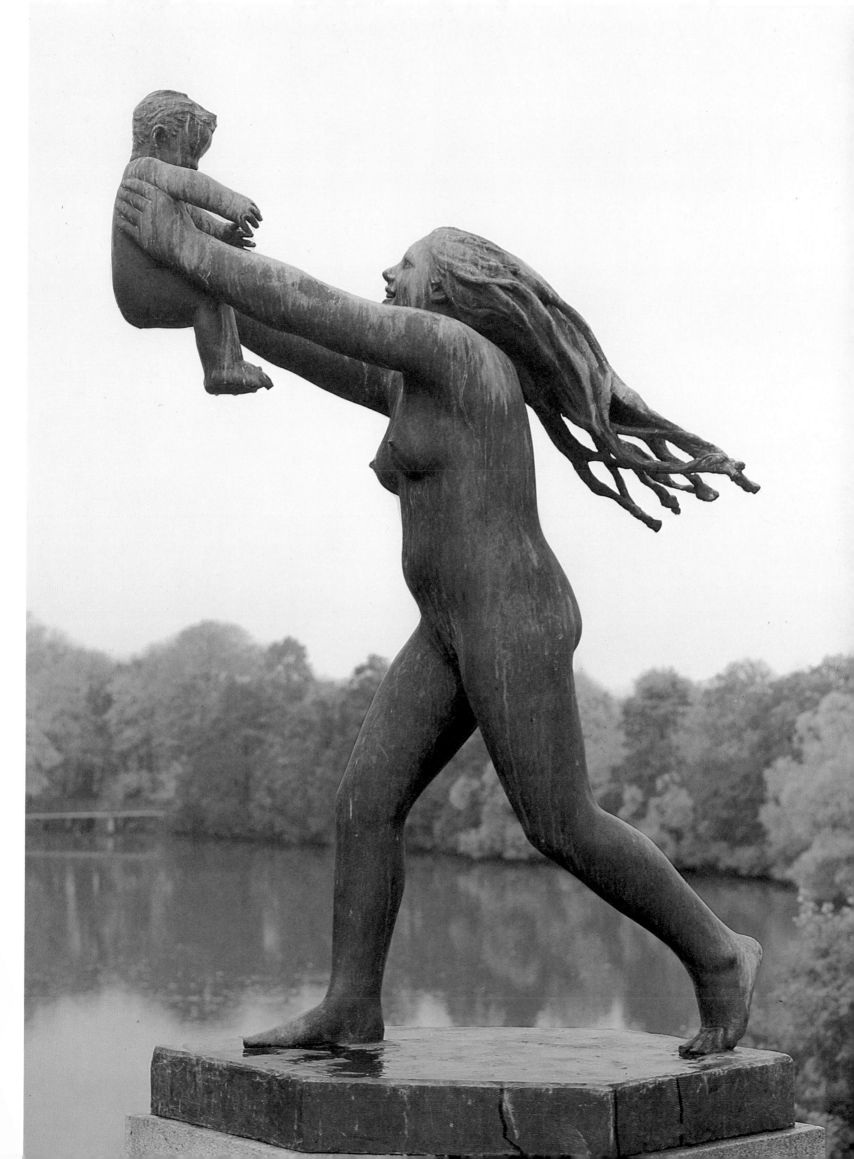

Romare Bearden (b. 1914)

DOMESTIC CLASSIC

1969, collage, 56x44" (142x112cm)

Cordier & Ekstrom Gallery, New York

Ah, Momma,

Did the house ever know the night-time of your spirit: the flash and flame of you who, once, when we crouched in what you called "the little room," where your dresses hung in their pallid colorings—an uninteresting row of uniforms—and where there were dusty, sweet-smelling boxes of costume jewelry that, nevertheless, shone like rubies, gold, and diamonds, once, in that place where the secondhand mirror blurred the person, dull, that place without windows, with doors instead of walls, so that your small-space most resembled a large and rather hazardous closet, once, in there, you told me, whispering, that, once, you had wanted to be an artist: someone, you explained, who could just boldly go and sit near the top of a hill, and watch the setting of the sun

Ah, Momma! You said this had been your wish when you were quite as young as I was then: a twelve or thirteen-year-old girl who heard your confidence with almost terrified amazement: what had happened to you, and your wish?

Ah, Momma: "The little room"—of your costumery, perfumes, and photographs of someone you did not marry—adjoined the kitchen, where no mystery survived, except for the mystery of you: woman who covered her thick, and long, black hair with a starched, white nurse's cap when she went "on duty" away from our home, woman who rolled up her wild and heavy hair before she went to bed, woman who tied a headrag around the waving, well-washed braids, or curls, of her hair, while she moved, without particular grace, between the table and the stove, between the sink and the table, around and around in the spacious kitchen where you never dreamed about what you might do instead, and where you taught me to set down silverware, and even fresh-cut flowers from the garden, without appetite, without expectation

It was not there, in that open, square cookery where you spent most of the days, it was not there, where nothing ever tasted sweet or sharp enough to sate the yearnings I began to suspect inside your eyes, and also inside the eyes of my father, it was not there that I began to hunger for the sun as my own, legitimate preoccupation; it was not there, in the kitchen, that I began, really, to love you

Ah, Momma, It was where I found you, hidden away, in your "little room", where your life, the rhythms of your sacrifice, the ritual of your bowed head, and your laughter, always partly concealed, where all of you, womanly reverberated big as the whole house, it was there that I came, humbly, into an angry, an absolute determination that I would, one day, prove myself to be, in fact, your daughter

Ah, Momma, I am still trying.

JUNE JORDAN

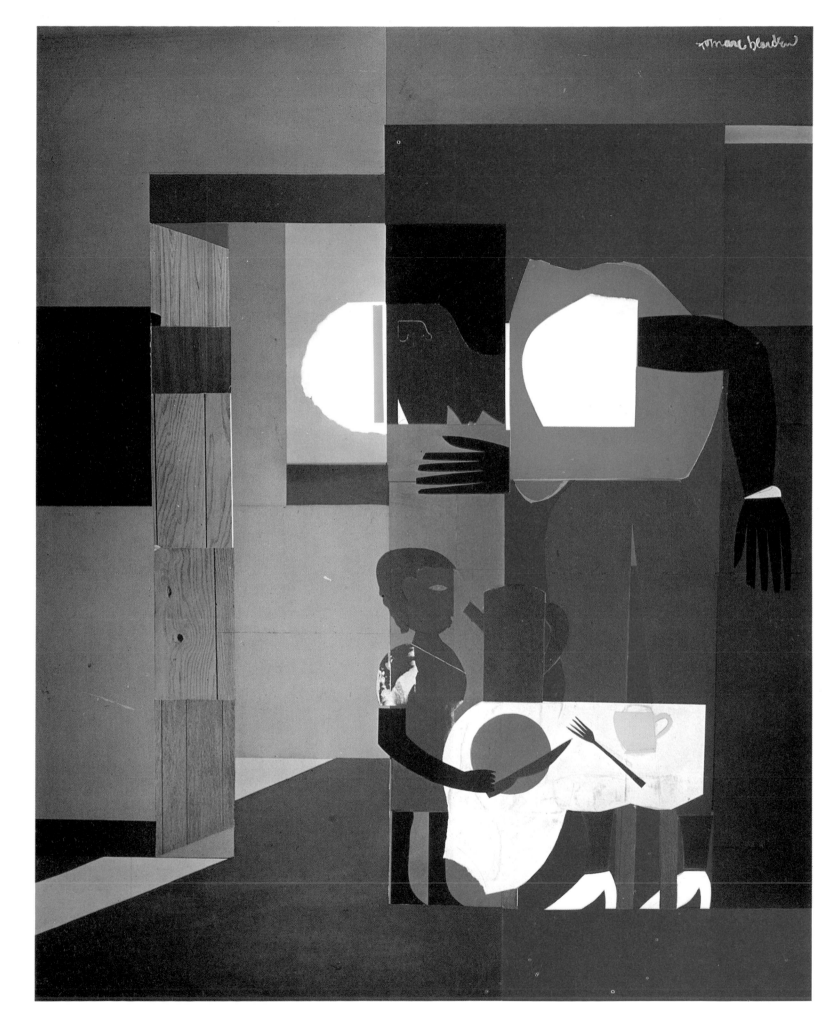

Edgar Degas (1834–1917)

THE BELLELLI FAMILY: Detail

1860–1862, oil on canvas, detail height 78¾" (200cm)

Louvre, Paris

WHILE visiting in Florence in 1858, Degas decided to paint the family of his aunt, Laura Bellelli, in whose house he was staying. On trips to Italy during the previous two years he had made sketches and studies of each member of the family, including Baron Bellelli, the father, who does not appear in this detail. (The baron was, in fact, relegated to the shadows.)

The figure of the baroness is made imposing and dominant. She holds under firm control the two little daughters, even if one is shown sitting not very properly on her folded leg. The solidity of the little family group is emphasized by the strong black pyramid of the three figures, broken by the starched white pinafores and collars of the girls. The mother and one daughter look into the distance, showing, probably, their best features, while the other girl looks straight at the viewer (and the painter). This seems to suggest a more trusting, intimate relation between the mother and the younger daughter (note that the baroness's hand does not touch her) and a more independent mind in the older one, who is being held quite firmly by her mother. About these mother-child relationships we can only speculate, and assume that Degas expressed well the situation that he knew and understood with the special perception of the artist.

Degas was only twenty-five when he painted this picture and had not yet come into contact with the impressionists. He was called back to Paris by his father before the painting was completed and did not finish it until two or three years later. Then the canvas was rolled up and never left the studio, where it was found after Degas's death more than a half century later.

It seems a pity that the invention of photography put an end to this kind of family portrait, from which we can learn so much about the atmosphere in which our ancestors lived. This particular painting has some personal interest for me, since my great-grandfather knew Degas well during the time he was painting in Italy.

PRINCE FERNANDO PIGNATELLI
DI TERRANOVA

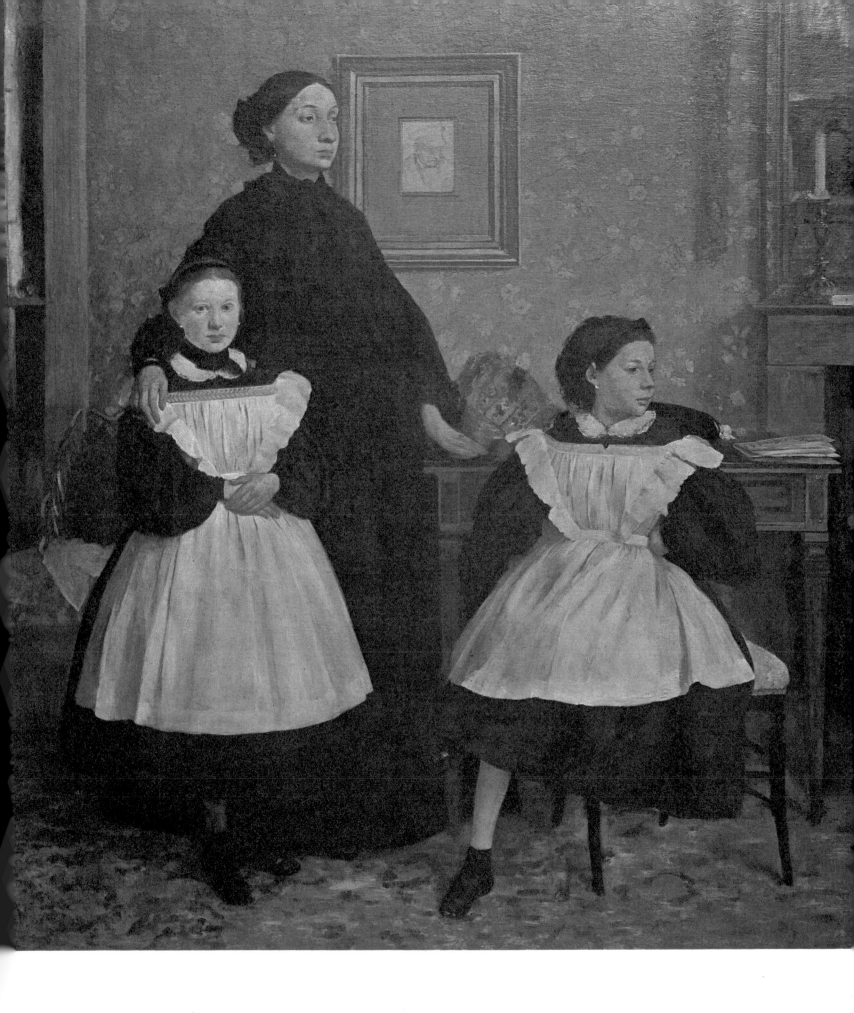

Luca della Robbia (1400 – 1482)

MADONNA OF THE APPLE

glazed terracotta, 25½x19½" (65x49.5cm)

Bargello National Museum, Florence

Luca della Robbia worked in Florence in the shadow of the great Donatello. Only when Donatello left that lovely city did della Robbia finally come into his own as one of the foremost and most prolific sculptors of the renaissance. Unlike many of his contemporaries, della Robbia never created a free-standing statue. He preferred to work within the more rigidly defined forms of the relief, the three-dimensional painting. Early in his career, he abandoned the use of marble and concentrated on perfecting terra-cotta. This medium he would apply with a glossy white glaze, which approximates the effect of the more-sought-after marble. His unique and very original style has reached across the ages and is still copied today.

In Luca della Robbia's *Madonna of the apple,* his technique and his form combine to make a cohesive and beautiful statement. He is a painterly sculptor. His forms are rounded, sensual, almost giving the viewer the illusion that warm flesh tones are detectable in the white glaze. The Mother's fingers, caressing and imprinting the body of her Child, reinforce the tactile awareness that della Robbia's work induces. The flat, azure background, characteristic of his pieces, lends further credence to the illusion that we are viewing a painting rather than a sculpture. Luca della Robbia's perception of the human form is inherently a sexual one. His Mother and Child are manifestly of the flesh rather than the spirit, though the innocence of their faces bespeaks the fact that theirs is a joyous, life-giving sexuality, rather than a tarnished, tawdry thing. In this work, della Robbia allows his audience to participate in the timeless communication of mother and child, of flesh speaking to flesh.

FREDERICK DOUGLAS GEISLER

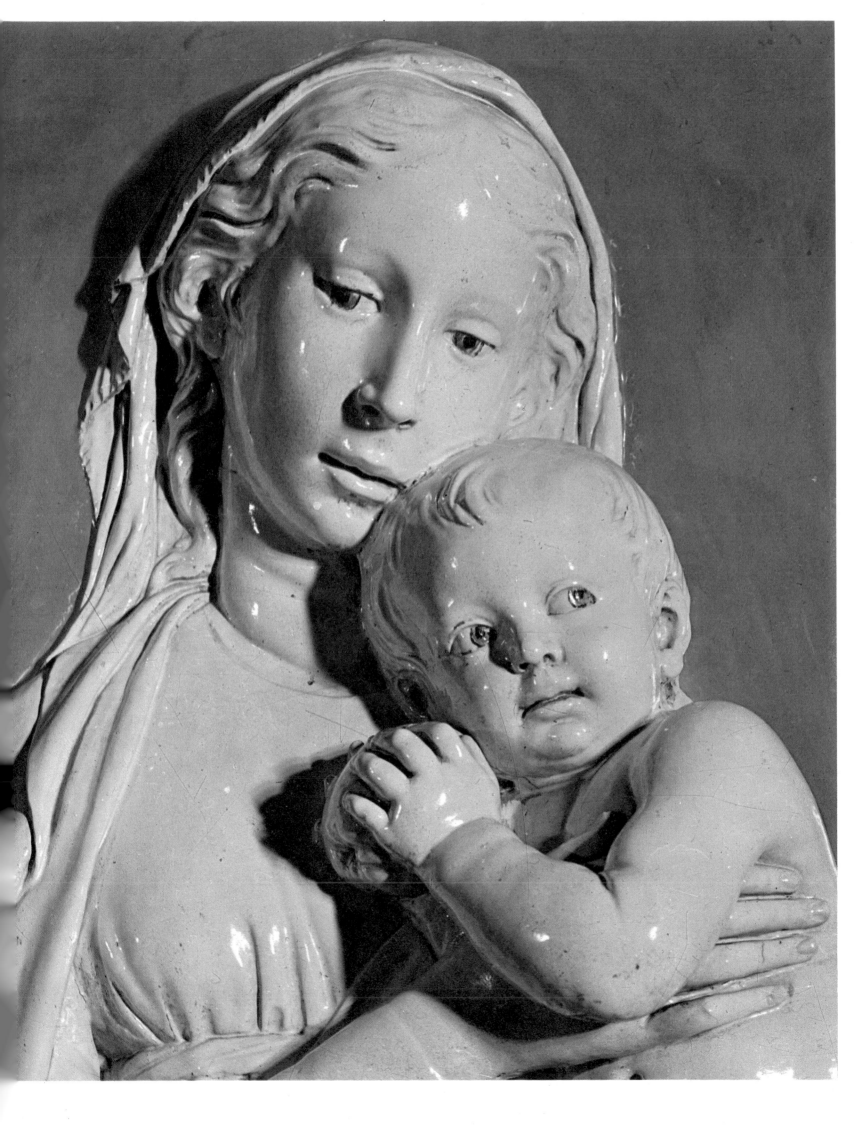

Francisco Goya (1746–1828)

THE FAMILY OF CHARLES IV: Detail

1800, oil on canvas, detail height 75" (190.5cm)

Prado, Madrid

THE FAMILY OF CHARLES IV by Goya is one of the three or four most famous and admired paintings in what is known as "the Goya museum" in the Prado. The whole of the royal family is arranged in the canvas in the same easy way that they would have grouped themselves in a photographer's studio. Goya had painted each of the eleven persons separately before placing them together in the painting, and in the Prado there still remain five of these magnificent sketches, all direct and lively. It is said that when the King saw the final painting, he instantly gave it its popular title, "We are all here".

Shown in this detail are the three central figures, the Queen Maria Luisa and her two youngest children, Maria Isabel and Francisco de Paula (the latter was the great-grandfather of Alfonso XIII, the Spanish monarch until 1931). The artist made them the focal point of the painting, placing them in the center—in the area where the light is more intense and brings out the silvers, golds, and crimsons of the clothes and the porcelain firmness of the flesh. This chromatic harmony brings into greater relief the deep and tender union between the mother and the two children, perhaps even more effectively than the mother's gestures, her arm around the princess's shoulder and holding the hand of her youngest son.

Goya had succeeded in making of this Queen, whom nature had endowed with little grace, a wonderful work of art by using a certain air of arrogance, which the model possessed, and enhancing the chromatic values with which he adorned the figure. Apart from this, the children reflect upon their mother a quality of beauty and candor that she herself did not possess.

DUCHESS OF ALBA

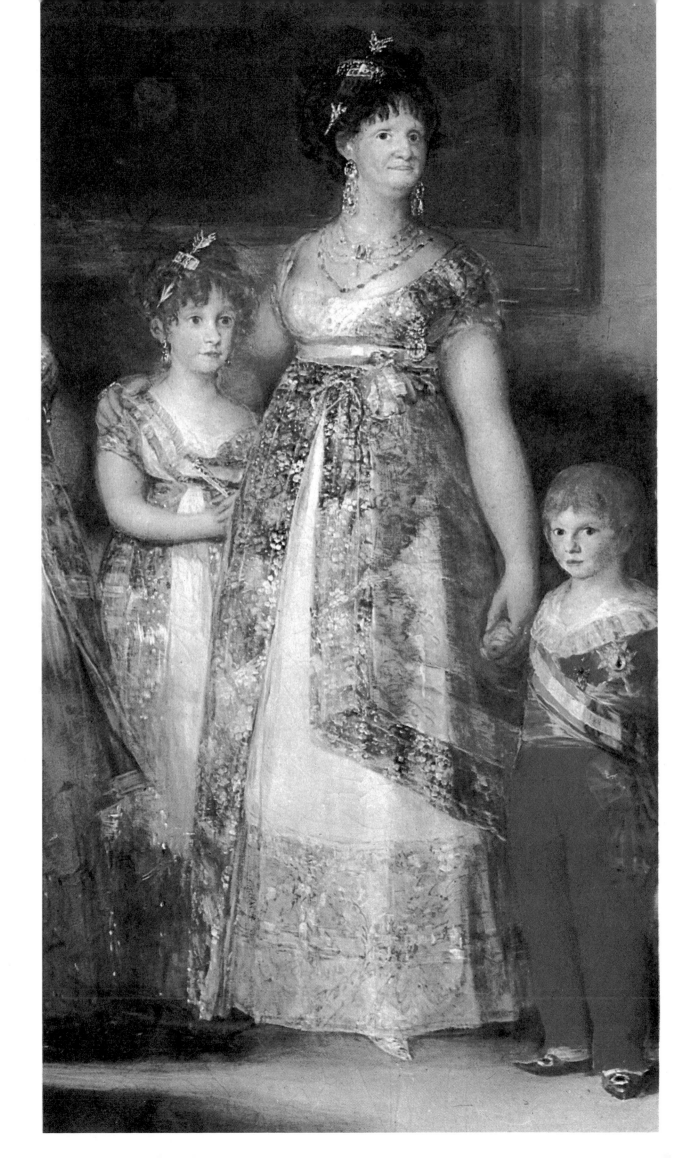

Mary Cassatt (1845–1926)

SLEEPY BABY

1890, pastel, 25½x20½" (65x52cm)

Dallas Museum of Fine Arts, Dallas, Texas, Munger Fund Purchase

A SIMPLE picture: a portrait of a woman, neither very young nor strikingly beautiful, holding her sleepy baby cradled against her shoulder. You have seen many pictures of mother and child—the mother gazing at the child with pride, with adoration, with detachment, with wonder—but where else have you seen such plain and homely love? This mother is a woman whole, fulfilled, without conceit or anxiety, happy in her motherhood, but—even more—content in her own womanhood. How rare that is in the world. One knows that the child feels it, is warmed and nourished by it, and will grow up to accept love, and to give it.

Yet Mary Cassatt never bore a child herself, and never married. Whether she was ever in love is not known—though one does think of Degas, her great friend. He might have been her lover; she burned his letters before she died, and her letters to him were never found. And there were outbursts of anger and bitter arguments between them. But if it was indeed a love affair, it was most certainly a Victorian one, in all ways circumspect: mind and spirit engaged, the heart stirred, but the body sternly suppressed.

That she, who had painted such a radiant portrait of her sister, Lydia, was aware of all that she was missing—had, in fact, already missed—in her own life, in that womanhood which she celebrated so beautifully in her paintings, is revealed in a plaintive remark in one of her letters to her friend Mrs. Havemeyer: "I think sometimes a girl's first duty is to be handsome . . .".

Mary Cassatt, with no child of her own, painted—in pastels, in oils, and with her heart—the children of others, and in particular those little girls in whose faces was the knowledge that they too would someday be "grown up", and be—perhaps—who knows?—happy in their womanhood.

ROBERT NATHAN

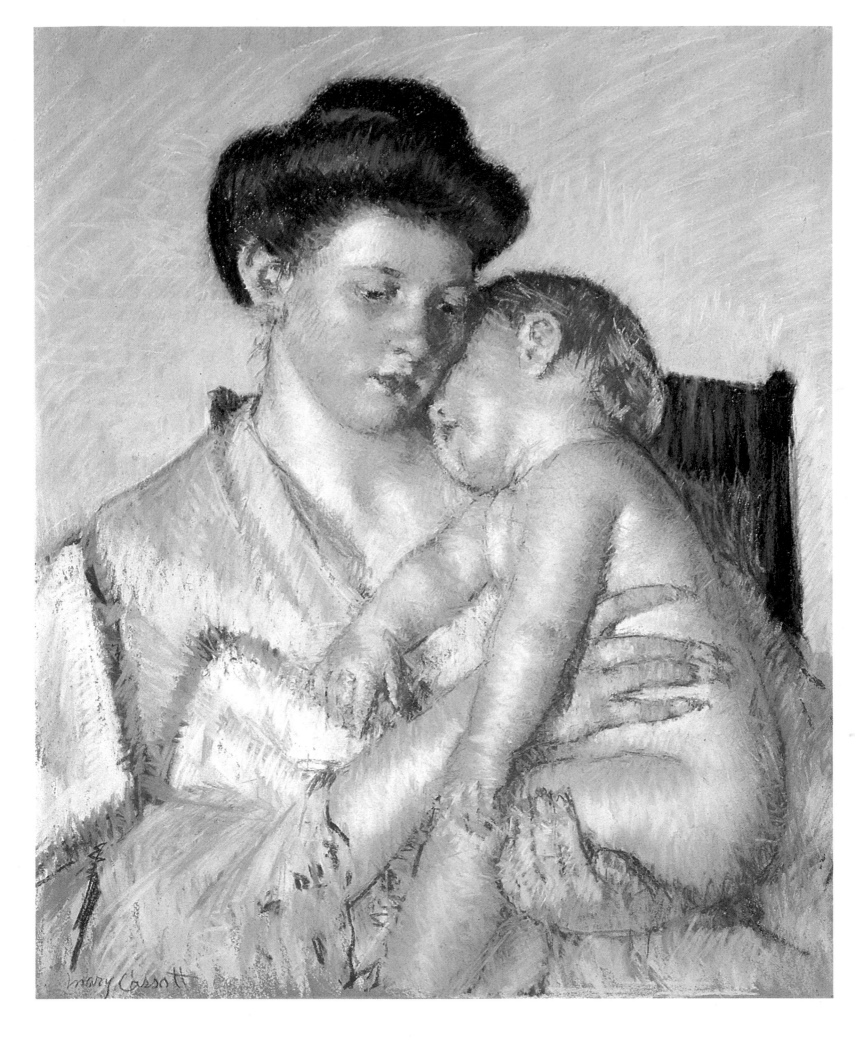

Stefan Lochner (c. 1400 – 1451)

THE MADONNA IN THE MYSTIC GARDEN

c. 1442, oil on wood, middle panel of triptych, 30x27" (76x68.5cm)

Wallraf-Richartz Museum, Cologne

AN ARTIST is often dominated by his subject. One can easily assume that Stefan Lochner believed this. His Madonnas still inspire us with their depth of mystical feeling, exquisite color, and fluid lines.

This painting is the middle section of a triptych. The richness of the navy blue robe of the Madonna is repeated in the eight heavenly angels above. Two hold her crown and protect the Child she holds, standing on her lap. The towers in the far corners of the walled-in garden give the painting balance and symmetry. The garden itself is abundant with naturalistic detail. Delicate lilies of the valley and carefully executed foliage decorate the ground. The flowers in the crown the Madonna wears and the jewels in her pin are expertly painted, and the rays in the golden background all combine to create an atmosphere of lyricism.

Little is known about the life of this artist. When Albrecht Dürer came to Cologne some seventy years after Lochner's death, the town councilors could tell him nothing more than that the artist had come from Meersburg on Lake Constance. His style is easily recognized. All of his Madonnas are fair, gentle, dreamy figures portrayed as very young girls and the Babies they hold are sweet, round-faced cherubs. *The Madonna in the mystic garden* is also in the Wallraf-Richartz Museum in Cologne, and the similarity of the model is apparent. Lochner painted what the people of his time wanted to see, and mysticism played an important part in the religion of that day.

COUNT MAXIMILIAN DE HENCKEL

Anatole de Vasselot (1840 – 1904)

MADONNA AND CHILD

1883, marble, height 68⅞" (175cm)

Palace Chapel, Monaco

THIS Madonna and Child has a very special meaning for me. I saw it on the day I arrived in Monaco, shortly before my marriage in April 1956.

Upon entering the palace, which is located in the old unfortified city, my parents and I were first taken to the chapel, where we knelt in prayer. There, towering above us, was this strong yet lovely work of art. The Blessed Virgin had such a soft and sweet expression and gentle regard toward the round Infant Jesus on her arm that I felt warmed and welcomed to my new life.

The Madonna's expression, which I have come to know so well through the years, and her special look change with the varying light of the day and season. With the flow of candlelight at midnight mass the more serious lines disappear, to suggest a secret smile.

This statue, in white Carrara marble, stands 1.75 meters high, nearly six feet. It was commissioned in 1883 under the reign of Prince Charles III of Monaco to the French sculptor Count Anatole Marquet de Vasselot.

The chapel, decorated in green, red, white, and black marble, is a parish in itself, placed under the jurisdiction of the Bishop of Monaco. It is consecrated to St. John the Baptist. Our three children, Caroline, Albert, and Stephanie, have all received their first communion here.

HER SERENE HIGHNESS
PRINCESS GRACE OF MONACO

Ammi Phillips (1788 – 1865)

MRS. MAYER AND DAUGHTER

1835, oil on canvas, 37⅞x34¼" (96x87cm)

The Metropolitan Museum of Art, New York, gift of Edgar William and Bernice
Chrysler Garbisch, 1962

ALL I could think when I saw Ammi Phillips' portrait of a Victorian American mother and child was that it was a pity the painting wasn't a tiny three- by three-inch canvas so I could hang it in the art gallery of my Fairy Castle Doll House in the Museum of Science and Industry in Chicago.

This desire may seem odd, as the painting has no light, fairy overtones, no whimsy, little of the intangible, luminous quality one finds in the imaginative, airy paintings by a Fragonard or a Chagall. This mother-and-child painting is rather somber, filled with the disciplined mores of Victorian society. Except for the cherry-red dress of the little girl, the colors are subdued, but again, wasn't that expressing Victoria's age? However, look at the child's bright face and you see a doll, a happy little doll who belongs in my Fairy Castle.

The mother in the painting could be any mother — her face reflecting her pride in her child. She has that secret mother-look which is the meeting place through the centuries of our knowledge that the one unchanging thing in this world is a mother's love for her baby. Ammi Phillips has captured that look.

COLLEEN MOORE

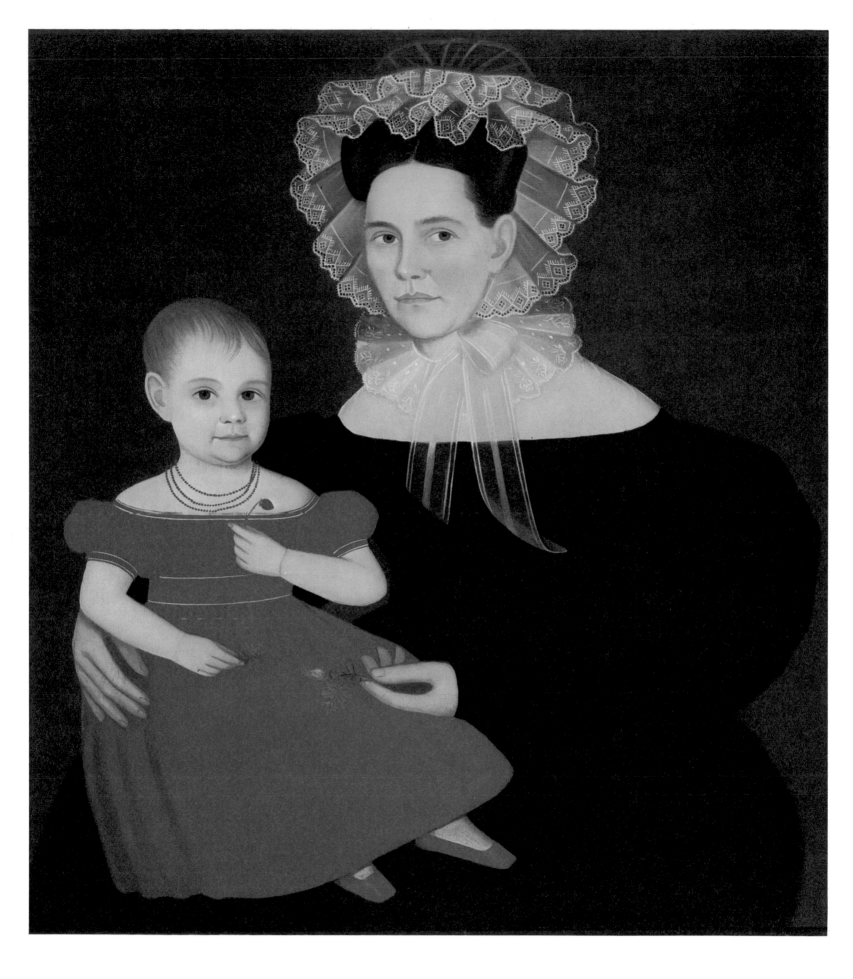

Honoré Daumier (1808–1879)

IN THE THIRD CLASS CARRIAGE: Detail

1862, oil on canvas, detail height 26¾" (68cm)

The National Gallery, Ottawa

DAUMIER was known as a political artist of social protest, a biting satirist. Yet when he turned to the subject of a mother and her child, no warmth, no tenderness was withheld. In the finest of Daumier's paintings, such as *In the third class carriage*, it is the earth-mother with the child portrayed. It does not seem too extreme a statement to say that part of Daumier's greatness as a painter could easily rest on his handling of the two central figures seen in this detail. A curious note, however, is that in a rare study and in a few of the paintings Daumier executed of this "third class carriage", the mother and child are not present.

To place this painting in historical perspective is to place the train in historical perspective, that is, in the heart of the industrial revolution, which was occurring throughout Daumier's lifetime. Loathing travel, Daumier made only two trips during his life, both by train. These two trips are recorded in numerous drawings, lithographs, and several paintings. Through Daumier's eyes we see haughty first class passengers and humble third class riders. Here, in the third class, we find Honoré Daumier's heart.

Coleridge wrote: "To most men experience is like the stern lights of a ship which illuminate only the track it has passed." This is not true when a genius such as Daumier is involved. Living during one of the most violent periods of French history and daring to satirize the mighty, it is not strange that Daumier found himself once imprisoned, then put into a madhouse, twice offered the Legion of Honor and twice refusing it. His "experience" and "lights" passed all the political upheavals of his period, including the death of the "eleven thousand" and the "shooting of the innocents". Perhaps in the darkest days artistic vision finds repose and hope in a hymn to mother and child. Certainly Daumier's basic experience was ever touched by their presence.

Daumier, with his deep artistic compassion and perception, recognized the eternal secret of every mother and child: that priceless moment when the two become so close, so intimate, they transcend the very worldliness of the world and are set apart from all except one another in the life process. Honoré Daumier's earth-mother and her babe in this detail from *In the third class carriage* could suffice as the eternal prayer of motherhood.

MICHAEL LEOPOLD

michael Leopold

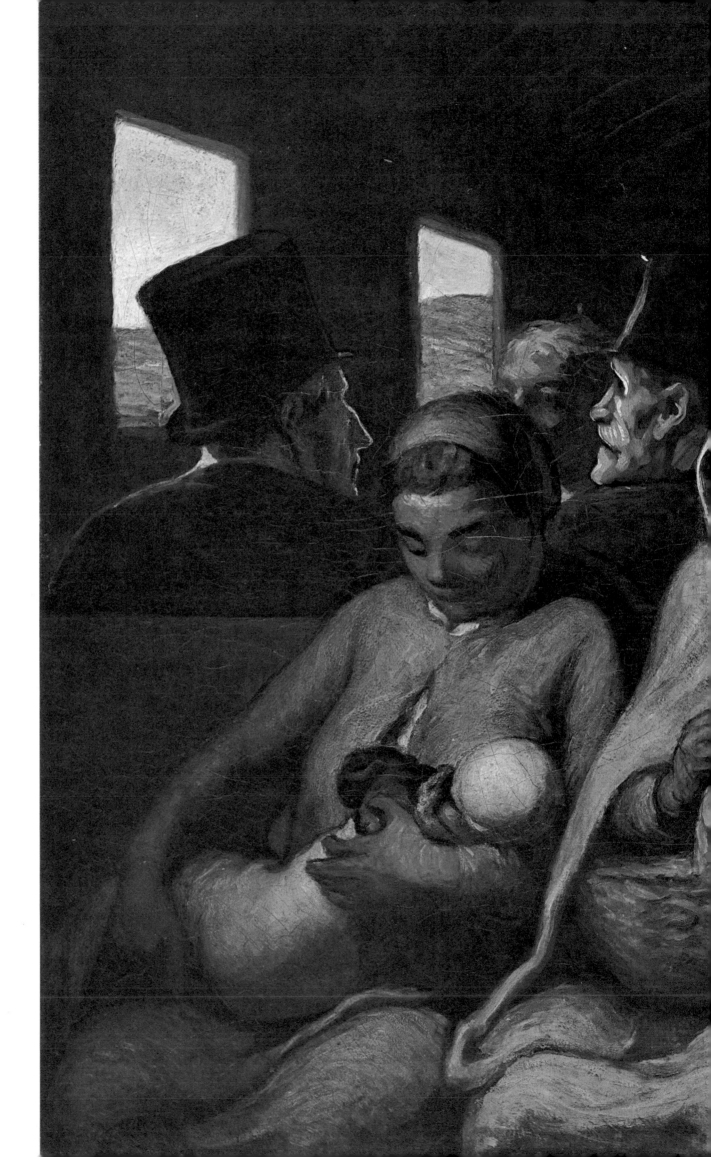

Mohammed Hassan

MOTHER AND CHILD WITH CAT

19th cent., oil on canvas, 46⁷/₈x29¹/₂" (119x75cm)

Palace Collection, Teheran, Iran

THE dignity of the mother, derived from woman's role in the family institution and social function, has had a progressive development in Iranian history.

The history of Iran embraces the matriarchal period, which, from the viewpoint of cultural anthropology, counts among the earliest human social systems and forms the generative basis of the family in the fifth millennium B.C., thus giving woman a degree of loftiness and symbolizing her as the goddess of creation and fertility. Among the Aryans and in the religious books and rituals of ancient Iran, women were sometimes regarded as deities and sometimes invoked as angels.

Mandan, mother of Cyrus the Great, the founder of the Persian Empire, had a momentous role in the social life of Iran. Darius the Great, disregarding protocol, chose his successor according to the advice of his wife, Atossa, a celebrated mother, whose statue he had cast in gold.

The achievement of Islam in this realm was to sanctify the status of the mother, and this outlook was offered to humanity in an era when Arab societies ignored women with absolute profanity.

Unfortunately, these precepts of Islam faded away in the flow of history, although the upbringing of children by the mother retained its significance. For many years, the nurturing of the child has been considered the exclusive duty of the mother, and special laws and courts have been established in order to secure this social right, perhaps a rare example in human history.

The mother and child painting reproduced here was most probably created by a painter called Mohammed Hassan during the nineteenth century, and is in the palace collection.

From the office of Her Imperial Majesty
EMPRESS FARAH DIBA PAHLAVI
of Iran

دفترمخصوص علیاحضرت شهبانوی ایران

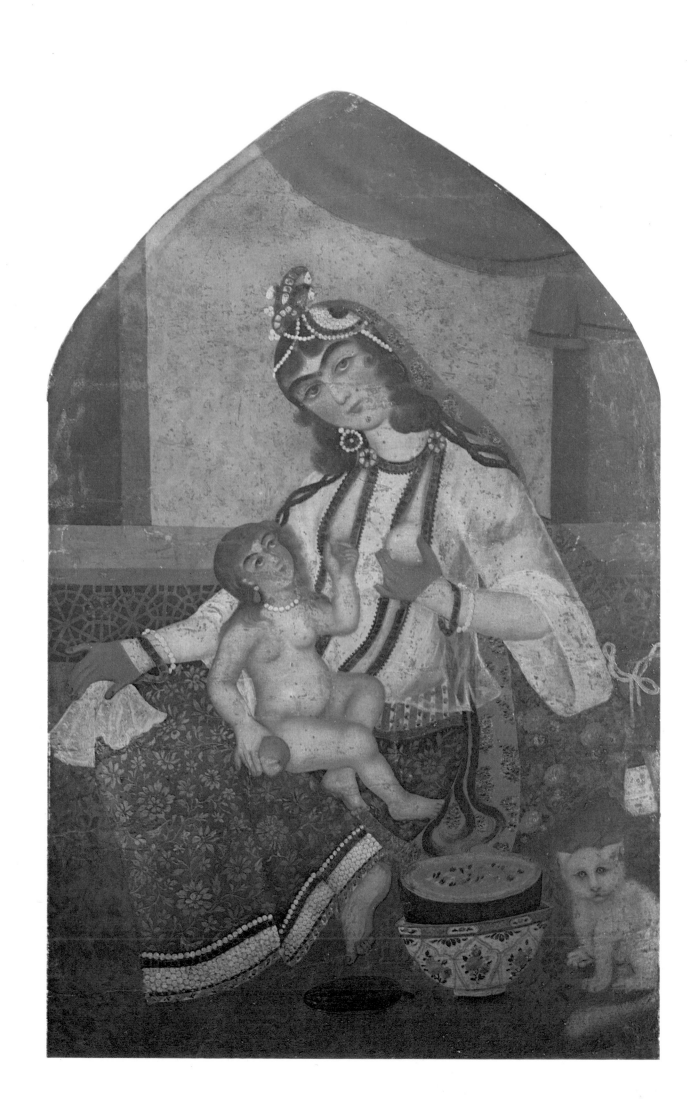

Leonardo da Vinci (1452 – 1519)

MADONNA AND CHILD WITH ST. ANNE AND ST. JOHN

c. 1499, chalk on paper, 55¾x41" (142x104cm)

The National Gallery, London

THIS great picture is on permanent display in the National Gallery in London. Aside from the fact that it was brought there from the British Art Association's more humble quarters at Burlington House, its provenance is unknown. It is the only picture in the National Gallery honored by being on display in a single room all its own. It is placed across a corner of the room, brightly lighted. The rest of the room is darkened. Visitors enter and leave at the opposite corner, sit a while in the shadows absorbing the picture's message, and then slip quietly away.

The center of attraction is the lovely face of the young woman intent upon the actions of the child. The pleasant face of the elder woman is in the shadow, shaded from the light by the shoulder of the younger woman who, together with the child, is seated on her lap. Her interest is in the younger woman upon whose face her gaze rests with thoughtfulness and affection. There is no awkwardness in the posture of these two in both being seated upon her lap. The group is completely natural in this position. The little boy is engaged in playing with his companion, a slightly older boy whom he seems to be enjoying effortlessly. In fact, almost in play, his right hand is lifted in blessing his companion, who except for this interest is almost outside the group. The bright expression of all is one of happiness and joy, which entrances the beholder. Fascinated, the observer sits in rapture before this scene of wholly natural felicity.

It may be only later that the observer learns that he has been viewing one of the trial drawings of the great Leonardo da Vinci. It is a slightly tinted, detailed charcoal drawing on brown paper, a little larger than life-size, and is a preliminary sketch for a painting. The lovely lady in the full bloom of young womanhood is Mary, Mother of Christ. She is seated on the lap of her mother as is also the Christ Child, who is playing with his older cousin John, St. John the Baptist, patron saint of Leonardo's Florence.

DR. ELMER BELT

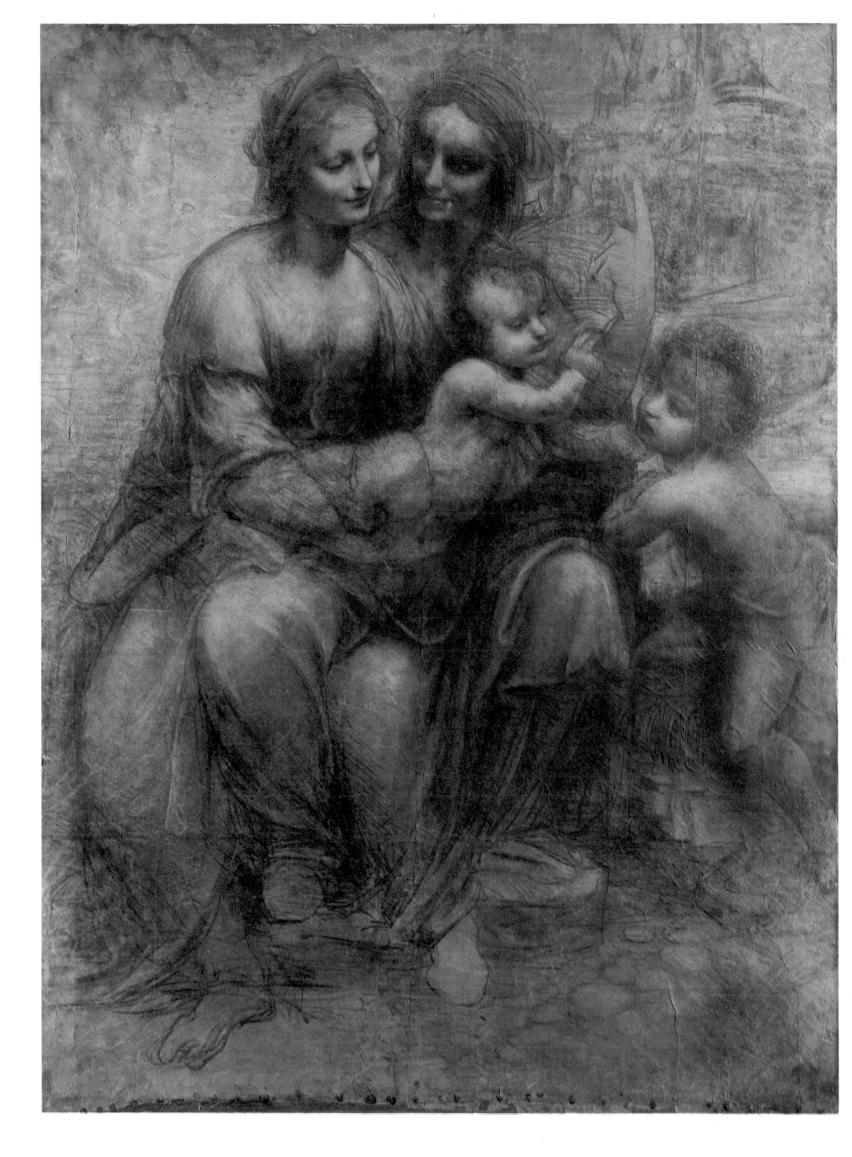

George Catlin (1796–1872)

STRUTTING PIGEON, WIFE OF WHITE CLOUD

1844, oil on canvas, 29x24" (74x61cm)

National Collection of Fine Arts, Smithsonian Institution, Washington, D.C.

IN nineteenth-century United States the native peoples called Indians were not appreciated as they should have been. There were many voices raised in protest of the manner in which these people were treated, but few were listened to. However, the Indian paintings of George Catlin, a unique figure in the annals of American art, were at least looked at. In the first half of the nineteenth century Catlin did more than any other individual to call attention to the many different Indian tribes and their patterns of life.

Catlin traveled where no white artist had ever been before. He was fascinated by Indians and their ways. He had a real concern for the survival of their cultures and ceremonies. His Indian gallery, always painted from life, became famous and was the source of many publications.

One of the most popular persons Catlin knew and painted was Ru-ton-ye-wee-ma, the Strutting Pigeon, wife of White Cloud, Iowa chief. White Cloud, his wife and daughter, and eleven other Iowa Indians joined Catlin in London in 1844. He writes of this woman: "Of the four women of the party, Ru-ton-ye-wee-ma . . . is the best looking, and has her child, a girl, playing around her. . .". Her dress is of deer and elk skins, most curiously and elaborately garnished, and ornamented with porcupine quillwork and beads from her own country.

Catlin's mother and child is an excellent example of his dedication to Indians and art. Ru-ton-ye-wee-ma is sensitively portrayed with complete respect for Indian adornment and face painting. Throughout his life, Catlin campaigned for an understanding of the Indian. He wanted to show that American Indians had the same feelings of love and compassion as all other humans. This painting reveals mother love and child adoration as well as Catlin's remarkable ability to humanize a people who were perhaps more misunderstood than any other of the world's inhabitants.

DR. KARL SCHAEFER DENTZEL

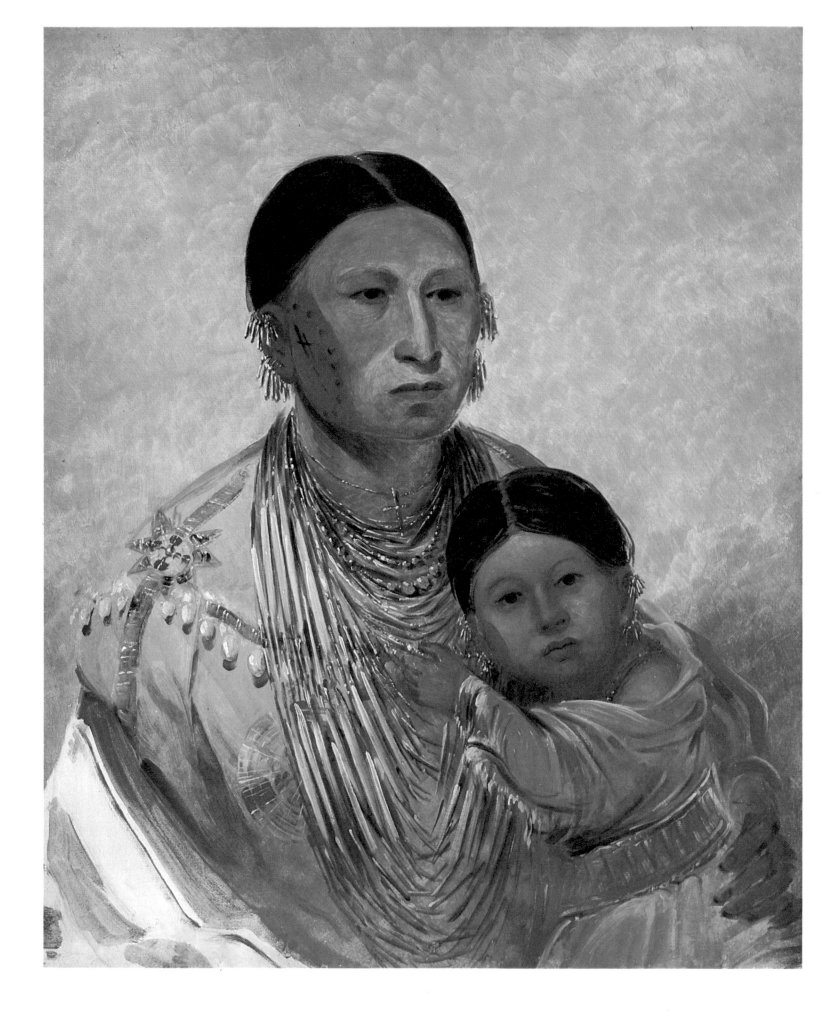

Anon.

MOTHER AND CHILD

15th cent. (Swiss), wood, height 36¼" (92cm)

Swiss National Museum, Zurich

92

EMOTION surfaced. In a way all Madonnas are that, but most endearingly in folk art. This joyous lindenwood Mother and Child, carved by an unknown Swiss artist in the late fifteenth century, is bursting with the robust reverence of country-bred talent and faith. Perhaps he used his wife's warm curves and wheat-yellow hair for his model, and their own sturdy babe for the Christ Child. Bright paint flowed and flickered onto every conceivable household object in Swiss homes then as it does now. Long, white winters made even ordinary eyes hungry for hot reds and rich blues and the golds of a summer sun. Our artist ladled color over his beloved Lady to make her glow in any icy, wind-buffeted church like a hearth fire. Her plump sweetness and curly mouth are doll-like and just as expectant of love.

God blessed you, artist, whoever you were, with gifted hands and heart. And blessed us, too, with a forthright and charming legacy.

ANNE BAXTER

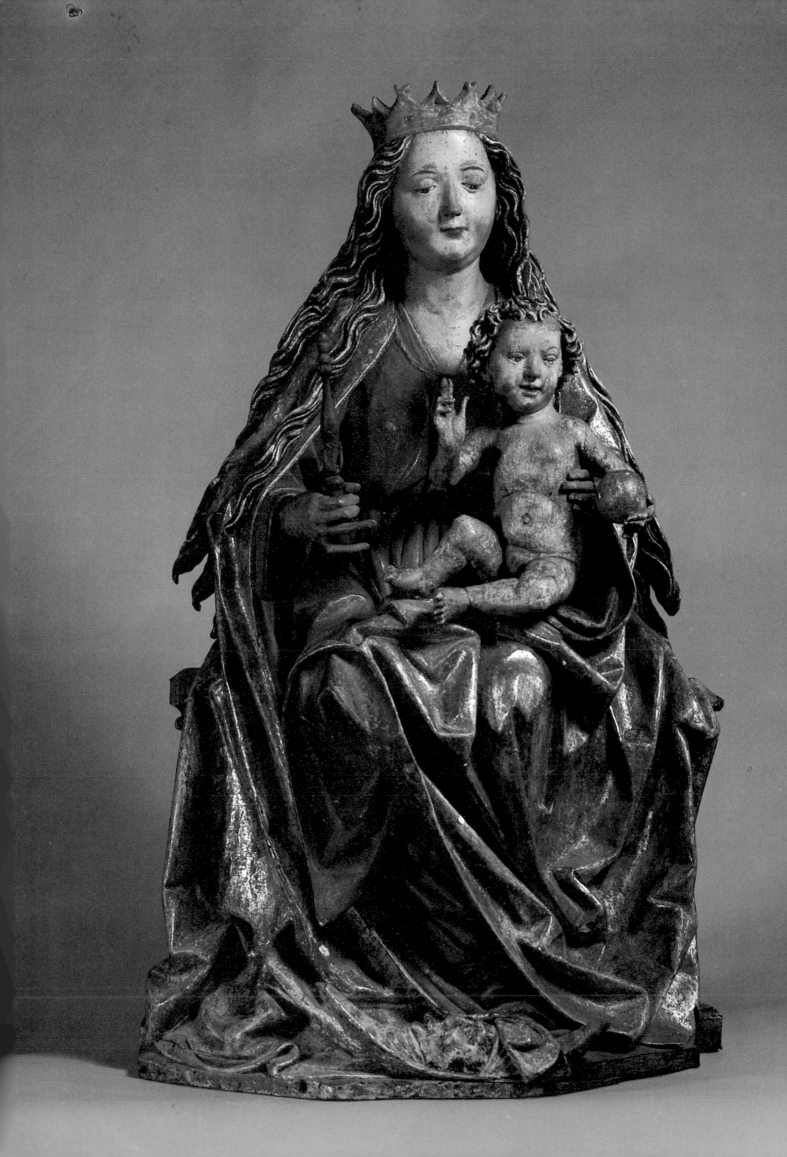

Auguste Renoir (1841–1919)

ON THE TERRACE

1881, oil on canvas, 24¼x19⅞" (61.5x50cm)

Art Institute of Chicago, Memorial Collection Mr. and Mrs. Lewis L. Coburn

MUCH of what Renoir seems to love best is in this picture. For me it is like a familiar piece of music. I often enjoy exploring it in memory, like humming a favorite song to oneself.

What is happening *On the terrace?* The mother has brought her little girl out for a pleasant afternoon by the river. The park or garden is near their house, I think, because she has evidently brought along her own striped canvas chair. And the basket on her lap is filled with balls of yarn the little one has helped to wind . . . Such fun! Judging by the mixed colors, there will be a cozy afghan crocheted at a later time. They often stop for a while in this familiar arbor with its trailing vines and dappled sunlight. The lacy trees around it allow a view of the placid River Seine beyond, with two or three rowboats in sight and a red-roofed villa or two on the opposite bank. The sky is clear but not too bright. For me, there must always be sky in an exterior scene or I feel cheated and shut in.

It is an unremarkable, everyday moment, one of those small halcyon intervals of repose and contentment that we do not often appreciate while we are living them but recall with tender nostalgia years later.

I confess—and this is probably the main reason for my preference— I love this picture because it reminds me poignantly of my own mother and my childhood. The fashions are of another era, but the young woman's face bears a strong resemblance to the one I loved. My father had died when I was an infant, so the companionship between the two he left was close and precious and lasted until she, too, slipped quietly away. Yet those we love never leave us . . . the past, the present, are indivisible in our hearts. I am grateful to Renoir for all his lovely work and especially for capturing forever in this picture a fleeting moment that is for me, and probably for millions of others, a very personal, cherished treasure.

GREER GARSON

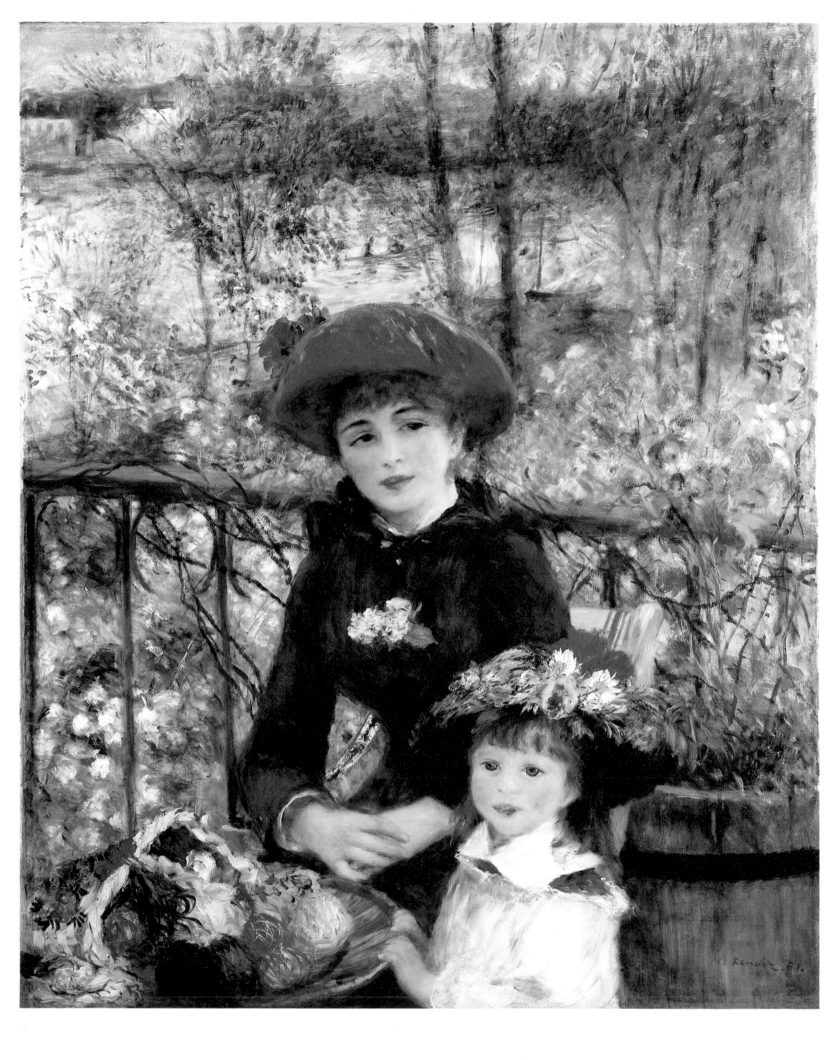

Domenico Veneziano (d. 1461)

SACRA CONVERSAZIONE: Detail

c. 1445, tempera and oil on panel, detail height 19⅜" (49cm)

Uffizi, Florence

ALTHOUGH Domenico was one of the fathers of the Florentine renaissance, only a few paintings extant can be attributed to him. His *oeuvre* has recently been subjected to a cross fire of theories on the formation of his style and on the chronology of his work. Today most critics see him participating as an equal—after Masaccio and Fra Angelico—with Fra Filippo Lippi, Paolo Uccello, and Andrea del Castagno in pursuit of the great aims of renaissance painting that were triumphantly fulfilled by about the mid-fifteenth century. Actually, by 1440 his work was more advanced than most of his contemporaries'.

Domenico's sense of line, which he introduced into the form-conscious Florentine school, and his draftsmanship are clearly evident. His lyric style and sense of color do not intrude upon the calmly contemplative beauty, but only add vibrant chromatic accents.

Domenico di Bartolomeo da Venezia, known as Domenico Veneziano, was correct when he stated in a letter written in 1438 that he considered himself the equal of the best masters of the quattrocento. For regardless of iconography, his was a revolutionary contribution when there were giants among artists. The beauty and tenderness of this Mother and Child certainly justify the claims of greatness made by Domenico himself and others for him.

PHIL BERG

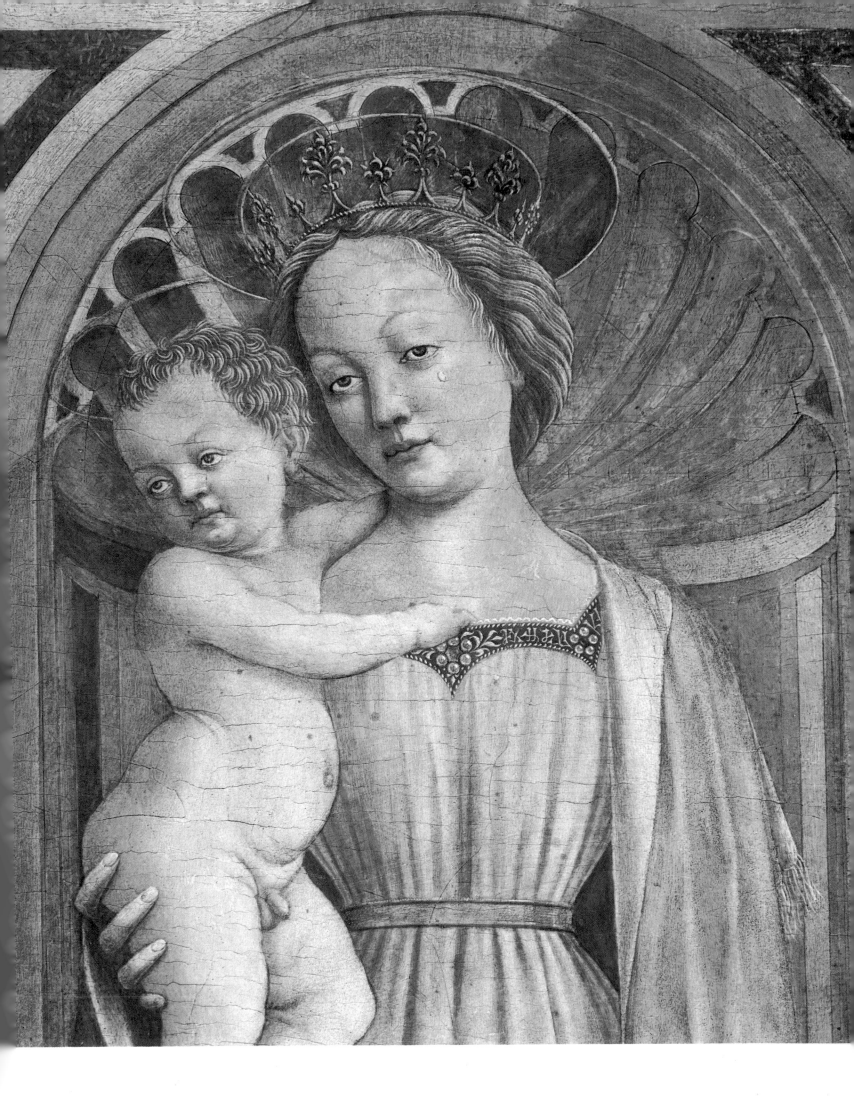

Théodore Chassériau (1819–1856)

THE FISHERMAN'S WIFE

1850, oil on panel, 16¾x11¼" (42.5x28.5cm)

Museum of Art, Rhode Island School of Design, Gift of Mrs. Gustav Radeke

THÉODORE CHASSÉRIAU. The short and brilliant career of the artist whom Ingres would characterize as the "Napoleon of painting" represents a struggle to reconcile the extremes personified by Ingres, who conceived of painting in terms of line, and Delacroix, who, rejecting the rigid idealization of the neoclassic tradition, favored the use of brilliant color. Chassériau, drawn to the precision and subtlety of the classicist and stimulated by the vision and intensity of the romantic, sought to assimilate, to reconcile, and finally to personalize these fundamentally contradictory attitudes.

By the middle of the nineteenth century, when *The fisherman's wife* was painted, Chassériau's progressive detachment from the strict doctrines of Neoclassicism is conscious, if not complete. Here sentiment and drama replace the restraint and decorum created by the neoclassic interior, and the free, well-formed figures of the mother and child are placed out-of-doors in an entirely naturalistic setting.

As if to dramatize the direct relationship between this peasant mother and her environment, the fisherman's wife appears to emerge from the rock upon which she is perched as a swirling pyramid of palpable fabric and flesh.

The artist's intent is to capture the delicate, intimate revery of a mother and child and to present not an isolated, static, otherworldly conception of womanhood and maternity, but rather a voluptuous, corporeal, altogether sensual depiction of motherly love. Thus the realms of the real and the ideal are literally fused in the figure of the fisherman's wife at the moment she clasps her loosely swaddled babe to her cheek. Chassériau, in a deliberate juxtaposition of two entirely different visual and conceptual modes, has succeeded in creating an image that is persuasive, generous, and radiant.

EDWARD J. LANDRIGAN III

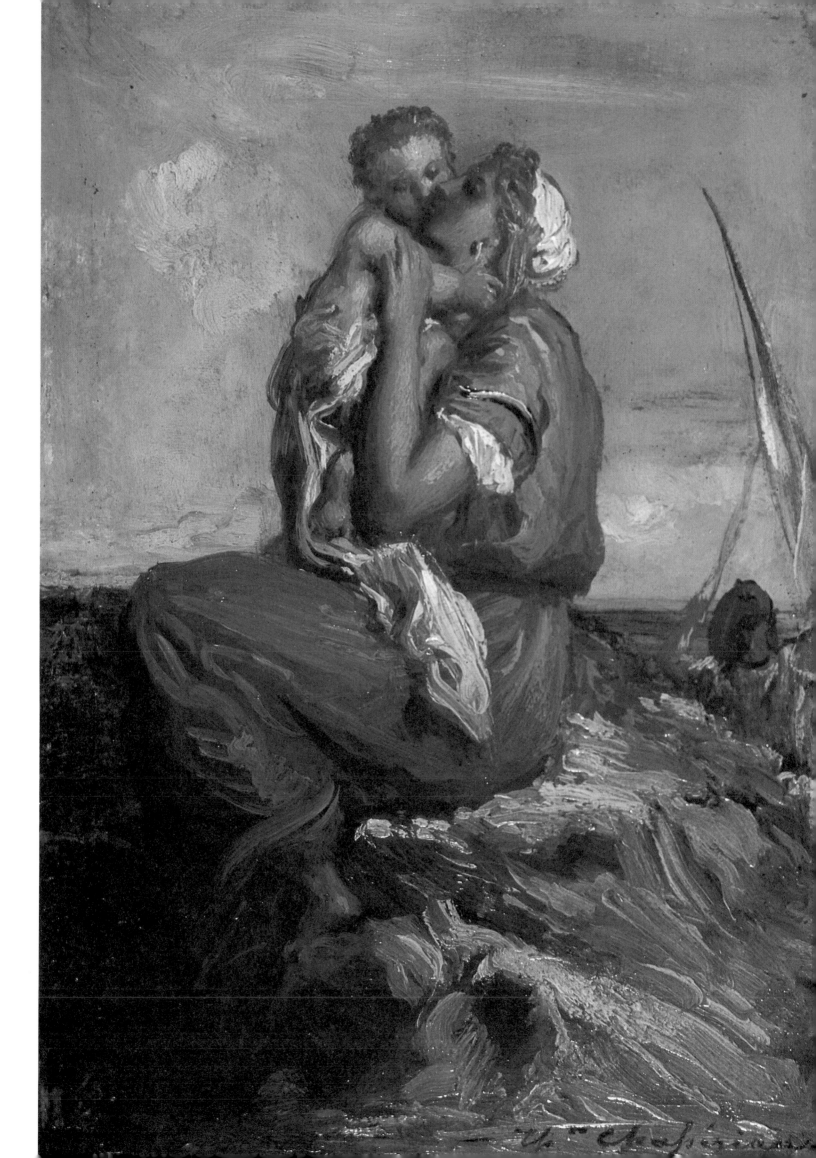

Stanislaw Wyspiański (1869 – 1907)

MOTHERHOOD

1902, pastel, 25½x18½" (65x47cm)

National Museum, Warsaw

A YOUNG peasant woman dressed in a robe is breast-feeding her baby. Her pale flesh tones, dark hair, and the robe in cerulean blue, with some azure and turquoise, and the baby drawn in soft gray-blue are so related in color that they don't detract from the strong flow of lines. It becomes the artist's emotional statement about the mother nursing her child.

The turn of the century was a very important time in Poland. It was then that the nobility turned to the peasants in an effort to gain their understanding, confidence, and love. The folk art had attracted great interest among the artists, writers, and intellectuals from the cities. Wyspiański in his *Motherhood* didn't quite follow the folk-art style, but in a very sensitive way combined the primitive elements with the current modern art style. His painting in some respects materialized his artistic aspirations, but it was also kept in a very Polish style. Much of its charm comes from its subtle perception of the inner spiritual life of the woman as a mother. The scene almost creates a feeling of a mystical ritual.

Stanislaw Wyspiański, a painter, playwright, poet, and intellectual, spent some time in 1890 in Paris and became a close friend of many important painters of this period. His work had a great influence on Polish modern art by bringing it in touch with international art movements. He was a skilled portrait painter, mostly in pastel; his favorite model was his wife, a girl from a peasant family. Wyspiański painted several pictures representing the motherhood theme, but this one is his finest.

EVA PAPE

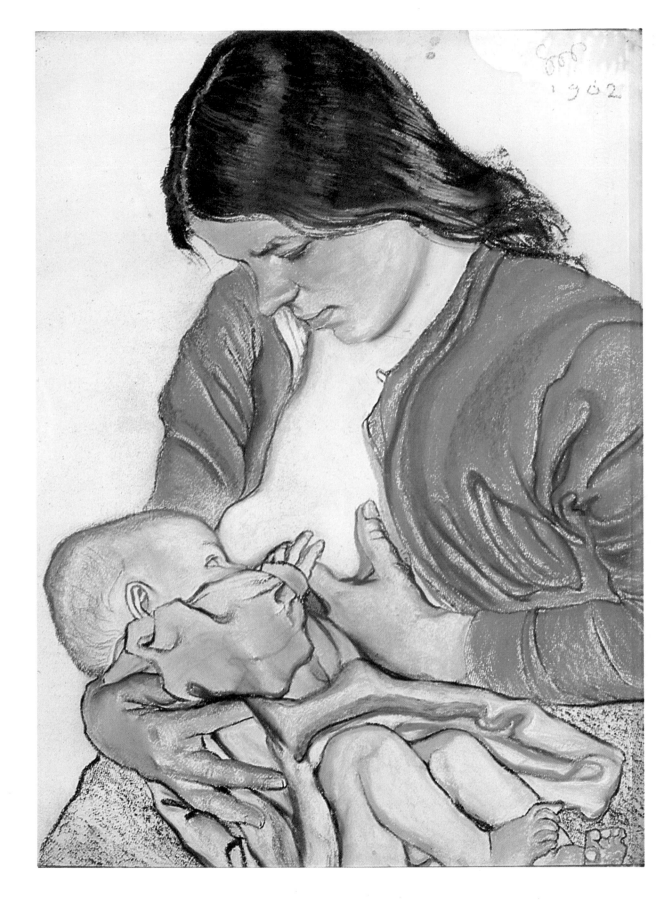

Utamaro (1753 – 1806)

YOUNG MOTHER GIVING MILK TO HER SON

wood cut, 13¾x9¼" (35x23.5 cm)

The British Museum, London

EVEN with the impingement of Western ideals and values on modern-day Japanese life, it is not uncommon to see a young mother breast-feeding her child on a crowded bus or subway train, or on the veranda of her home. Most Japanese will not stop to observe or even comment on such an encounter because it is a "natural scene" which falls within accepted mores and practices. A great number of artists have depicted the mother-and-child theme during the long history of Japanese painting, but no artist has treated this genre as beautifully as Kitagawa Utamaro.

The secure and joyful glee on the countenance of the child as he suckles his mother's breast and the fulfilled look on the mother's face crystallize into a universal message. It is a message unnecessary to translate into words or to restrict within a time-space boundary, for it is quickly comprehended by all peoples in all societies.

Utamaro's women did not represent specific individuals from particular social strata of the feudal Edo Period (1615–1868). He succeeded in synthesizing the beauty of the young prostitutes, housewives, courtesans, diving women, and others to form the truly ideal feminine loveliness. Utamaro created an aesthetic world in which these sensuous women engaged in the pursuits of everyday life. The trappings and environment were familiar to the people of Edo, but the delicate and graceful ladies in the wood-block prints were Utamaro's own women.

Little is known of Utamaro's personal life, but it is recorded in the annals of Japanese wood-block-print history that he lost either his mother or his wife in 1790. This singular event seems to have contributed to the artist's maturation. From the 1790's to his death in 1806 Utamaro's subjects and form took on an added substance. He was able to detach himself from the influence of his teacher, Sekien, and his contemporary, Kiyonaga, and finally succeeded in developing the special Utamaro world of sensuality and a little bit of pathos. There can be no doubt that Utamaro's works will endure time and change.

TOMOO OGITA

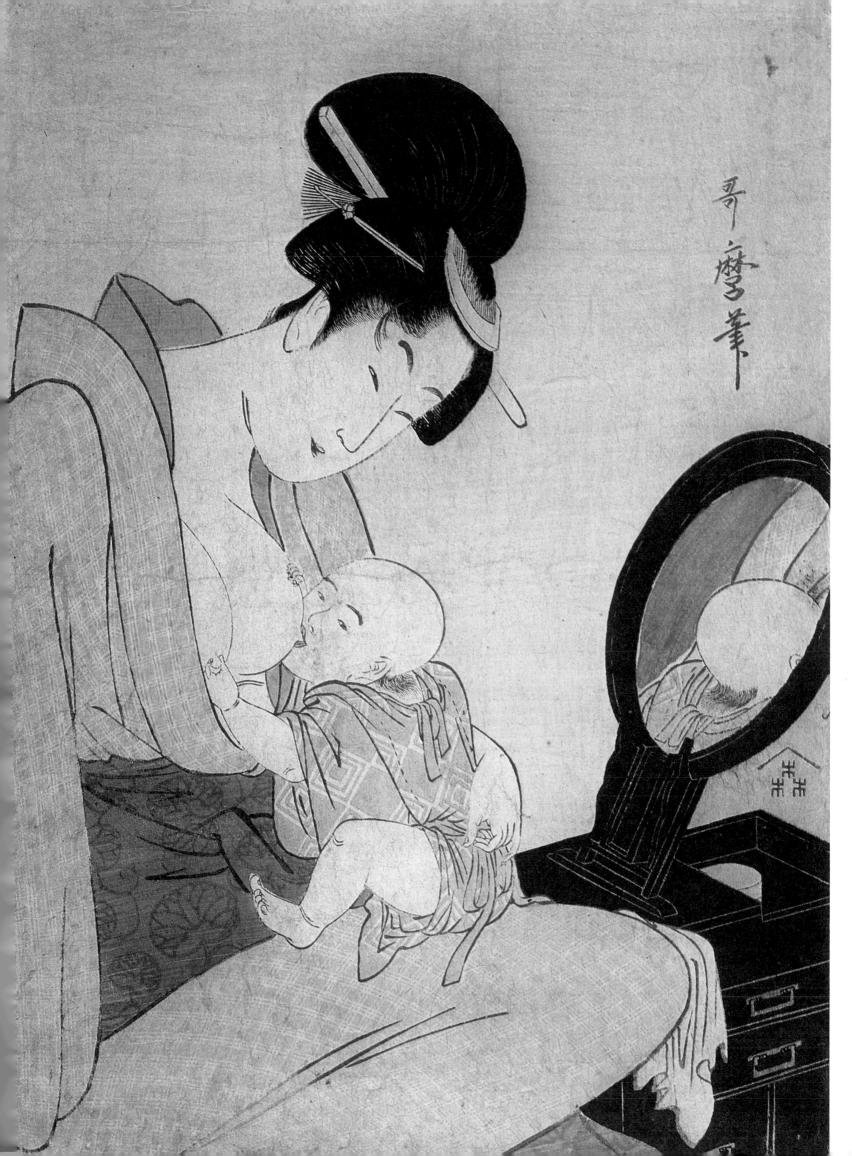

El Greco (1541–1614)

HOLY FAMILY (MADONNA OF THE GOOD MILK)

c. 1594–1598, oil on canvas, 44x41⅓" (112x105cm)

Hospital San Juan Bautista, Toledo, Spain

To the Spaniard, mysticism has long been an integral part of his life and his thought. This mysticism, as manifest in this handsome painting, is in reality as much a part of his nature and of his thoughts as is the sweeping, austere landscape of the plains about Toledo, El Greco's adopted home.

The *auto-da-fé* of Cardinal Cisneros' Spain and the ensuing "black legend" are frequent themes of discussion when the art of "the Greek" comes under scrutiny. The tortured, elongated figures of his subjects are so intense in their distortion that both art critics and historians of an earlier age believed the artist to be a victim of a type of visual disorder. Those sometimes demoniac faces, heightened by extraordinary withered attitudes, while not a part of the earthiness of the Iberian people, would seem to become a part of their agonies as well as their torment and self-condemnation. Such ugly, searing faces, with rapt, otherworldly expressions, would appear well attuned to Spain and the Spaniards as typified in the writings of Lope de Vega.

In this regard, one feels that this well-ordered painting is an important work of the Byzantine expatriate who was thought by his contemporaries to have become more Spanish than the Spaniards. In a sense, his treatment of the personages of this domestic grouping has managed to convey to the viewer the essence, indeed the soul, of Spain. The tenderness of the scene is obvious in the arresting rapport between the Madonna and the Christ Child; all of this is delineated without sentimentality. Yet at the same moment, the painter has conveyed the zeal of the theologians and the spirit of the counter-reformation. Above all, the flaming red, the acid yellow-orange, and the variety of blues—azure through cobalt—lock together visually a viable and thoroughly personal rendition in the history of the depiction of the theme of mother-and-child.

DR. F. M. HINKHOUSE

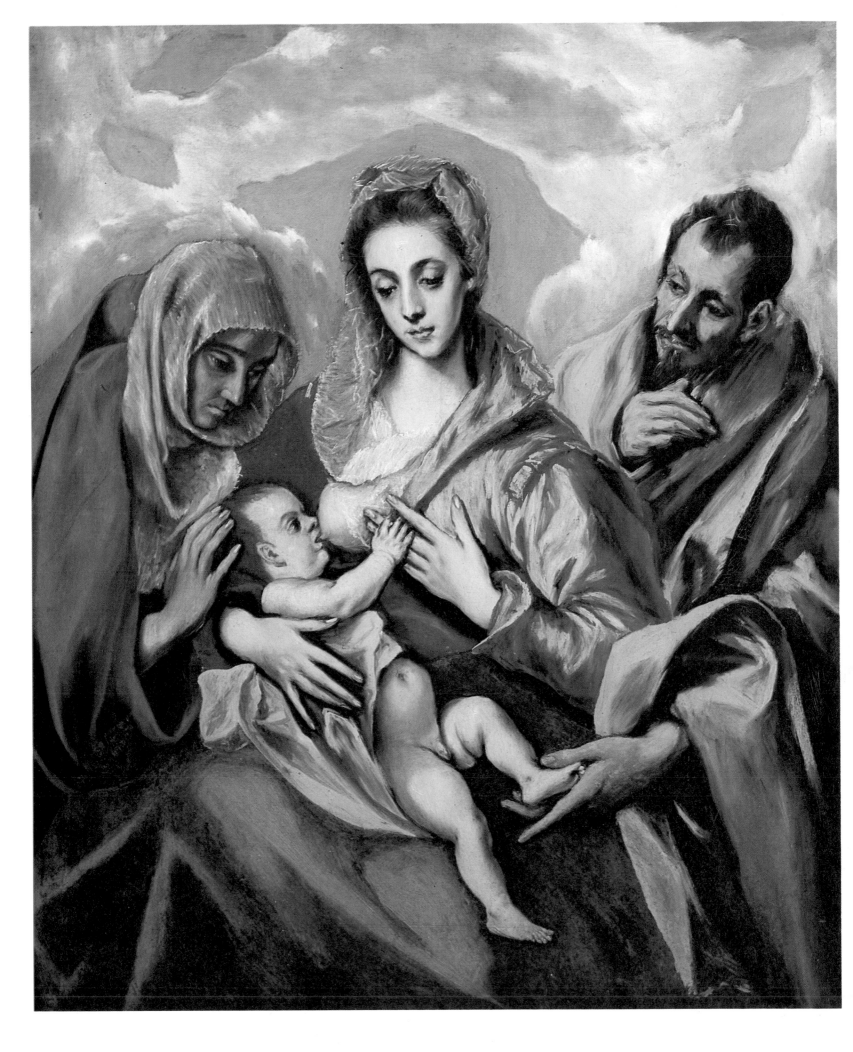

George Romney (1734–1802)

MRS. JOHNSTONE AND CHILD

1775–1780, oil on canvas, 35¼x28″ (89.5x71cm)

The Tate Gallery, London

Georgeorge romney was the son of a humble Lancashire cabinet-maker, whose trade he first adopted. Later he apprenticed himself to a second-rate painter but then, striving for better things, went to London in 1762 where he achieved success almost immediately, largely by winning a Royal Academy of Arts prize for his work *Death of General Wolfe at Quebec*. He soon became a popular and sought-after portrait painter, leaving an artistic legacy of no less than 2,000 paintings.

Romney's studio in London, whence the fashionable flocked to be immortalized, was close to the home of his great rival, Sir Joshua Reynolds, whose presidency of the Royal Academy of Arts led Romney to refuse to exhibit there. Since Romney never signed his pictures, over the years many of his works have been attributed to Reynolds, his lifelong enemy. Both men have, no doubt, been turning in their graves with indignation.

In retrospect, Reynolds is recognized the world over as undoubtedly a greater and more profound master. Nevertheless, there is hardly a historic house in England where you cannot find a splendid Romney, all extraordinarily pleasing, with rich colors and pleasing details to catch the eye.

The history of this mother and child, now hanging in the British Embassy in Washington, is not known, other than the name of the lady, but it typifies the charm of Romney's aristocratic still-life style. Here we see calm tenderness combined with hidden strength. The mother's expression demands from us compassion and protection. Perhaps she has been recently bereaved, or is she waiting patiently for a husband who is away in the colonies or fighting for king and country? The child's innocent eyes stare at us confident in his mother's love. The serene dignity of this picture was designed to complement the walls of the great stately houses of England, where still today, 200 years later, one can smell oak fires in the halls and hear the sound of happy children's voices in the long passages.

LORD MONTAGU

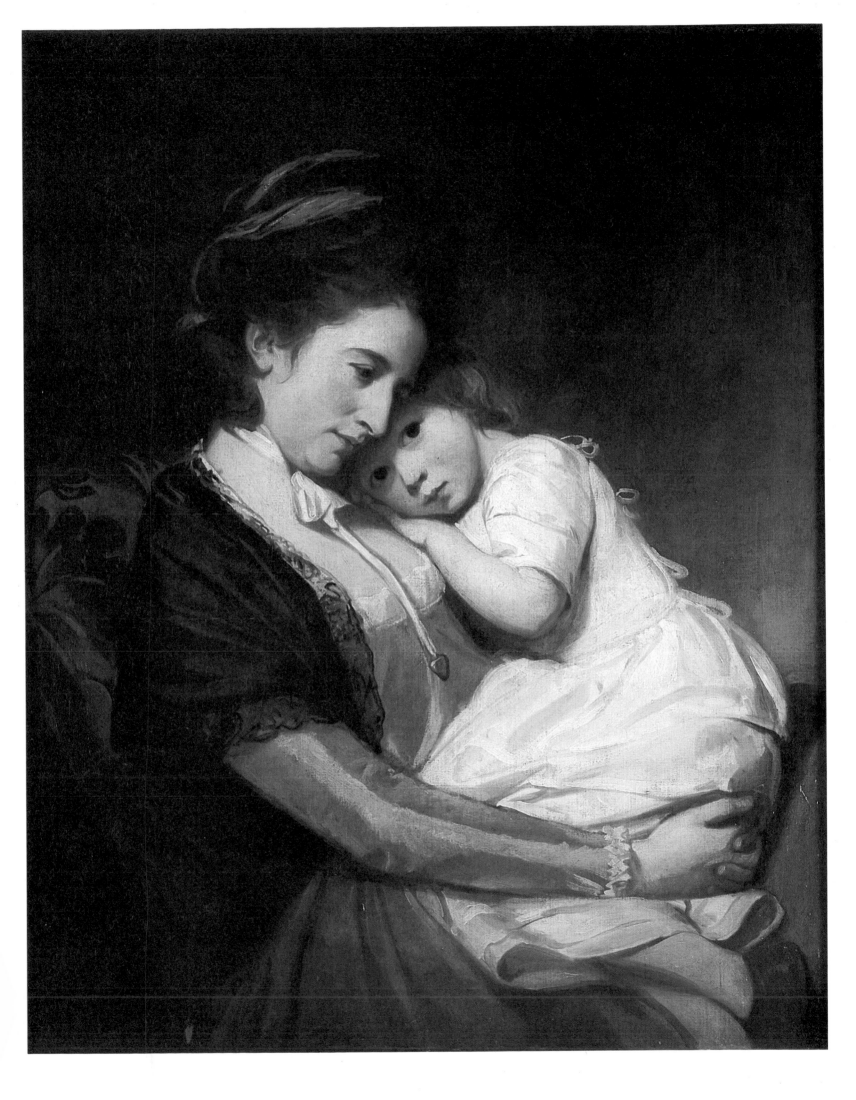

William Clarke (1760–1810)

NANCY STUART WILSON WITH TWIN DAUGHTERS

1792, oil on canvas, 31x27" (79x68.5cm)

Collection General and Mrs. Robert George Fergusson, Los Angeles

NANCY WILSON née Stuart, the wife of James Wilson, Scottish-born doctor of medicine and a Presbyterian minister as well, lived her not very long life on the Eastern Shore of Maryland in Wye. As the mother of six children and wife of a doctor-minister, her life in the last quarter of the eighteenth century was one of rigorous simplicity—joyous, nonetheless, because of her dedication to her family. It is obvious to the viewer that the twin babies of this Tidewater mother, like those of the Roman matron Cornelia, are her jewels. Her gently enfolding gesture conveys, through body language, more than could be described in words.

It is impressive how the gift of insight allowed the so-called "naïve" painter William Clarke to transcend limited training and enabled him to portray a shining spirit of gentle pride, love, and determined protectiveness—the very essence of maternal love. The painter has caught the ineffable aspects of the relationship between mother and child: the sense of security, which is reflected in the faces of the children, the strength and devotion and purposefulness of the mother. We can only suppose that it was the delightfulness of the subjects that inspired the artist to surpass the rigid, mannered, and stylized interpretation so frequently found in naïve paintings.

Despite the soft blues of the dresses, the white lacy bonnets, and the pink rosebuds held by the babies, the overall impression here is one of great charm relieved of over-sweetness by the beguiling expressions of the three sitters. It is a painting not easily forgotten.

CHARLOTTE FERGUSSON

Charlotte L. Fergusson

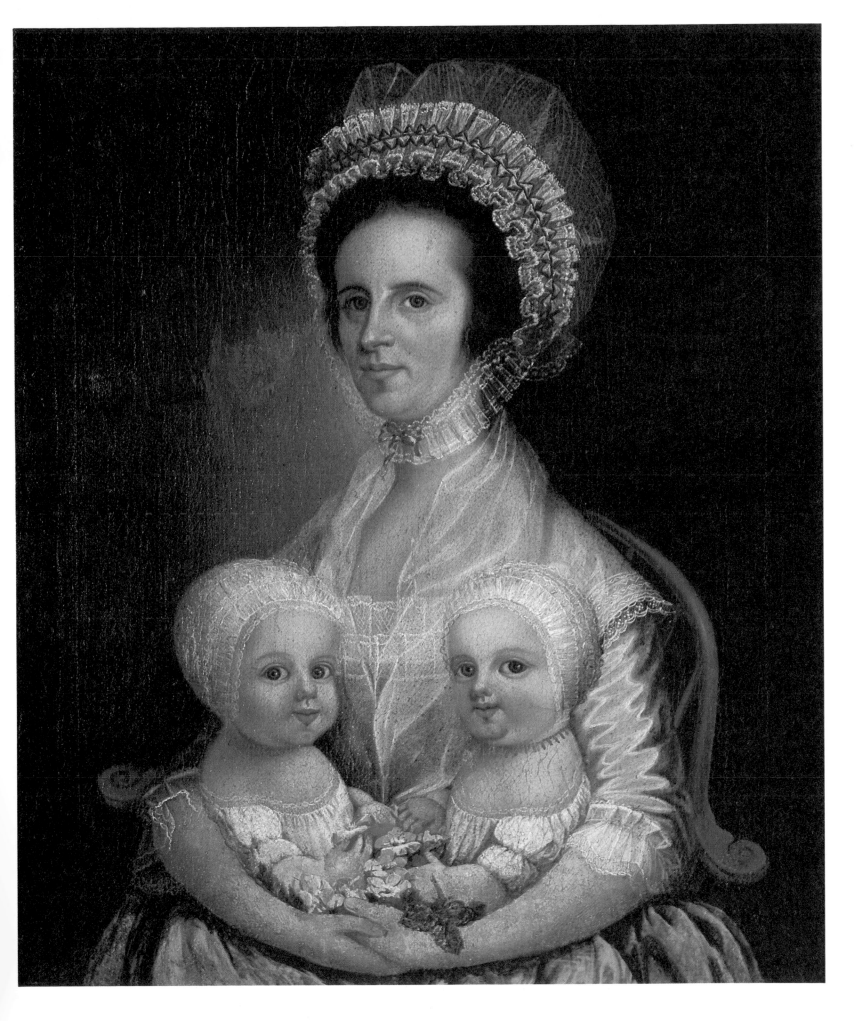

Anon.

BALARAM PLAYING WITH YASHODA

18th cent. (Indian), watercolor on paper, 6½x4½" (16.5x11cm)

Benares Hindu University, Benaras, India

110

INDIAN miniature painting reflected a delicate taste in the Pahari (Hill) schools during the late eighteenth century. The dying traditions of the late Mughal school at the imperial *atelier* in Delhi were revitalized by local painters in Guler, Kangra, Jamu, Jasrota, and other towns of the Punjab Hills (at present most of these are in the state of Himachal Pradesh).

As in medieval Indian poetry or music, the setting of the paintings is usually a harem. With the advent of *ghakti* (devotional) cults, the same environments were used in the illustrations of scenes related to Krishna or any similar mythology. In the absence of any definite text to confirm this, one cannot pinpoint the scene to the Krishna theme; yet this could easily fit in with Krishna's elder brother, Balaram, tantalized by the jewelry of his mother, Yashoda.

The human feelings as depicted in the scene dominate the redundant paraphernalia of the harem, and we are attuned to the parental love expressed in the serene smile on the youthful mother's face. The artist has successfully caught the dramatic moment in the scene as is reflected in the childlike attitude of the boy.

ANAND KRISHNA

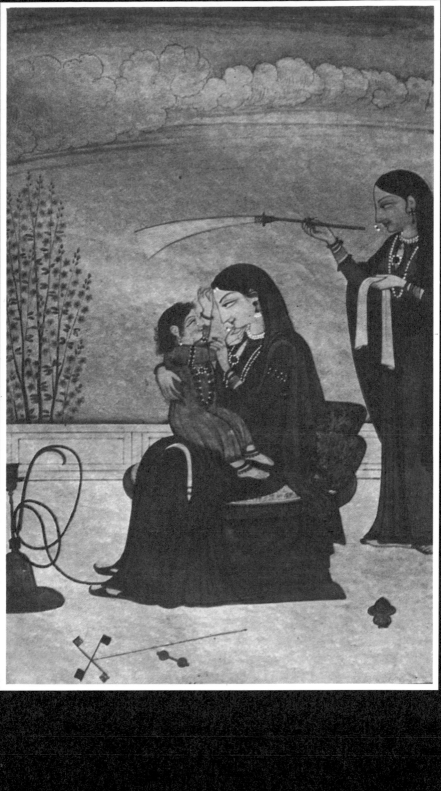

François Boucher (1703–1770)

MADONNA AND CHILD WITH ST. JOHN THE BAPTIST AND ANGELS

1765, oil on canvas, 16⅛x13⅝" (41x34.5cm)

The Metropolitan Museum of Art, New York, gift of Adelaide de Groot
in memory of the de Groot and Hawley families, 1966

112

ROSES, grapes, a picnic basket, cherubs suspended among the clouds, a baby goat, a small boy gazing at a young shepherdess and her child in a sylvan setting—all of these disposed within the oval of what seems at first glance to be no more than a banal eighteenth-century pastoral scene.

But the mother and child reach out powerfully to touch the heart with something familiar, deep, in their relationship to each other. They are infinitely comfortable together; perfectly, wordlessly intimate.

The child's face arrests the attention with its beauty, its grave expression, as he leans easily against his mother's shoulder and breast, regarding with apparent sensitivity and comprehension some distant reality which exists beyond the frame.

The second child, with his hands clasped, seems silently aware of the infant's thoughts, and somehow apprehensive, though the mother adjusts her child's wrappings in confident solicitude.

Above, the five cherubs appear to be in agitated communion, three of them looking down upon the infant distressed and alarmed, another looking outward, perceiving some fearful and shocking event.

The child seems to have left by choice the companionship of the young spirits above, so as to rest in the harboring warmth of his mother's arms and then go forth to the destiny he contemplates.

And so one discovers that the bucolic scene is alive with an intense drama which exists on three levels of time and place, and that the most powerful picture of all is visible only to the child, his friend, and the cherubs, but is so vividly communicated that the heart is stilled, moved, awed, and permanently affected.

Understanding comes long before one notices the full title of the painting: *Virgin and Child with St. John the Baptist and angels.*

OLIVIA DE HAVILLAND

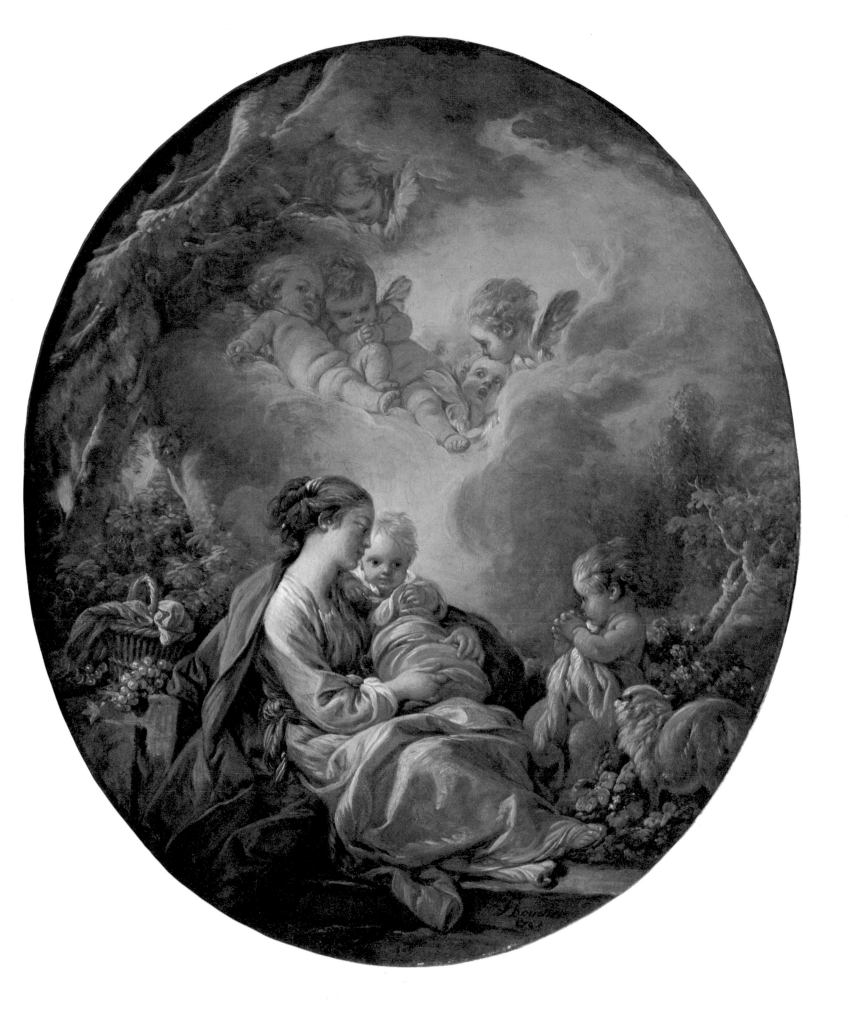

Antonio Rossellino (1427 – 1479)

MADONNA WITH LAUGHING CHILD

1465, terracotta, height 19″ (48cm)

The Victoria and Albert Museum, London

To elaborate to have been designed for reproduction in stucco, and too free in handling to have been acceptable as a completed work in an age which set such store by finish as the renaissance, this statuette was almost certainly modeled as a sketch for a marble sculpture, and it is from its sketch-like character that much of its fascination derives. Had it come down to us in a finished marble version, the core of natural observation around which it is built would be less evident, and the relationship between the figures would have been colder and more restrained. As it is, in few other sculptured Madonnas of its time is so intimate and informal a connection established between the figures of the Madonna and the Child.

For a long time the group was attributed to Leonardo da Vinci, perhaps because of the mysterious smile which breaks across the Madonna's lips; however, it is probably the work of Antonio Rossellino, the most eminent marble sculptor active in Florence through the middle of the fifteenth century. This is strongly suggested when one compares its freely handled drapery with that of the three angels in Antonio's masterpiece, the tomb of the cardinal of Portugal in San Miniato al Monte outside Florence.

Vasari declares that Rossellino "was regarded by all who knew him as more than a man, and reverenced as a saint for the very great gifts which were united to his virtues", and in this statuette he has created one of the most memorable and most appealing of the sculptural representations of the Madonna and Child of the renaissance.

SIR JOHN POPE-HENNESSY

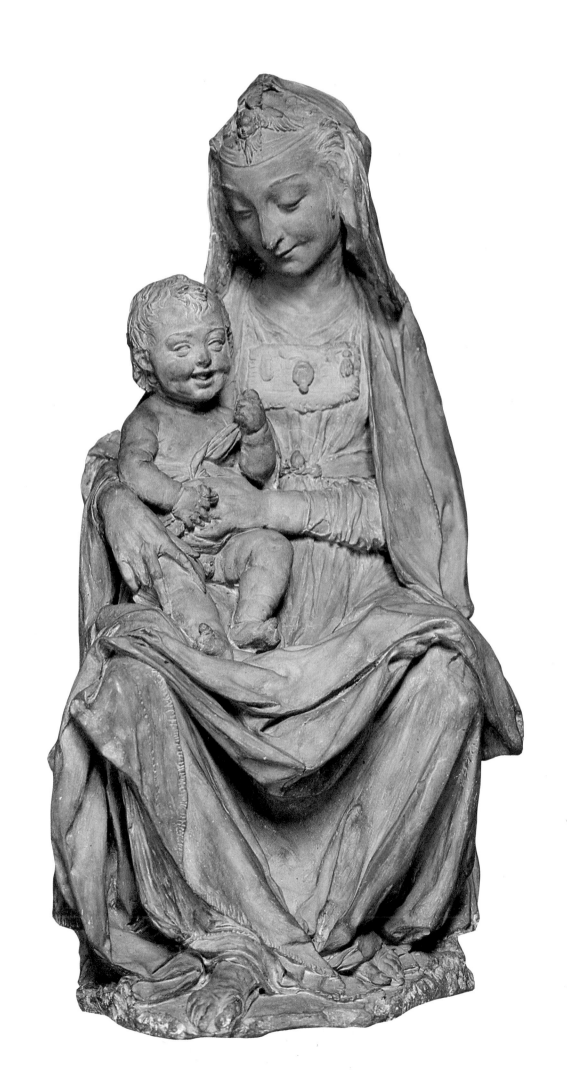

Adriaen van der Werff (1659–1722)

REST ON THE FLIGHT INTO EGYPT

1706, oil on wood panel, 21½x17" (55x43cm)

The National Gallery, London

THE flight of the Holy Family into Egypt soon after the birth of Christ is recorded summarily in Matthew, 2:13–15. From an early date, anecdotal additions were made to the evangelist's account. The rest on the flight into Egypt became, from the fifteenth century onward, very popular for representation in painting and sculpture.

Paintings of this subject often included a palm tree; by ancient tradition, the dates from it refreshed the travelers. However, here there is an oak tree, the leaves of which—to judge from several of his pictures—van der Werff thought greatly decorative. An ass (the ass of the Nativity?) was long considered *de rigueur,* but in this picture there is no ass; presumably it was thought low by the painter.

Refinement rather than lowness is aimed at in this picture. Flowers are associated, as a graceful thought, with the Child. The Madonna's bared breast might humbly suggest her maternity; yet it is shown also, one may be sure, to interest the sophisticated eye, and her coiffure may be thought not rustic.

Van der Werff's pictures are painted with high finish in the Dutchtaste of the time; he sought particularly for elegance. This painting is one of his best.

SIR MARTIN DAVIES

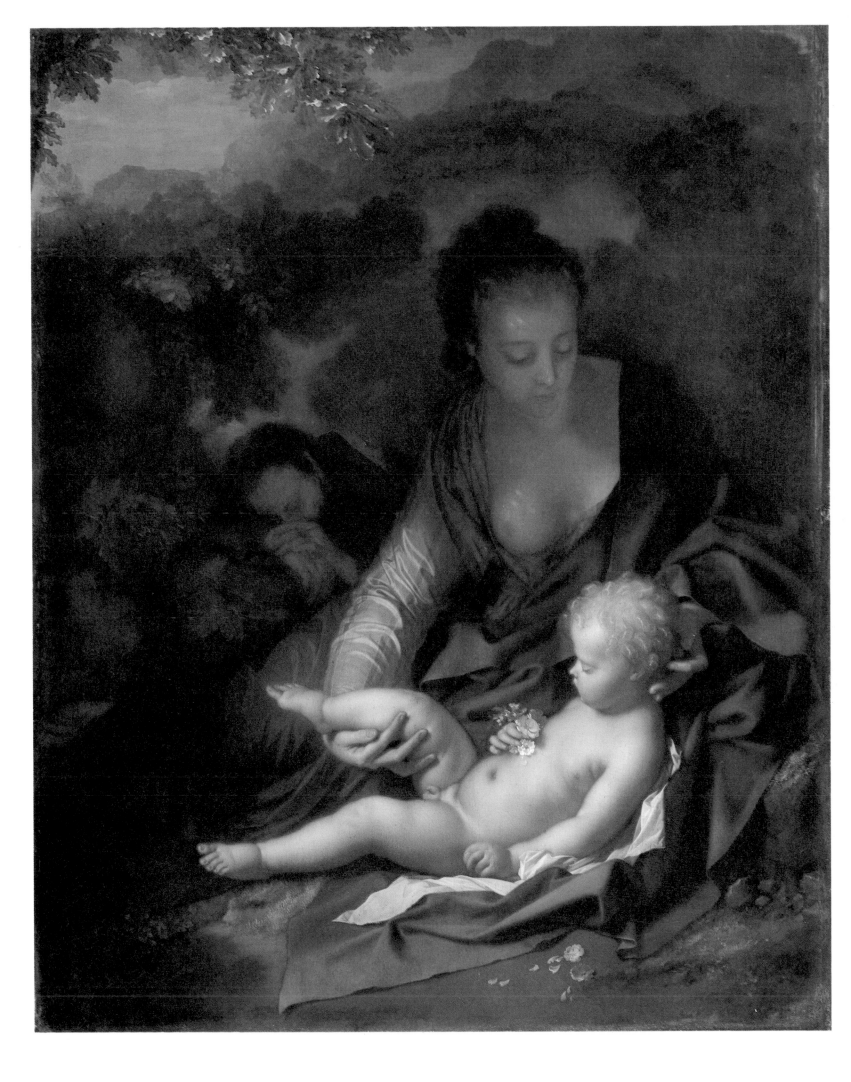

Chin T'ing-Piao (active 1720—1760)

MENCIUS' MOTHER REMOVING HER RESIDENCE

18th cent., ink on paper, 58½x46¾" (148x119cm)

National Palace Museum, Taipei, Taiwan

MENCIUS lived in the Warring States Period. He died in 289 B.C. at the age of eighty-three. His father passed away quite early, and it was only through the instruction of his mother that he became a great scholar. Although her family name was originally Chang, she has been remembered simply as Meng-mu, the mother Mencius.

When Mencius was young, his family lived in a small house near a graveyard. The children, not understanding the significance of their gestures, playfully imitated funeral and burial rites. Mencius' mother, deciding that such surroundings were unsuitable for a small child, moved the household to a dwelling near the marketplace. In their second home, Mencius began to copy the actions of merchants on the street. His mother again said, "This place is not suitable for the raising of my son", and moved to a house near the school. Mencius then learned to play at offering sacrifices and worship to the ancestors and his mother was satisfied. She announced, "This is the place where I may raise my son". Because of the high moral standards that led her to change dwellings three times, the phrase "Meng-mu moved three times" has come to signify motherly duties.

Mencius became a student of Tzu-ssu, the grandson of Confucius, and thoroughly mastered the teachings of the sage. After his studies were finished, he traveled in many parts of China, visiting the kingdoms of Liang, Ch'i, Sung, and Lu. However, these warlike states would not listen to his teachings, and he finally returned to his home and disciples.

The remaining years of his life were devoted to writing and studying and, with his students, to composing commentaries on the *Shih Shu* of Confucius. His principles were based on the assumption that all men are born with good hearts. One must recognize that a king who rules by justice is precious, while one who rules by force has no value; one should hold the principles of love and righteousness important and think last of pragmatic needs. Mencius has been given the appellation "Second only to the Great Sage".

DR. CHIANG FU-TSUNG

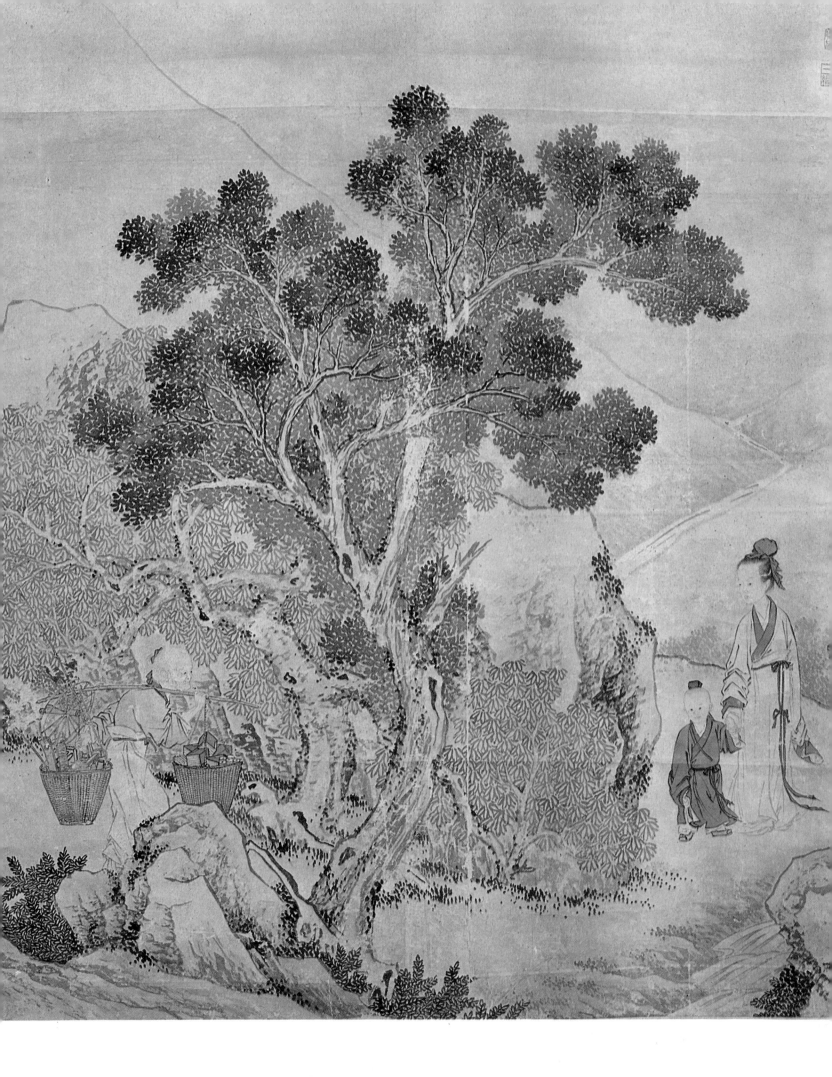

Albrecht Dürer (1471 – 1528)

MADONNA OF THE IRIS

1508, oil on wood panel, 58¾x46⅛" (149x117cm)

The National Gallery, London

BEING a painter, what draws me into the alluring web of Dürer's work is his intense activity as a draftsman, which he combined with an insatiable curiosity. Also being a writer, I greatly admire how all his life he built up such a vast collection of visual information, which he drew on superbly.

He used that inquiring mind and precision with a moving humanism —using pen, brush, and pencil as his tongue, his diary, his language. What he saw, what he did, and what he thought of the world, he committed to paper and canvas (switching from print-making to drawing to painting) with unparalleled skill.

Madonna of the iris, like all else he produced, is exquisite in detail. The painting now hangs in London, where I have the pleasure of seeing it at will. Though a somewhat disputed restoration, what I find nevertheless delights me; there is the firm accuracy of hand, the mastery of drawing, and magnificence of coloring that one expects of any Dürer.

FLEUR COWLES

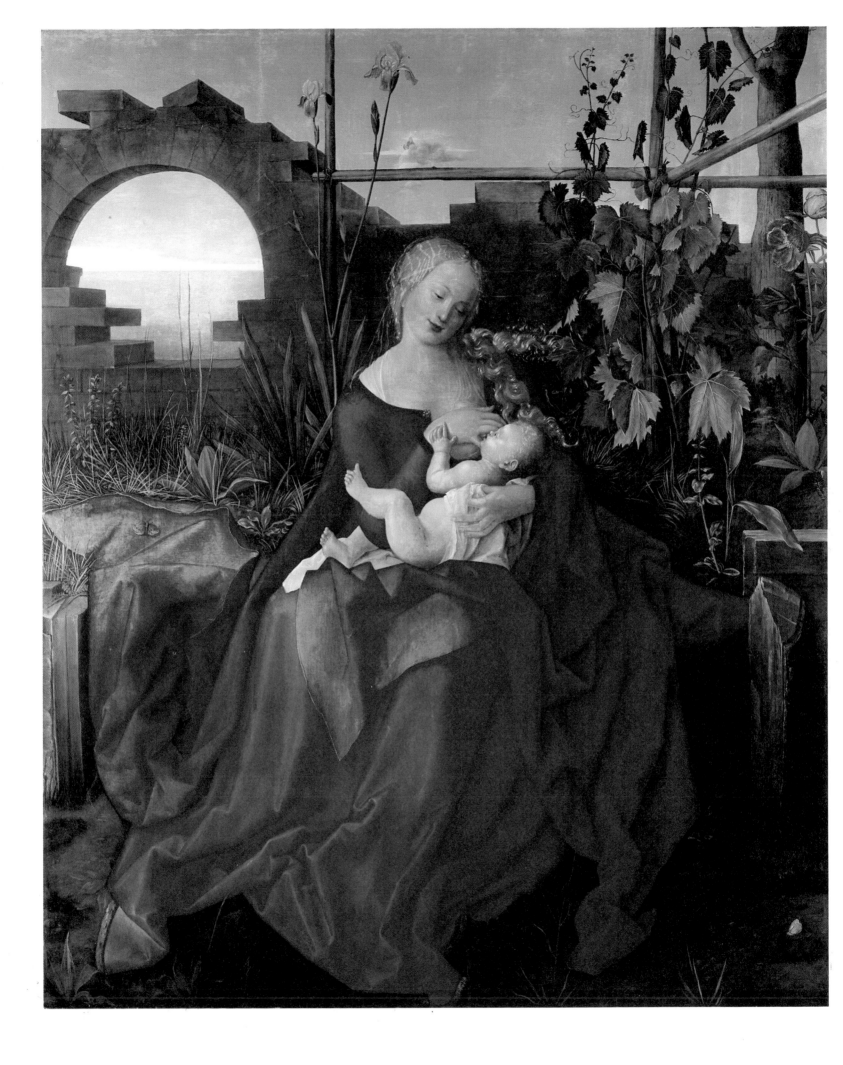

Anon.

OUR LADY OF THE ROSARY OF PUEBLA

17th cent. (Mexican Colonial), wood and satin, height 30" (76cm)

Santo Domingo Church, Puebla, Mexico

WHEN the Spanish conquerors destroyed the images and temples of the Mexican Indian religious cults, they put in their places the images and cathedrals of the Catholic Church. It was the image of Mary, the Holy Virgin, Mother of Christ, that became the focus of the Indian's adoration and worship. From the hot, swampy coasts to the cold, solitary, inaccessible mountains, everywhere are images of the Madonna—none more loved than Our Lady of Puebla. She is a typical "show image"; only the face, the hands, and the Child she carries are really carved, the rest is designed only to support her rich garments. In a setting of baroque splendor she has a lady's bearing. She holds in her left hand the fruit of her womb, in her right hand her rosary's flowers. Here there is the expression-less face of a doll, framed by a coif with a diamond lock, the forehead crowned by a diadem of gold and precious stones. This Madonna's jewelry and clothing have always been famous; at one time her dress was embroidered with pearls worth 20,000 gold pesos. Now, her riches have gone and even her silver pedestal has been replaced with a nineteenth-century wooden one. She makes us feel the innocence and purity of a faith that could supplant the barbarism of a pagan worship with this naïvely sweet Mother and Child. It is amazing that a people could worship an image that does not even remotely resemble themselves.

Here is the song chant of the pilgrims to Our Lady of the Rosary of Puebla:

> We all bid you
> Adiós Holy Mother
> For you open our way
> You are our guide
> Adios most beautiful
> Mother of the Holy Lamb
> Adiós beautiful Child
> Until you come again.

KENT SMITH

Anon.

MOTHER NURSING A CHILD

16th cent. (Nigerian), ivory, height 5¾" (15cm)

Collection William J. Moore, Los Angeles

THIS ivory figure was produced in a civilization alien to ours, whose aesthetic we dimly understand. Perforce, we see its sculptural values according to our own Greco-Roman/European critique, since we have no other. We see the figures as self-contained, compactly balanced in form, and thus we might label it "classic".

The subject, a mother nursing her child, is universal in appeal and understanding. It produces an irresistible empathy in the viewer. The anatomical features of the figure do not conform to European ideals of representational naturalism, but their exaggeration is purposeful and deliberate, serving rather to enlarge than to diminish the dramatic impact of the subject.

Every element of the figure works abstractly to enhance, with subtle repetition, variety, and restatement, the literal image. The forms of the mother figure swell against and into one another. They return again and again upon themselves. Their movements are forcefully sensual, eternally maternal.

The figure is squat, the legs diminutive. Solidness relates it to the earth as mother rather than to any spiritual elevation as "Madonna". The head of the mother sits firmly erect; the eyes look forward as if on guard for the child. At nursing, the mother is not lost in her own thoughts, nor is her head bent in the expected maternal attitude of love for her child. Her over-scaled hand supports the whole weight of the child's head. The child wraps itself close to the curves of the mother's body, is one with the mother, dependent upon her in sculpture as in life. Its enormous hand is cupped around the mother's breast in possessive hunger. The child's alert stare unites it directly to the head of the mother.

The sculptor has maintained an honest respect for the integrity of his medium. As was the ivory tusk from which it was carved, the figure is round.

WILLIAM J. MOORE

Peter Paul Rubens (1577 – 1640)

HELENA FOURMENT AND HER SON, FRANS

1635, oil on canvas, 57x40" (145x101.5cm)

Alte Pinakothek, Munich

Historians studying the lives of the great artists are understandably interested in their loves, which does not necessarily mean their wives. Yet, in the lives of the two greatest seventeenth-century painters in the Netherlands, Rubens and Rembrandt, their wives occupied an important place.

In Rubens' case both marriages of the artist were very proper affairs, though we may be sure that the beauty of Isabella Brandt, who died young, and of Helena Fourment excited not only his painter's eye. But both women were also capable of taking their proper place at the side of a famous husband. Helena, who was sixteen when the fifty-three-year-old master married her in 1630, had five children; this painting shows their second child, Frans.

In painting Helena and Frans, Rubens had obviously more in mind than a picture of a young mother with her child. There is a pervasive stress on opulence of dress and setting. Even the nude boy is given distinction by a black velvet beret with a white ostrich feather. The column, curtain, and balustrade denote a sumptuous home. Given the pictorial splendor of execution in addition, we realize that we are confronted by the wife and child of a man ennobled by the King of Spain and knighted by the King of England; a man owning a great house in town and a château and large estate in the country; a renowned artist who had also been engaged in delicate and important diplomatic missions and whose every move was watched and recorded at the courts of Europe. The social formality, the representative *mise-en-scène* are all there; nor are Helena and Frans permitted to engage in a normal show of affection between mother and child. Both look out of the painting as if aware of the presence of beholders—and not the least of them the artist himself, their famous husband and father.

And yet we cannot possibly overlook that we have before us more than members of a distinct social class or a prominent family. We see a lovely young woman, ripe with the sensuous charm of her age, and a small boy whom we can easily imagine engaged in a child's innocent merriment—or mischief; and we admire again Rubens' unique gift of lending significance to the particular by embedding it in the general, and enriching the general by the warm presence of the particular.

JULIUS S. HELD

Julius S. Held

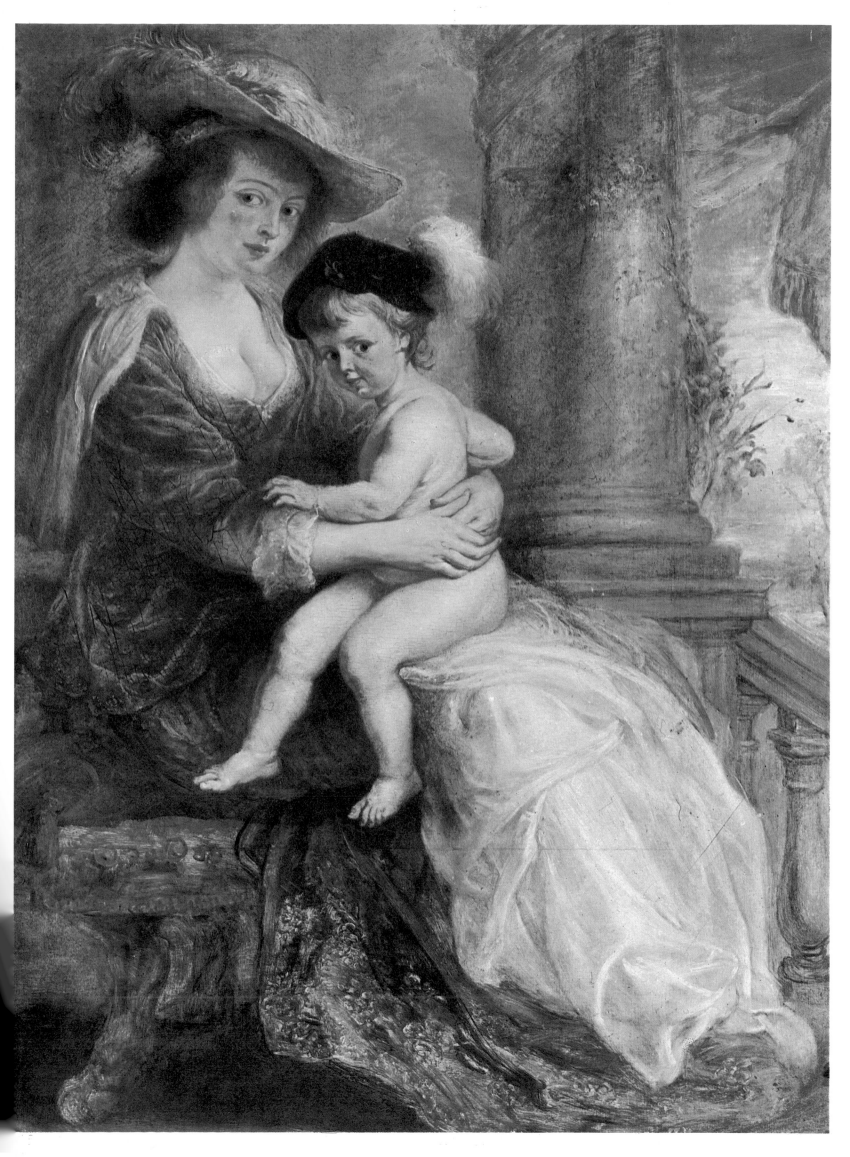

Anon.

A LADY SUCKLING HER BABY

c. 1640–1650 (Persian), ink drawing, 6½x4⅛" (16.5x10cm)

Los Angeles County Museum of Art, Nasli and Alice Heeramaneck
Collection, gift of Joan Palevsky

ISFAHAN of Shah Abbas I the Great, the then bustling and prosperous capital city, set the tradition for the arts of Persia in the early seventeenth century. The famed Royal Plaza, where the court and the diplomats gathered in the Ali Kapu Palace to watch the noblemen on horseback participate in the polo games against a backdrop of blue minarets and golden domes, is to this date surrounded by the studios and shops of the artists and artisans who were brought from the far corners of the empire by the King.

This miniature depicts a scene in a Persian garden. It combines the reverence the artist had for nature and for motherhood. Nature is represented by the garden, the muted colors accentuating the freshness and lightness of spring, and his feelings for the mother and child are expressed by putting them stage center in a special tent set up for their privacy and comfort, while the young husband is chatting with a *mullah*—wise man—seated in the background under a sycamore tree.

As in many other cultures, the most exalted role of woman in Iran was that of the mother and giver of life; in the humanistic tradition of the period, the artist depicts her not as a goddess or a fertility symbol but in the natural role of nursing a child. Children, too, occupied a very special and affectionate place in Persian culture, and "mother's milk" was synonymous with the expressions of strength and wisdom. Women, therefore, exulted in nursing children well and long (hence the fat, juicy baby!), and men expressed their approval by their love and admiration of the children; to this day it is common to see a Persian man cuddle and play with a family's children before greeting the parents.

Paintings of this period developed greater realism and naturalism and were characterized by a leitmotiv of luxury—fluid line and harmonious color, an ambience of grace, elegance, and warmth. The figures were youthful, lazy, daydreaming, and terribly sophisticated, exuding an air of total refinement.

ERIC AZARI

Eric Azari

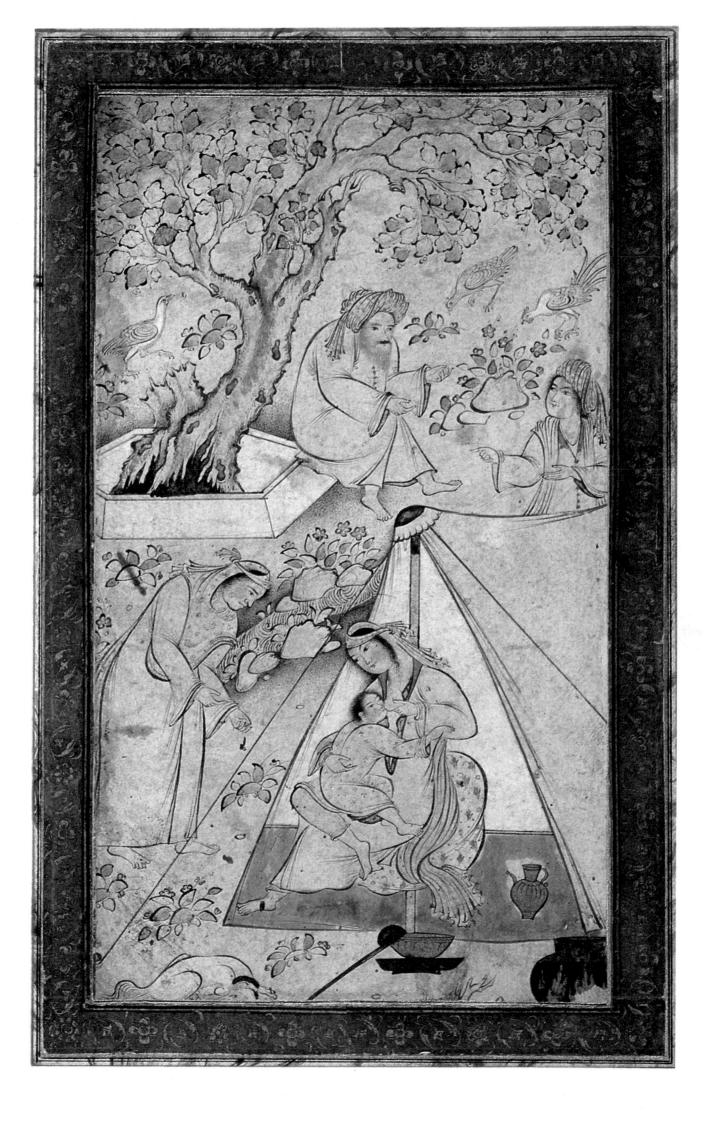

Georges de La Tour (1593 — 1652)

THE NEWBORN: Detail

1630, oil on canvas, detail height 20¾″ (53cm)

Museum of Fine Arts, Rennes, France

A MOTHER contemplating her young child sees so much newness: new eyes with no pictures in them yet, new ears, tender and perfect, with all of language unrecorded, small scraps of unused hands with their work before them. She sees before her a beginning, a promise, infinite possibility, infinite hope. In those early times together, love has a startling clarity. Of course it doesn't always remain clear. It sometimes becomes possessive, or perverse, or disappointed, as human love has a way of doing. Children depart or die or grow badly. But that first recognition of new hope has left its imprint on the heart and is forever a part of shared human experience. We see another mother contemplating her young child, and time and death are redeemed.

Time and death have been redeemed in another way for this artist. Georges de La Tour had been forgotten, and for 250 years many of his paintings were attributed to others. Rediscovered, he has been acclaimed by the world of art and his unique style has been recognized. *The newborn* was painted by La Tour when he was thirty-seven, using a candle or hidden source of light. There are no extra details. His figures are large in scale and are simple, almost geometric forms. The clear brick red of the mother's dress glows. Her hands tenderly cradle the miracle she holds.

BARBARA INGRAM

Barbara Ingram

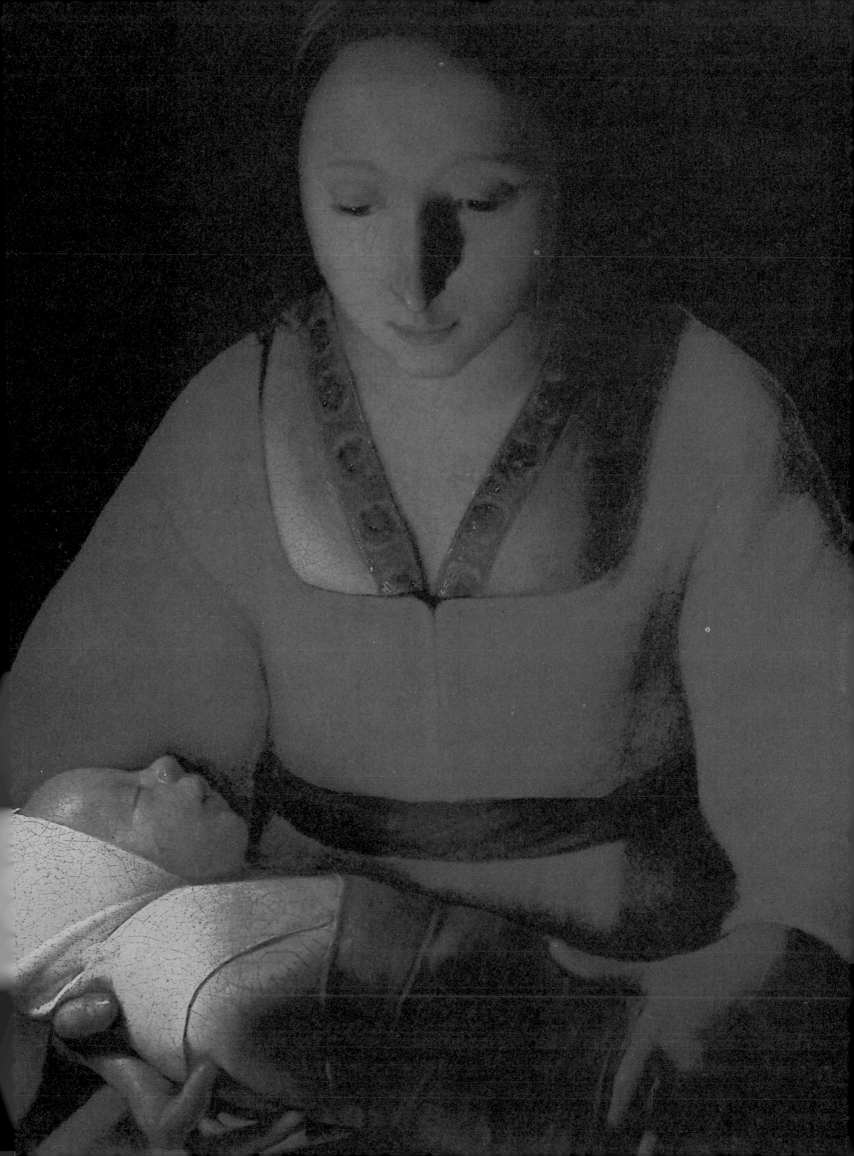

Giovanni Tiepolo (1692–1770)

MADONNA OF THE GOLDFINCH

1750, oil on canvas, 24⅞x19¾" (63x50cm)

National Gallery of Art, Washington, D.C., Samuel H. Kress Collection

Of ALL mother-and-child compositions, by far the most significant in art history is the Madonna and Child. The countless representations of these Christian holy figures vary not only in their design, but also in the choice of symbols associated with the Madonna and her Baby. Tiepolo's *Madonna of the goldfinch* is of interest in that it reveals the continuity in art of symbolic devices long after their meaning was forgotten. The little goldfinch, held in the Christ Child's left hand, was a bird of many symbolic meanings and had become one of the most popular and most widely used symbols in European devotional art from the early years of the fourteenth to the middle of the sixteenth century. After that its use declined rapidly; when Tiepolo suddenly reintroduced it, he obviously had no idea of what it had stood for earlier.

Originally, any small bird was a symbol of the soul, the part of man that, unlike his body, was not earthbound. The fact that the goldfinch has a bright red mark on its face caused it to be associated with the Passion of Christ, a connection furthered by its habit of feeding on thistles, plants allegorically comparable to the crown of thorns. Partly because of this, the goldfinch came to be looked upon as a "savior bird" in times of the plague. During the epidemics, hundreds of paintings including a goldfinch were commissioned, each in the hope that the little bird would act as an amulet against the plague for the donor and his family.

However, by the middle of the eighteenth century all this had been forgotten. How little understanding of it was left is shown by the fact that Tiepolo carefully painted the flight feathers of the little bird's wings clipped to prevent flight, as was commonly done to birds given to children as playthings. To represent the winged symbol of the soul deprived of its chief attribute clearly shows that to the artist the goldfinch was merely a pretty, decorative item with which to embellish a picture. This is consistent with the purely pretty nature of the painting of the Mother and Child themselves.

HERBERT FRIEDMANN

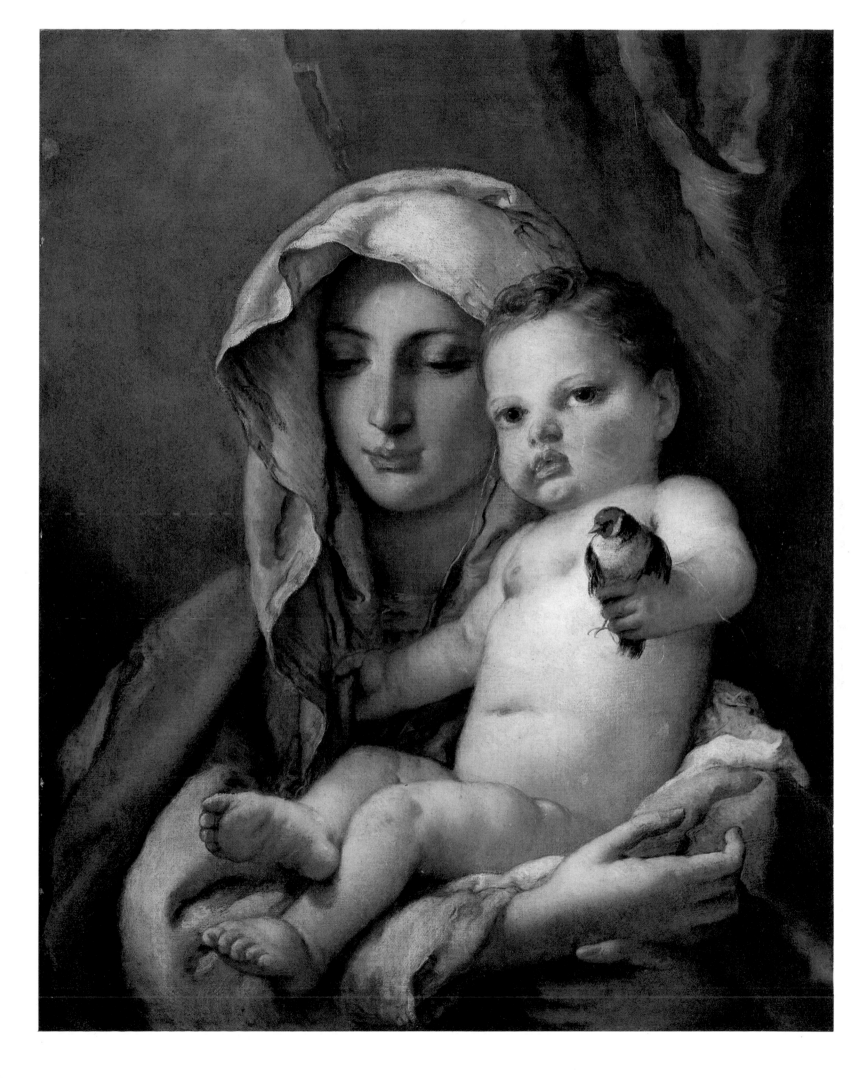

Basawan

MOTHER AND CHILD WITH A WHITE CAT

c. 1590–1610 (Mughal), watercolor on paper, 15³/₄x9³/₄" (40x25cm)

Collection Mr. and Mrs. Edwin Binney 3rd, East Orleans, Mass.

THE seventeenth-century Mughal Emperor Jahangir inherited from his father Akbar a studio of great painters and a treasury so swelled that his slightest whim as an art patron could be easily fulfilled. Already, as prince, he had assembled a group of artists including both native Indians and Persians. "My liking for painting and my practice in judging it have arrived at such a point that when any work is brought before me . . . , I say on the spur of the moment that it is the work of such-and-such man," wrote the royal esthete in his memoirs, the *Tuzuk-i-Jahangiri*.

Such enlightened patronage brought about the assembling of several royal *muraqqas* (albums of miniature paintings and calligraphies) whose sumptuousness has never been surpassed. Chief among them were the Muraqqa Gulshan, now in Teheran, and another, in Berlin. The present album leaf is similar in style and size to those in both—the ornamental roundels showing deer surrounded by birds reflects the Emperor's taste for animal portraiture.

The miniature mounted within the album border presents problems —both of style and origin. The copying of European motifs, such as the disinterested Madonna nursing an inordinately wizened child, and techniques like the perspective of the portico in the rear, in opposition to that of the book-cover-like bed seen in aerial perspective, are readily explained. European easel pictures and books of prints were sent to the Emperor Akbar, notably from Portuguese Goa, and were used for copying by the artists of the Mughal *atelier*. What Indian master painted the scene is more conjectural. The noted Cary Welch (*A Flower from Every Meadow*, 1973) suggests Basawan, an Akbari artist, whose earlier work might thus have been mounted into an album for Jahangir. A previous attribution to Manohar, son of Basawan, whose major artistic production was for the younger Emperor, has also been suggested. Regardless of exact dating, the mother and child remain wedded to their superb mounting on an album page made for the greatest esthete among the Mughal emperors.

DR. EDWIN BINNEY 3RD

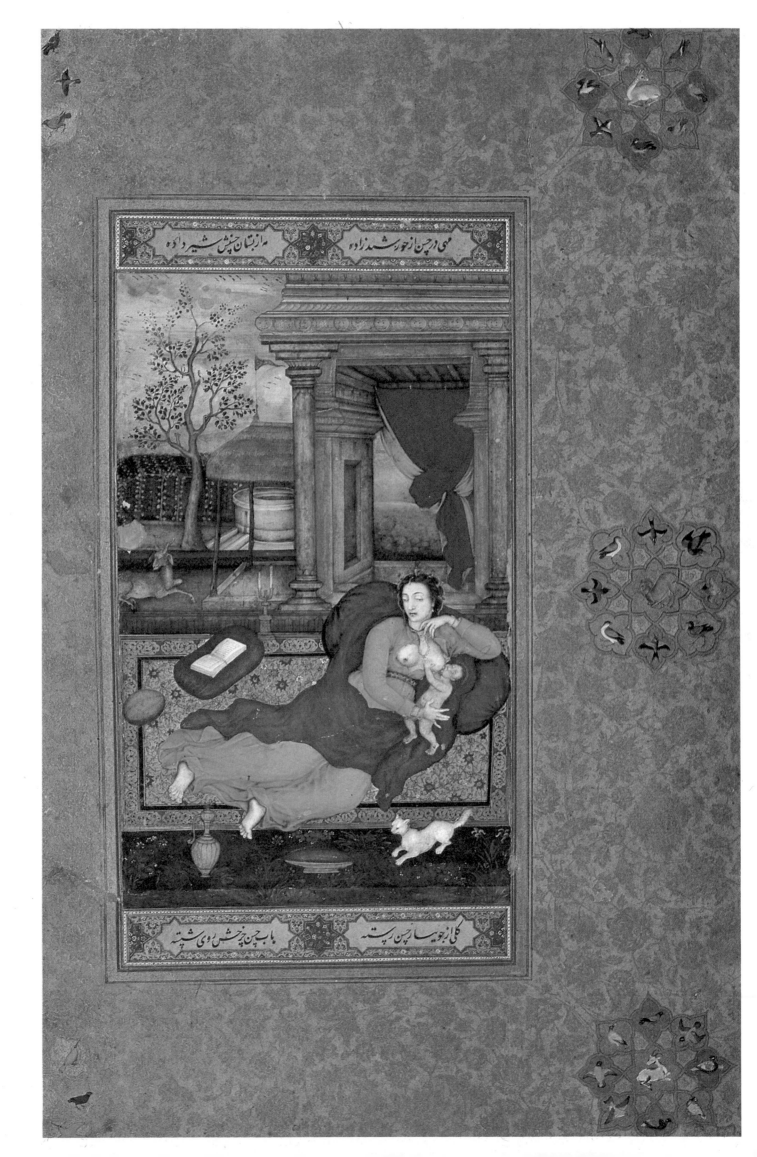

Luis de Morales (1509 – 1586)

MADONNA AND CHILD

1560, oil on panel, 33x25¼" (84x64cm)

Prado, Madrid, P. Bosch Bequest

LUIS DE MORALES, whom tradition has given the title "Divine" —not because of the sublime quality of his art, but rather for the sincere and deep religious fervor of his compositions—is still a mystery for historians. Isolated in Extremadura, a remote province at the Portuguese border, with hardly any documented contacts with the great artistic centers of his times, he was able, nevertheless, to crystallize a personal and refined art. Morales' art was clearly of Italian renaissance inspiration, particularly indebted to Leonardo. He used a subtle modeling, obtained with the most delicate sequences of light and shadow, together with an impeccable technique of clear Flemish origin, that outlines with exquisite minuteness of detail the folds in the cloth, the golden hairs of almost metallic exactness, and the minute accessories of still life.

This Madonna and Child is one of his most fortunate creations. In it one finds the most delicate and tender revelations of humanity —with the playful Child who looks for the maternal breast and the subtle melancholy with which his Mother contemplates him, with half-closed eyes and trembling hands, foreseeing, perhaps, his grievous fate.

A mysterious, silent penumbra wraps both figures. And a cold, almost lunar, light emphasizes the magic quality of the green cloth of the Madonna's dress, accentuating her paleness.

The religious emotion and human tenderness are counterbalanced with prodigious mastery. And if we today perceive a maternal sensibility above all, Morales' contemporaries could detect in it a holy symbol that evidently answered their devout needs.

ALFONSO E. PEREZ-SANCHEZ

Michelangelo (1475–1564)

MADONNA AND CHILD

c. 1505, marble, height 99" (251cm)

Medici Chapel, San Lorenzo Church, Florence

STANDING in the Medici Chapel, doubly darkened by a late afternoon rain, separating the self from the shuffle of the tourists and the hushed voices of the guides, one isolates the mind's eye to stand before Michelangelo's *Madonna and Child*. The beholder first feels the presence of the Mother and Child emerge out of dimness . . . still, very still . . . impervious to the sweep of time. The eyes seek and hold the introspective eyes of the Holy Mother . . . Hera . . . Earth . . . Universe . . . Queen of Heaven. Does she dwell on thoughts prophetic, or on the grave acceptance of life? Or the knowledge that the fulfillment of God is the fulfillment of man's love for his fellow man? Perfection in her symmetry, with her smooth triangular face, far-apart eyes, strong nose, fine mouth, makes her at once aloof. The body bends gracefully to loosely hold the Child . . . curly haired, baby-fleshed, charged with life . . . the Child "adored". There is the slightest suggestion of the sturdy shoulder that will bear the cross. The head is turned from the beholder . . . the face with its infinite love left to the heart's longing.

DOROTHY McGUIRE

Vincent van Gogh (1853–1890)

MME. ROULIN AND HER BABY

1888, oil on canvas, 36¼x28¾" (92x73cm)

Collection Robert Lehman, New York

VINCENT VAN GOGH burned with—and was burned by—his passion.

He was a man possessed of genius, yet this creative fire frightened people because when it glowed, it could burn. He had the capacity for love and the power for violence.

I studied the man deeply when I portrayed him in *Lust for Life*. I read about him. I read letters by him. I read why those in his time ignored him and those in ours exalt the genius with which he pushed aside forever the boundaries of art, setting colors free, letting lines live and breathe and explode.

Perhaps no man left a better record of his emotional strength and misfired dreams than Vincent van Gogh. Every brushstroke came from a deep passion, whether on the brink of life or the step before death. He used colors as another man might shout his agony or declare his hope. He projected every inner tremble.

Mme. Roulin and her baby, painted during his most productive Arles period, evokes a tranquillity and a beauty that van Gogh desired but never found in his own life. To van Gogh, all things were alive—the earth, the sky, a house. During the Arles period his pallette became extremely light, he used glowing colors, his strokes became soft, tender, like a child to whom all dreams are possible, a life not yet battered by time, everything in its eyes filled with wonder and hope. When van Gogh painted his friend Postmaster Roulin, the man's wife had just had a baby. The artist wrote letters ecstatic about wanting to paint the mother and child.

The full, bright yellow background here is like an overpowering sunrise, promising a glorious day, yet also a cosmic symbol of where we came from and where we'll go. The mother's face is Madonna-like, the child's eyes wide, innocent, searching. The mother holds the child tenderly, yet his arms are searching for freedom, reaching out. It was perhaps van Gogh himself reaching for the elusive things he would never have in his lifetime.

KIRK DOUGLAS

Jacques Louis David (1748–1825)

MME. SERIZIAT AND HER DAUGHTER

1795, oil on panel, 50¾x37¾" (129x96cm)

Louvre, Paris

JACQUES LOUIS DAVID was once described as "a genius who arouses our admiration but not our love", and the notion still persists that he was a cold painter, dominated by theories and by classical ideals. Like many generalizations, this fails to take into account *all* the evidence. Dramatic masterpieces like the *Death of Marat* and many portraits point to a different artist, one with a strong romantic streak, capable of great psychological insight, one with a sense of the dramatic and an eye for the graceful pose and the pleasing color.

Even his detractors would not want to deny the freshness and grace that permeate his portrait of Madame Seriziat and her daughter, a work which in many ways typifies the "other" David. The sitter was his sister-in-law and it was painted during a three-month stay at Saint-Ouen near Tournon after his release from prison. It was a companion piece to a portrait of Monsieur Seriziat, who had helped gain David's freedom. Both works were an expression of the artist's gratitude and both suggest his sense of relief at finding himself in the country after the turmoil into which he had thrust himself in Paris following the outbreak of the Revolution.

This portrait in particular reveals David's painterly qualities, his sense of design, his method of composition, and his feeling for color. The graceful pose of Madame Seriziat, the unaffected way she holds the hand of her daughter, owe a great deal to his neoclassical training. The work has charm, but not sentiment; the eyes of mother and child are not on each other as they are in so many pictures with this subject, but on the artist, and by implication, on the outside world. Both figures are presented in direct light without theatrical highlighting. The color is laid on thinly and evenly across the canvas. The creamy white dress of Madame Seriziat, her green sash, her straw bonnet, and the bunch of wild flowers in her hand suggest the freshness of early summer. The painting as a whole shows how David was able to create something beautiful and timeless without losing contact with observed reality, a perfect blend of his classical and romantic inclinations.

IAN DUNLOP

Gustav Klimt (1862 – 1918)

THE THREE AGES OF LIFE: Detail

1905, oil on canvas, detail height 60" (152cm)

National Gallery of Modern Art, Rome

"To ME it is not important *how many* like my work but *who* likes it." Thus spoke Gustav Klimt whenever offended, disregarded, or misunderstood. These words should give guidance to any artist.

Gustav Klimt entered my life in a beautiful way.

One day my Austrian-born husband—an artist himself and producing plays by artists in a Vienna theater—presented me with a doll. Her head, her hands, her legs, are of finest porcelain; her hair, long and dark and real, put up with tiny hairpins; her expression soft and longing, unfulfilled, and full of devotion to whoever may want to love her. This doll had belonged to Gustav Klimt.

The painter's last model—by that time an old lady—used to come to my husband's theater almost every day, and, with his rare gift for being able to make even an old woman feel desirable, he had her seated without a ticket. The ancient model was as wonderful as Klimt's paintings. She still wore the dresses, the hats, the jewelry, and the complexion of her time. Unfortunately, I never knew her.

The city of Vienna gave her a pension for life in exchange for all she possessed of Gustav Klimt. She excepted only that doll and a drawing of a mother and child, both of which she had presented to my husband to thank him for letting her participate in the youth of his theater. The drawing, which is reproduced below, expresses with the simplicity of genius the holding, the loving, the anxiety for our children and the knowledge that we will have to let them go into a life of difficulties we cannot solve for them.

Gustav Klimt to me is a painter who paints the feelings that wrap and possess us. Even if his pictures sometimes look merely decorative I feel that they are the outer expression of what people feel, of their inner emotions—like an aura of gold. In the painting opposite we find the unconscious dawn of childhood and the fulfillment of life through mother love.

MARIA SCHELL

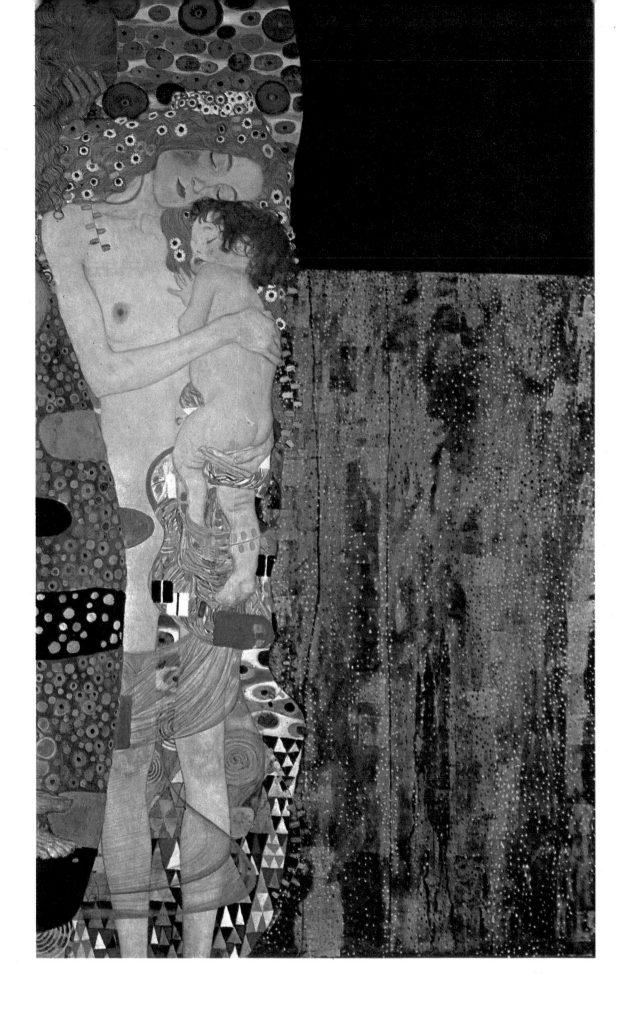

Anon.

MADONNA AND CHILD (BOOK OF KELLS)

9th cent. (Irish), ink on vellum, 12½x9½" (32x24cm)

Trinity College Library, Dublin

THE Book of Kells contains the four gospels in Latin, enlivened with intricate and imaginative designs, which continue to astonish by virtue of their richness and variety. It is generally believed that it was begun on Iona, and when that remote island monastery of the Columban order was sacked by the Vikings in 805, the unfinished manuscript was brought over to the sister foundation at Kells in County Meath, Ireland, where it was completed. A team of monks would have worked on it over a long period in disciplined harmony. There is a unity in both text and illustrations unusual in a work of many hands, the result, perhaps, of the influence of the chief artists over their pupils. The style of a particular artist sometimes expresses itself in the ornament or in a preference for certain color combinations (these are often violent), but his identity will perforce remain anonymous. There are few pages of illustration, of which this is one. Françoise Henry, writing in *Irish Art During the Viking Invasions,* suggests that there is Eastern inspiration in the Madonna and Child and looks for comparison to models in the Coptic Church.

The Madonna is represented full face with the Infant Jesus across her knee. He boasts neither crown nor halo and wears a tragic expression. She is, in concept, somewhat larger than life, perhaps indicating the predominance of Our Lady in the Irish Church. Mother and Son are represented with two right and two left feet respectively, adding to their apartness from human form. No attempt has been made at realism in the two figures, yet there is ample evidence in the book that the artists were capable of conveying this when they so desired. The very border that frames the picture is positively teeming with movement and life. The Madonna and Child were the objects of daily ritualistic devotion by the monks who depicted them and provided the reason for their existence. This sad, powerful, and mysterious representation reflects the holy life they led.

DESMOND GUINNESS

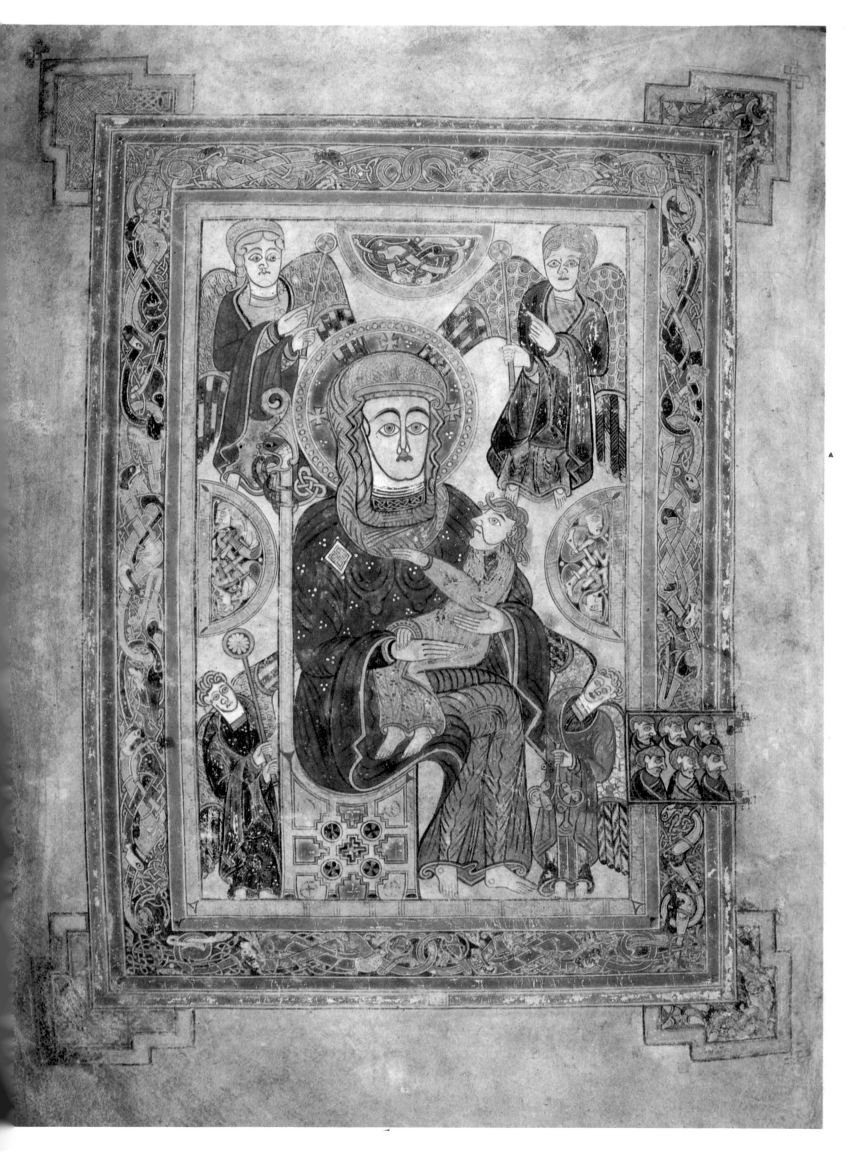

Anon.

ISIS NURSING HER SON HORUS

c. 2200 B.C. (Egyptian), gilded bronze, height 8¾″ (22cm)

Cairo Museum

THIS sculpture of the fifth century B.C. was discovered in recent excavations at Saqqara, not far from Cairo. It is another example of the richness of the lost civilization of Egypt before the Roman conquest.

The seated mother is Isis, principal goddess of the Upper and Lower Nile and daughter of the god of the Earth and the goddess of the Sky, the basic root deities of the Egyptian religious structure. Her name comes to us as the Greek form of the Egyptian word meaning "throne". In picture-writing, or hieroglyphics, the image of a throne followed by the feminine sign equaled Isis, who thereby became the "throne-woman", that is, the Queen. Cleopatra, several centuries later, was often associated with Isis for this reason.

By the time of the Late Period of Egyptian history (after 712 B.C.) she became increasingly portrayed as a mother with her child, Horus, on her lap. She is shown here in a rather naturalistic pose, offering her breast to feed her child. The typical Old Kingdom hieratic or stiffened pose of rigid centrality has been softened and made somewhat gentler. Her child leans back and rests his head in her hand in a rather helpless, infant-like way. Granted the legs of the mother and son are rigidly parallel, and the son's arms are too, there is more tenderness conveyed in these subtle modifications of the traditional Egyptian pose than frequently can be found in fully naturalistic portrayals of mothers and children of later periods of European art.

This naturalness is an innovation of the times after the Ethiopian conquest that began in the Late Period when the images of the god and the king, or queen, became distinct and separate. Until that time royalty and the god were identical, but in later centuries the ruler was seen as only the earthly representative of the god. This allowed the ruler to enjoy human attributes, actions, and even failures. The ruler was no longer held on a divine level but in many subtle ways became closer to mankind, as in this example.

HENRY G. GARDINER

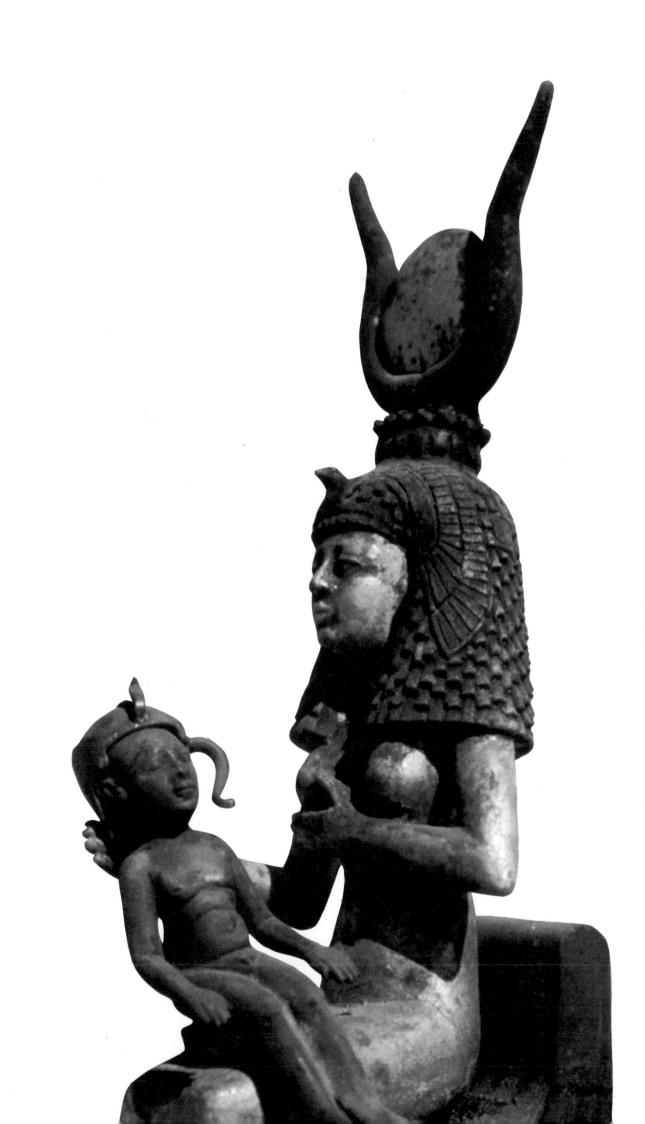

Anon.

MADONNA AND CHILD ENTHRONED

c. 1515 (Flemish), tapestry, 102x116" (259x295cm)

Pasadena Museum, Pasadena, Calif., The Norton Simon Foundation

WITH a desire to show us a domestic, more intimate, human aspect of the Madonna, the artist has placed her in a richly decorated Gothic interior and shown her in the company of her two sisters, Mary Cleophas and Mary Salome, who are seated in the foreground. The sisters are engrossed in their handwork, a familiar pastime for ladies of the period. Both are making items for the Madonna to wear on her head: the one at the right embroiders a kerchief similar to the one the Madonna is wearing, which is in keeping with the domestic qualities of an interior scene. However, the sister to the left prepares a heavenly crown with the roses in her lap: a motif which can be read as both a straightforward domestic procedure or one filled with heavenly symbolism. Thus, the scene becomes a combination of everyday life, appealing to the Flemish artist's love of realism, and an event filled with religious overtones.

The Madonna and Child are part of the foreground group by ambiguous spatial relationships. We are not quite sure if she is in front of the columns or behind them. One can sense the tenderness of the Madonna as she gently caresses her Child's foot as he plays with one of the roses to be used in the crown. Yet the Madonna is still set apart from her earthly sisters by being raised on a carved throne resplendent with jewels and tapestries, and she is surrounded by singing angels and angel musicians.

Various traditional symbols are found throughout the picture. Mary's tunic is red, the color of love, and her mantle is blue, the color of constancy and heavenly purity. The foreground is filled with flowers and fruit: the violet, symbol of humility; the strawberry, symbol of perfect righteousness, and the pansy, symbol of remembrance. The tapestry is signed MAN(DE)R behind the pillar capital in the upper left. It was woven at Brussels about 1515 and is one of the so-called "Spanish Tapestries", as these tapestries, woven in silver and gold, were first made for the Spanish monarchy under the reign of King Philip I.

NORTON SIMON

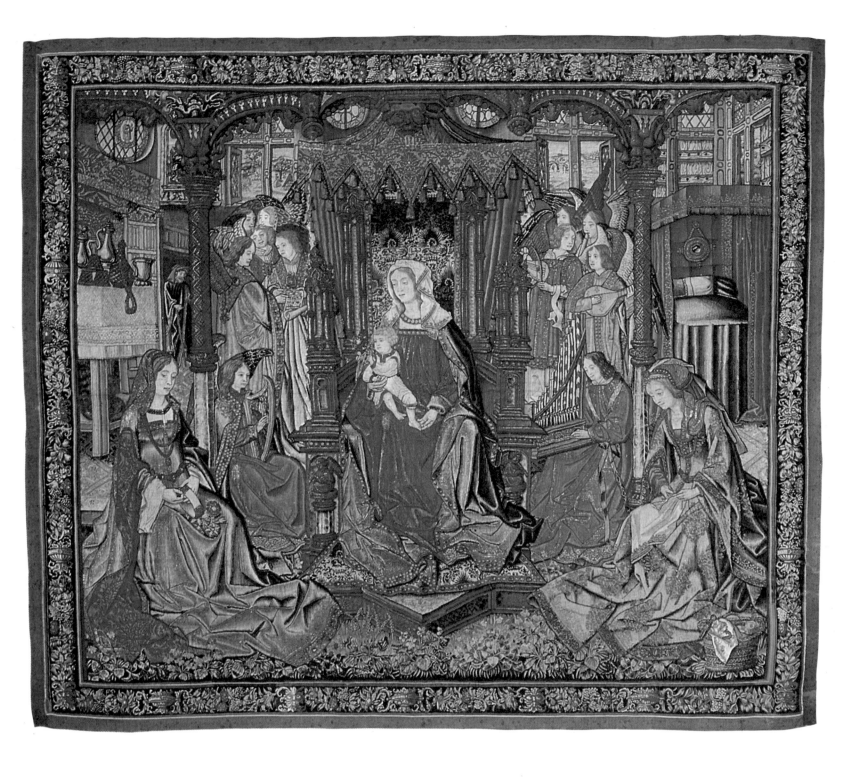

Honoré Daumier (1808 – 1879)

THE WASHERWOMAN

1861, oil on wood panel, 19½x13″ (49x33cm)

Louvre, Paris

THE French have always prided themselves on their logic; in fact, they do not admit of the existence of a logic other than theirs. This leads people, unused to looking the truth unflinchingly in the face, to consider the French to be either hard or cynical or, of course, both. In France, people do not pass away, or fall asleep, or rest. They die. And French horoscopes have no place for the daintiness which describes those born under a certain sign of the Zodiac as Moon Children. Their sign is Cancer, and if the word happens to echo a dread disease, that's just too bad. Nor are members of an age group referred to as senior citizens. They are old men and women.

This no-nonsense attitude is nowhere more eloquently crystallized than in the painting of Daumier. Unlike his graphic work, which is sharp and caricatural, his painting is muddy and muscular— suggesting in the uneasy gloom of the background all manner of brooding social evil. The mother who helps her child climb the steps is no less a mother because her hands are chapped with labor, nor is the child any less a child because its youth will be short and not necessarily sweet. Help is given and accepted not only out of a sense of belonging, but out of a feeling of solidarity. The bitterness of industrial reality looms everywhere in the background, threatening to cast its shadow over mother and child, who, faceless as symbols, manage their minor obstacles with strength, health, and fiber. They are all mothers and all children, and around them is all the smoke and dust of the industrial revolution, the first poison to spiral into the innocent air, the price of creature comforts, of luxuries, of status symbols.

And yet Daumier is no polemicist; there is no dry political engagement or even anger here. As a man of the people, he reflects the people. He shows them as they are, unsentimentally— strong and vulnerable as animals. It is instinct which makes the mother guide her child. But as soon as the child is old enough to negotiate the stairs herself, the mother will be occupied elsewhere. And before long, the child will be a mother herself.

PETER USTINOV

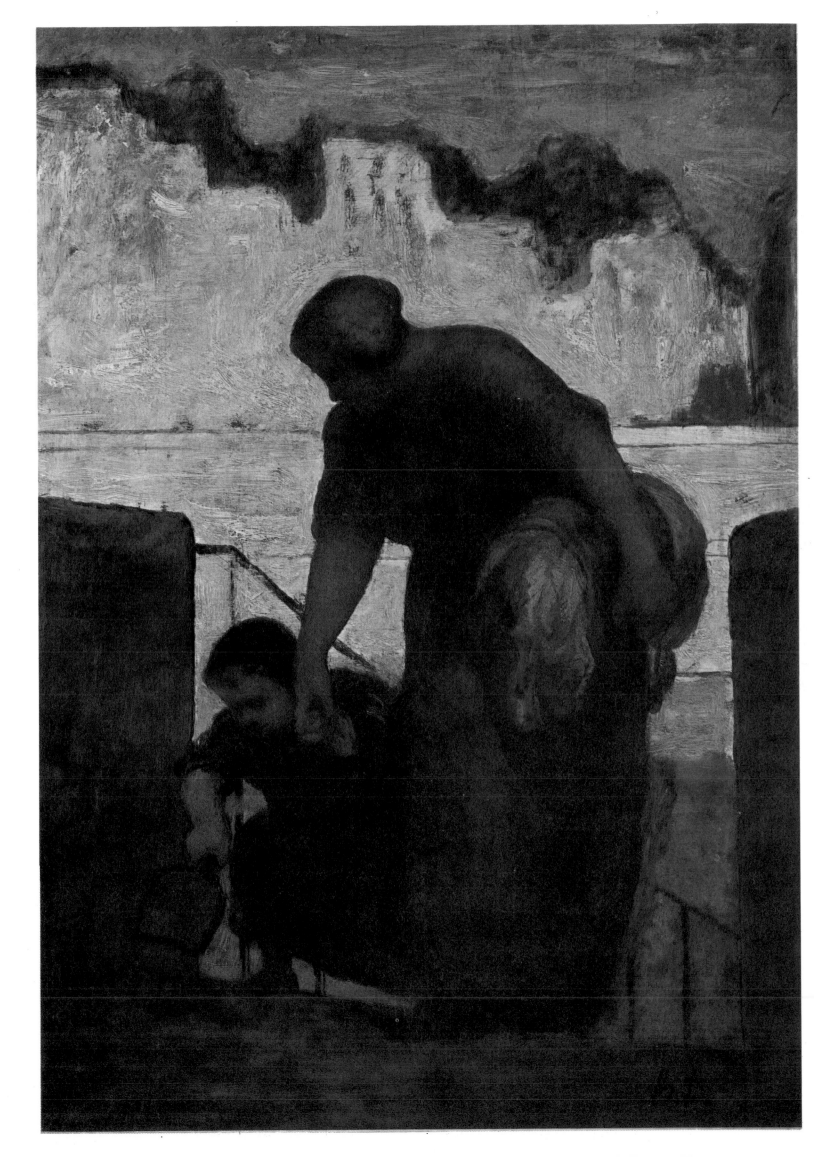

Anon.

MOTHER AND CHILD

11th cent. (pre-Columbian), terracotta, height 16" (41cm)

Collection Mr. and Mrs. Everett Gee Jackson, San Diego, Calif.

THE pre-Columbian cultures of Mexico, unlike those of the Central Plateau and the Southeast, never made a distinct break with the ancient archaic past. Nothing comparable to the monumental classical styles of the Mayas, the Olmecs, the Teotihuacáns, the Toltecs, and the Aztecs can be found in the West. The many tribal units in this area continued creating small ceramic figurines in the preclassical styles until their subjugation by the Spaniards in the sixteenth century. Although the western part of Mexico, until after the tenth century, was inhabited by a great many independent tribes, the sculptural concepts and techniques throughout the area were basically the same. Working spontaneously with clay, which was later baked, they represented practically every human activity that took place in their society.

The Tarascan figure shown here is believed to date from the eleventh century. It possesses many of the basic characteristics of the very early figurines of this western area. It is naturalistic in intention, and impressionistic in the sense that it embodies the immediate impression the artist had of his subject.

When we look at this figurine we recognize the subject at once as a seated woman holding a nursing baby. Although the artist tells us nothing we can understand about the anatomical details of this woman and child, he does nonetheless present his subject with directness and logic. If we restrict our attention to the figurine's form as it is "felt" to be, we will discover that form to be strongly unified and to include a lively group of rhythmic lines and shapes. It is the artist's involvement with these special qualities that causes his work to be in harmony with that of modern artists of our own culture, such as Picasso; anyone who can experience the spatial qualities of Picasso's art will have no difficulty in responding to such pre-Columbian sculpture as this mother and child.

EVERETT GEE JACKSON

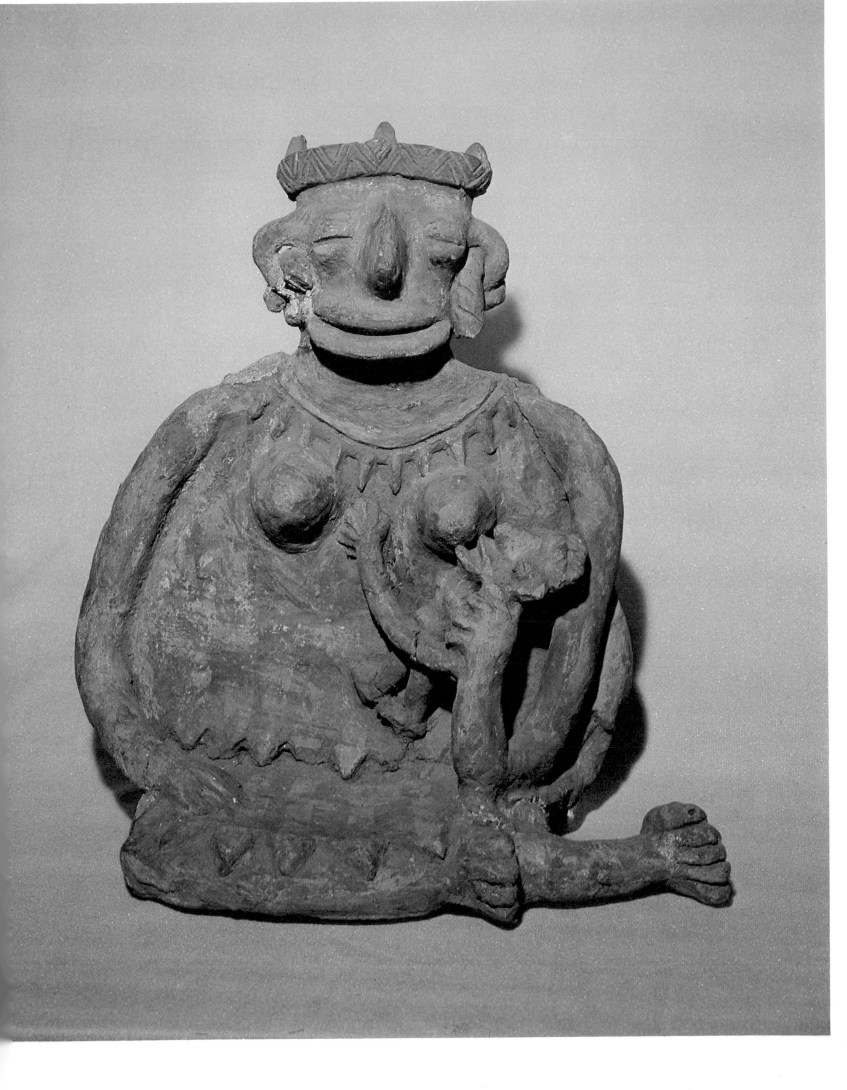

Piero della Francesca (1410/20 — 1492)

MADONNA DEL PARTO

c. 1460, fresco, 102½x79⅞" (260x203cm)

Cemetery Chapel, Monterchi, Italy

THIS beautiful pregnant Madonna is slightly less than life-size. The calm, almost Oriental face is haunting. Proud of the child within her womb, she gazes serenely out from the parted curtains held by the two angels.

A pregnant Madonna is most unusual in Italian painting. Piero painted this superb lady in honor of his mother, who is thought to be buried in the Cemetery Chapel. (What a wonderful way for an artist to pay tribute to his mother!)

This painting has a very personal meaning for me also, beyond its extraordinary beauty and charm. Here I find a reverence for the process of birth and concern for the continuity of life. Piero gives the woman with child a noble dignity that reflects both his own sensitivity and the inner world of the pregnant woman. I think every woman feels that the child she is bearing is a precious being that she is privileged to bring into the world, and Piero makes us see this sense of worth in the face and bearing of his *Madonna del parto*.

Many Italian girls, as well as tourists, journey out from Arezzo to the peaceful chapel in the countryside of Monterchi to pray. In 1954 the painting was to have been loaned for an exhibition in Florence, but the mayor of Monterchi did not want to risk sending it away. It was so venerated by pregnant women that he feared possible reactions if, during its absence, a woman might miscarry.

SOPHIA LOREN

Anon.

THE BLACK MADONNA

12th cent. (Spanish), height 36" (91cm)

Sanctuary of Montserrat, Spain

THE Madonna of Montserrat is a beautiful Romanesque carving of the twelfth or thirteenth century representing the Mother of Christ in a hieratical pose, but with an expression of great sweetness, holding the Child on her lap. The dark color of her face has given rise to the various names by which she is known to her devotees — the Black Virgin, the Dark Virgin, or more familiarly, "la Moreneta" ("the Little Dark One").

An abbot of Ripoli, Oliba, founded a monastery beside the hermitage of Santa Maria. The sanctuary-priory grew rapidly with the fame of miracles wrought there by the Madonna, and the name of Montserrat very soon became known beyond the limits of the surrounding countryside. The pilgrims of Santiago de Compostela made it known along their route, and the King of Castile, Alfonso the Wise, dedicated six of his poems to six miracles of Montserrat. Later, the Spanish imperial dynasty consolidated the cult of the dark Madonna in Central Europe and spread it westward with the discovery and conquest of America, which was linked to Montserrat by the presence at the side of Columbus of a former hermit of the mountain, Bernat Boil, the first missionary to the New World.

As one enters the Benedictine Chapel at Montserrat at high noon on a lovely day in May and participates in the mass and listens to the Esconlania (one of the most celebrated boys' choirs in the world), one feels at least halfway to heaven, as "the Little Dark One" high above the main altar seems to prompt her Son to bestow on you a very special blessing.

IRENE DUNNE

Raphael (1483–1520)

THE HOLY FAMILY (MADONNA DI LORETO)

c. 1509, oil on wood panel, 47½x35⅞" (121x91cm)

J. Paul Getty Museum, Malibu, Calif.

UNTIL the most recent times, Raphael was considered the highest summit of artistic perfection, and to many he was the standard against which everyone else was measured. He was most famous for his Madonnas and produced a series of such paintings which were so influential and so widely imitated that each of them still carries a name by which it is commonly known, such as the "Alba Madonna", the "Madonna of the chair", and so on. The present composition has a long and curious history and has also acquired such a name: it is known as the "Madonna di Loreto" because, during the eighteenth century, a picture of this description was to be seen in the famous sanctuary in that town in Italy; it was stolen during the time of Napoleon and after that everyone who spoke of it referred to it as the Madonna from Loreto.

But the earlier history of the painting is still more complex. We know that the church of Santa Maria del Popolo in Rome contained a picture by Raphael which various writers in the sixteenth century, among them Vasari, describe sufficiently to suggest that it was the same composition as that of the "Madonna di Loreto". It was done about 1509, and it was probably commissioned by Pope Julius II, because he patronized this church; moreover, Raphael's portrait of the pope hung near it. A few decades later a certain Cardinal Sfondrati took both pictures from the church; he paid for them, but he paid very little, and he was powerful enough to get what he wanted. After this time it is uncertain where the picture went, and many unsuccessful attempts were made to locate it; but most experts believe it is the painting we illustrate here. The portrait of the pope that hung near it is in the London National Gallery.

In the "Madonna di Loreto" one sees very clearly the characteristics that typify all of Raphael's Madonnas: the delicate and graceful relationships between the Child and his Mother combined with a monumentality of composition. Dozens of copies have been made from this composition, attesting to its popularity and success, and it remains one of the artist's most beautiful achievements and one of my proudest possessions.

J. PAUL GETTY

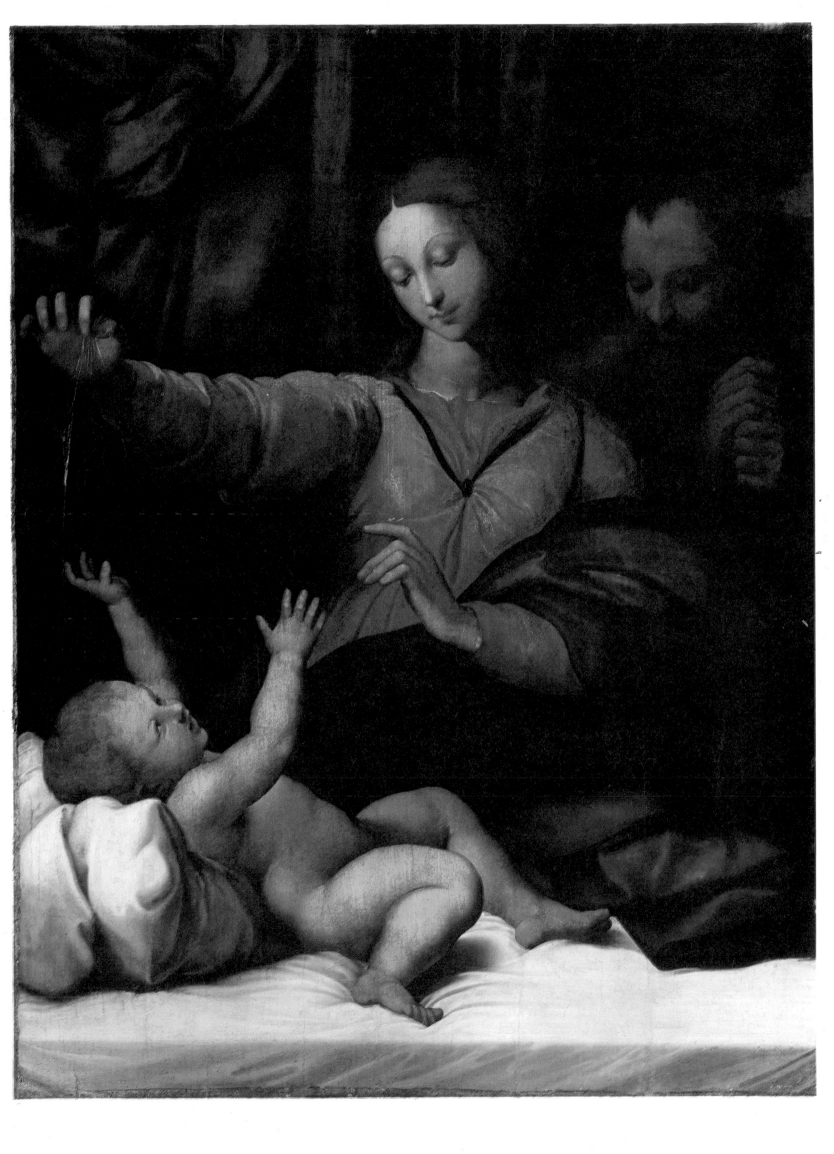

Mary Cassatt (1845–1926)

AUGUSTA READING TO HER DAUGHTER

1910, oil on canvas, 45½x35" (115.5x89cm)

Private collection

"AND the prince and princess lived happily ever after. . . ."

Are our dimpled childhood dreams born in dappled afternoon sunshine—as through closed eyes we see, and believe—the promise of a never-never land—a land we shall grow up to discover is not a foreverland?

But this little girl still believes in fairy tales. She still believes— and sees—the closed-eyes-sunbeam-dancing world *her* mother is promising her. . . .

. . . and Mary Cassatt will never let her grow up to find out otherwise—because she knows that "If you don't have a dream, you can't have a dream come true!"

EDANA ROMNEY

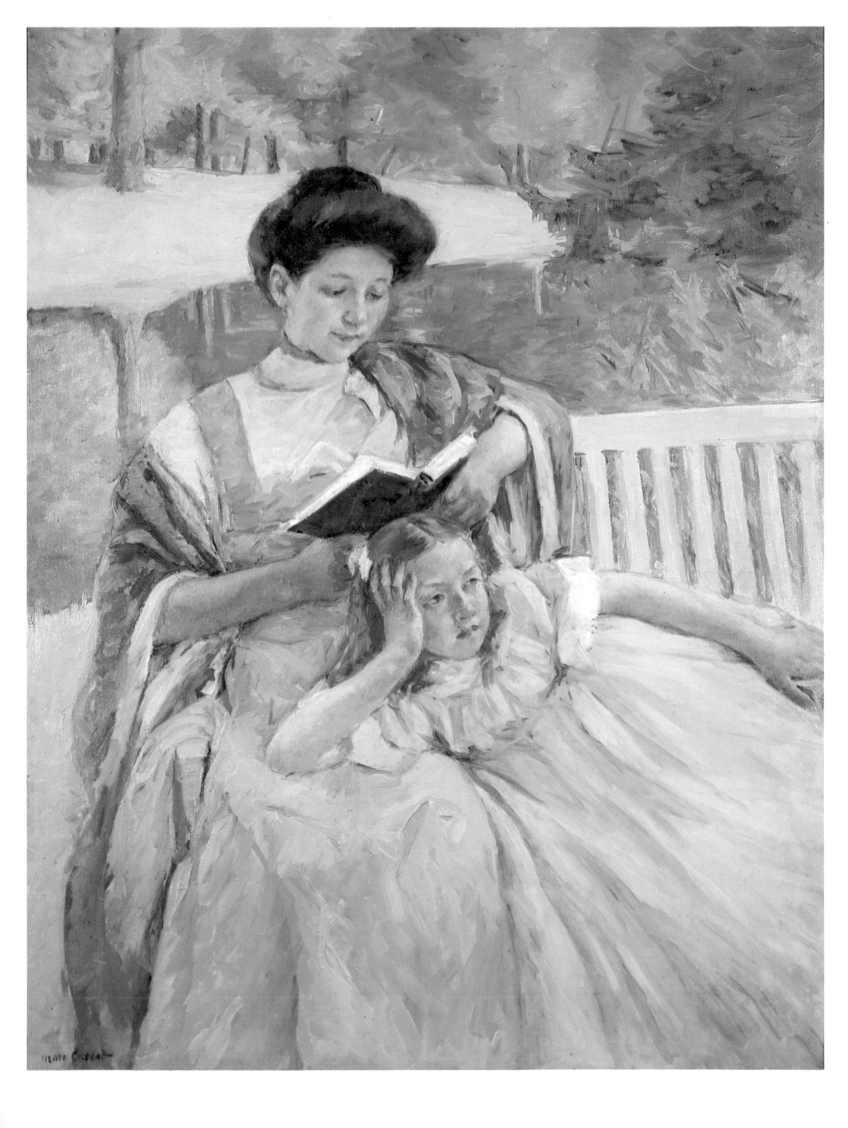

Jean Fouquet (1420 – 1481)

MADONNA AND CHILD: Detail

c. 1450, oil on panel, detail height 29½" (75cm)

Royal Museum of Fine Arts, Antwerp, Belgium

Fouquet's *Madonna and Child* is a product of an age which historian Eugen Weber has named the Age of Anachronism and Adaptation, which may help to explain why the painting is so profoundly disturbing. Framed by the strong vertical post on the left and by a succession of vertical spheres on the right, the Mother and Child are thrust into a foreground space that seems too small to contain them. Yet they scarcely touch, even by a glance. Both subjects are rigidly immobile and self-contained. Following the conventions of the late medieval hieratic tradition, this painting lacks the humanism of the renaissance.

Yet, at the center of the painting is that circle of perfection, the Madonna's bare breast, which is far more sensual than spiritual. Her half-hidden second breast is equally erotic. Moreover, she is surrounded by fleshly angels of fiery red (a color usually reserved for the demons of hell), whose faces wear disdainful and cynical expressions. The painting teases the imagination and poses questions that cannot be answered by the formal conventions of its artificial pattern or limited color range.

Perhaps the answer can be found in the few known facts about the worldly woman whose face was chosen as the model for the Virgin Queen of the Heavens. She was Agnès Sorel, mistress of King Charles VII of France. She bore the King four daughters out of wedlock and inspired passionate love, not only in the King but also in Étienne Chevalier, who commissioned this painting. But she was despised by the King's son, the future Louis XI of France. She died mysteriously, probably the victim of poisoning. None other than her royal lover, King Charles, suspected his own son, the Dauphin, of arranging her murder.

Thus, it may be the mingling of the sacred and the profane, the imposing of this blasphemous image on the face of the Virgin Queen, that provides the formal tension and the ironic content of Fouquet's Madonna. Nonetheless, this painting lingers in the memory after many images of more maternal and soft-faced Marys have faded away.

DR. REGINA K. FADIMAN

Regina K. Fadiman

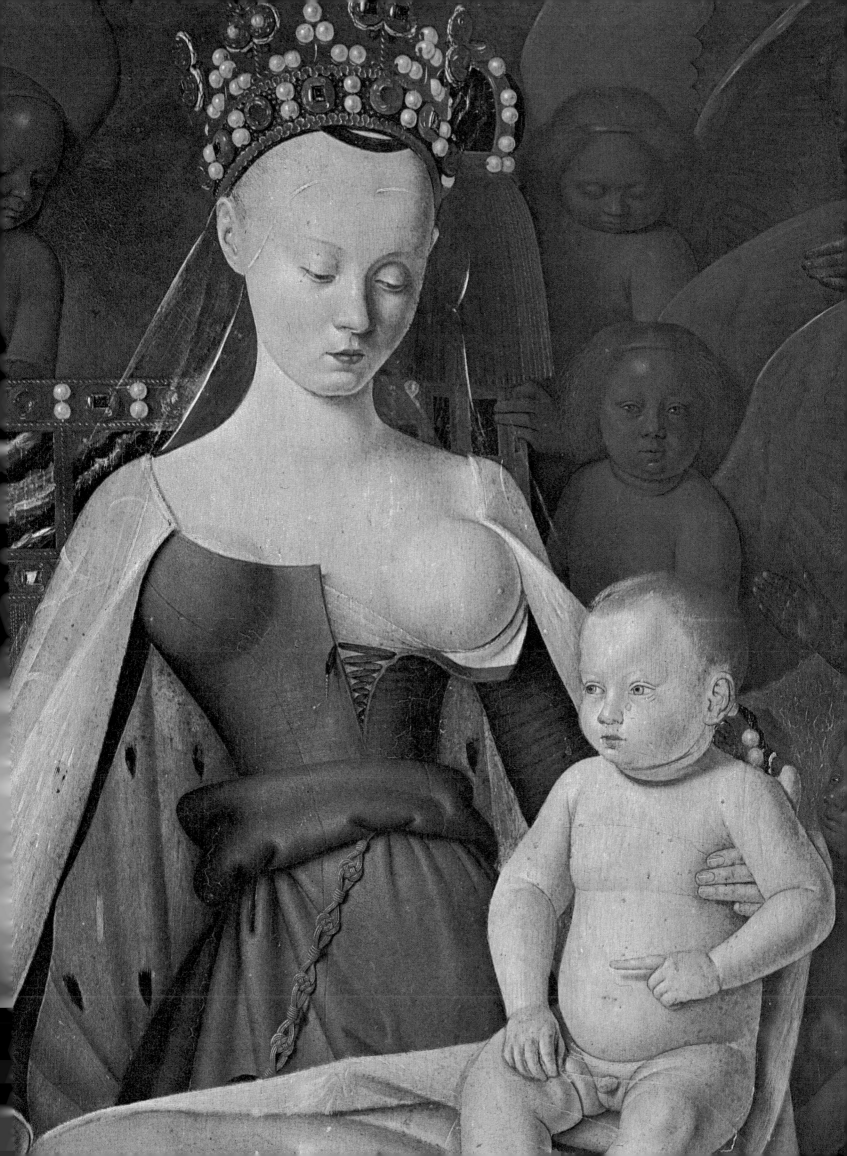

Amedeo Modigliani (1884 – 1920)

GYPSY WOMAN WITH BABY

1919, oil on canvas, 45⅝x28¾" (115.5x73cm)

National Gallery of Art, Washington, D.C., Chester Dale Collection

166

IN 1920, at the age of thirty-six, Amedeo Modigliani died of tuberculosis and pneumonia in the Hôpital de la Charité in Paris. Thus ended a life of poverty, suffering, anger, and excess. The inner man, however, lives on in his paintings. Poet and artist, sensitive and seeking, imbued with psychological insight, he was able to capture the mood of the working-class people he normally painted. Where many of his contemporaries frequently painted landscapes and still lifes, Modigliani concentrated almost exclusively on the human form, expressing with a direct linear style the countenance of people dealing with the hard realities of life. In the year after his daughter was born, and the year before his death, *Gypsy woman with baby* was painted. The mother sits, clasping her baby firmly with large, inelegant hands, protectively, contentedly. The baby, bundled in cap and blanket, turns toward her, relying on her strength. The gypsy's clear, direct gaze exudes satisfaction without sentimentality, tenderness, and resigned tranquillity in the achievement of motherhood.

PHILIPPA CALNAN

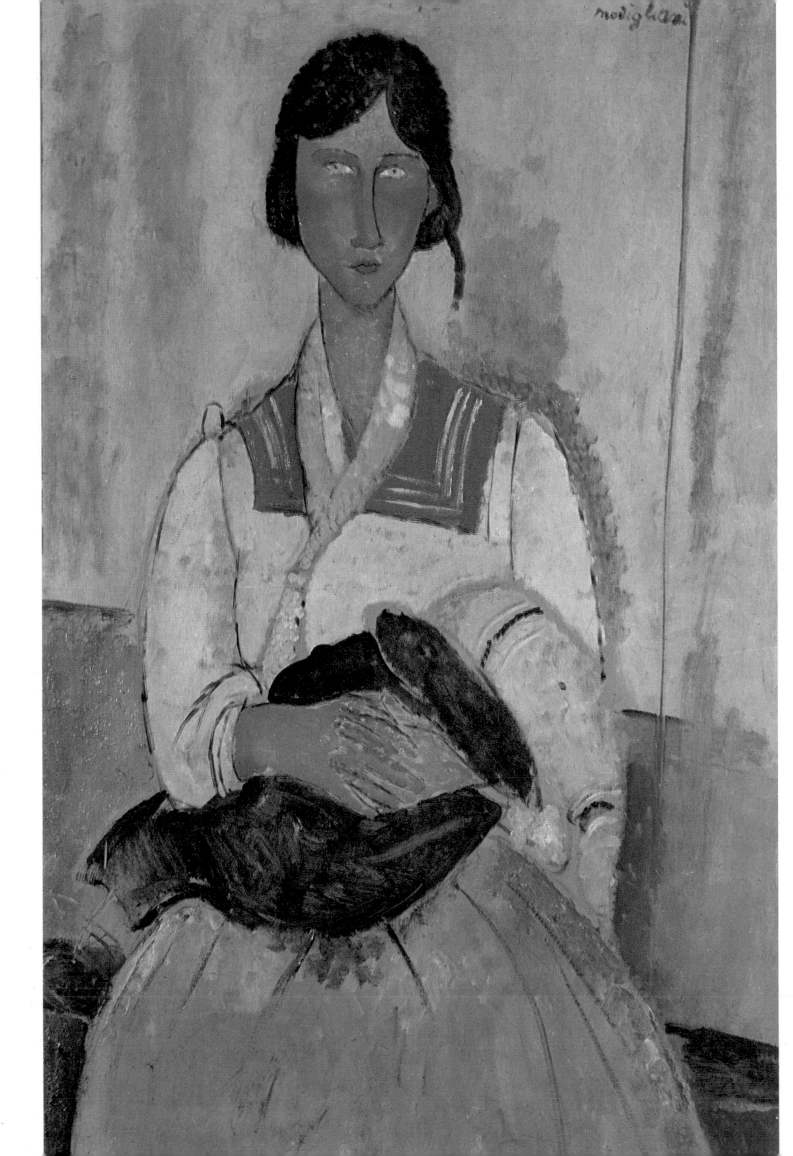

Antonello da Messina

MADONNA AND CHILD

c. 1462, oil on wood panel, 17¼x13¼" (44x34cm)

National Gallery of Art, Washington, D.C., Andrew W. Mellon Collection

FOR five centuries this renaissance *Madonna and Child* lived in darkness. It was little respected, held in small value, and disregarded.

In London, in the early 1930's, a man named Robert Benson saw it, liked it at its price, and bought it for less than $100. Eventually, because at that time he was shown almost all renaissance pictures, this painting was shown to Bernard Berenson, who identified it as the work of Antonello da Messina.

Antonello lived in a generation of naturalists. He was himself a forceful realist. The time demanded pyramidal form: Antonello complied. But he did not make a structure of stone; he used the pyramid to create intimacy, to communicate warmth and love.

The figures are unique to the fifteenth century; the gesture of the child touching his mother is an expression of serenity in a hundred years of struggle. The limpid face of the Madonna is typical: there is nothing of the abstracted ecstasy of the Saint, only the simple quietude of innocence against a placid sky — perfect space for the wonderfully luminous eyes of the Baby and the intensely human closeness of the encircling arms. Touching, feeling, clasping, the fiercely strong curve of the Mother's fingers around the Child, cheek touching brow, all excruciatingly and sublimely loving, encircling, making circles of love, taking us back to the eyes of the Baby. Does he look at you? Not quite? Look again. Yes, yes, he does! No wonder we are so drawn, involved, invited to join the circle of love, his love, for eternity.

Berenson saw, and now we see too. In 1937 this *Madonna and Child,* its authenticity guaranteed by the great scholar of the renaissance, was bought by Andrew Mellon and donated to the National Gallery. It no longer cost $100.

DONNA REED

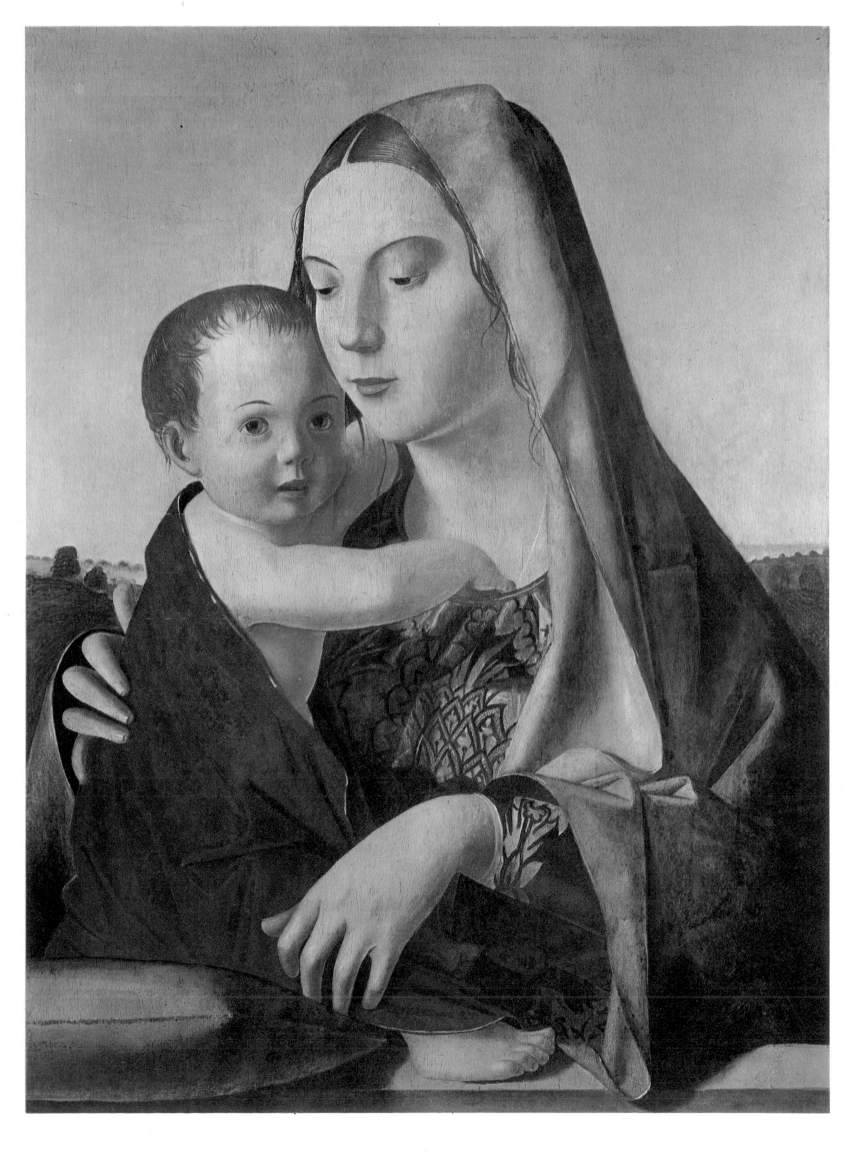

Rembrandt (1606–1669)

HOLY FAMILY WITH ANGELS

1645, oil on canvas, 46x35¾" (117x91cm)

Hermitage, Leningrad

IN his early years, Rembrandt Harmensz van Rijn was generally thought to be ill-mannered, selfish, and something of a libertine. Some said he had one love, and that was for the guilder. But all this is excused in the light of his tremendous talent. At twenty-eight years of age he married Saskia van Uijlenburgh; from that moment his manner and behavior seemed to change, and I think his work became more perceptive and humanitarian — gentler.

In 1642 Saskia died and three years after that sad event Rembrandt painted this picture. There is so much kindness and concern in it, so much quietness and warmth that it could have been painted only by a man in whom these feelings dwelt. The wondrous burst of light upon the Child is so golden, warm, and mystical; the expressions of concern upon the faces of the cherubim and the hushed watchfulness of the Mother instill in one a feeling of great comfort and peace.

I have seen this picture only once — at the end of a long, dreary journey from Khabarovsk at the Pacific end of Russia-in-Asia (with many stops) to Leningrad. In the Hermitage, one glimpse of this radiant vision of mother love made the whole dismal trip seem worthwhile.

RAY MILLAND

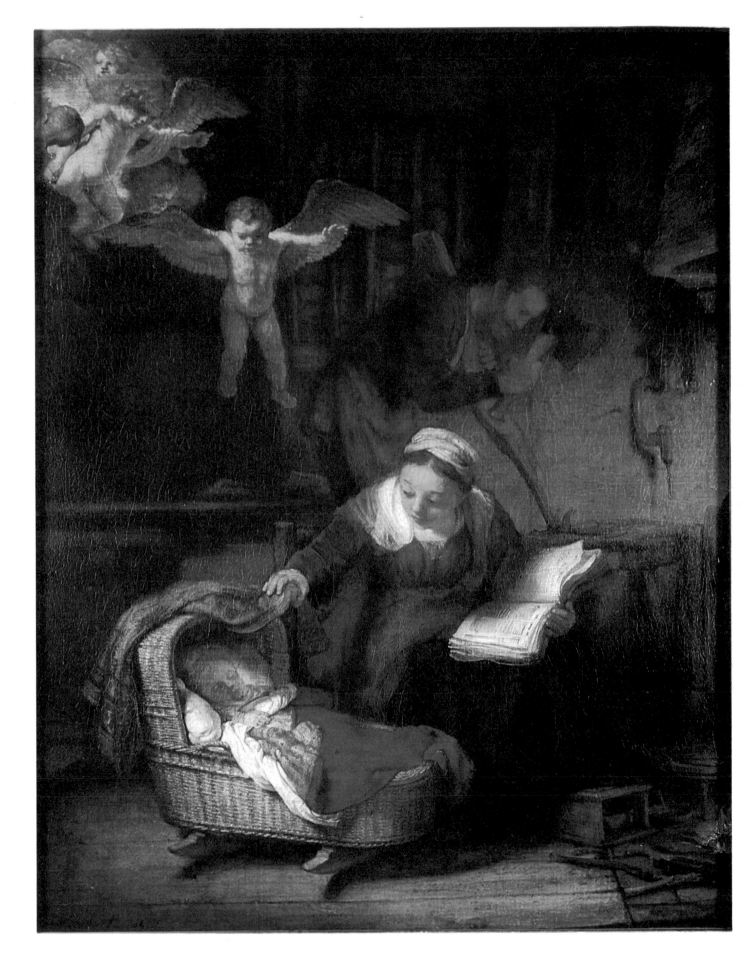

Thomas Hart Benton (1889–1975)

RITA AND T.P.

1928, oil and tempera on canvas, 33x25" (84x63cm)

Collection Rita Benton, Kansas City, Mo.

Sculptures, paintings, drawings representing a mother with her baby are found almost as far back as the first records of man's life on this earth. They are, in fact, a rather considerable part of these records, appearing symbolically in religion after religion over thousands of years, expressing sometimes divinity, but always love and wonder at the continuity of life.

So, there is nothing novel about this painting.

Except—except for me who painted it and for the mother who posed for it.

Mothers by the thousands have had sons by the thousands—and by the millions too. The arrivals of these are, however, always unique for particular mothers, and for particular fathers also, who contribute to their arrival. This painting is then a personal novelty, even though it repeats what has been done over and over again.

The form of the painting is a derivative of the Catholic Madonna-and-Child paintings of the Italian renaissance. This is obvious but appropriate because my wife is Italian. The scene in the background is the island of Martha's Vineyard and the sound separating that island from the mainland. The time is the summer of 1928. The baby is eighteen months old. Never mind about the mother's age.

THOMAS HART BENTON

Thomas H. Benton

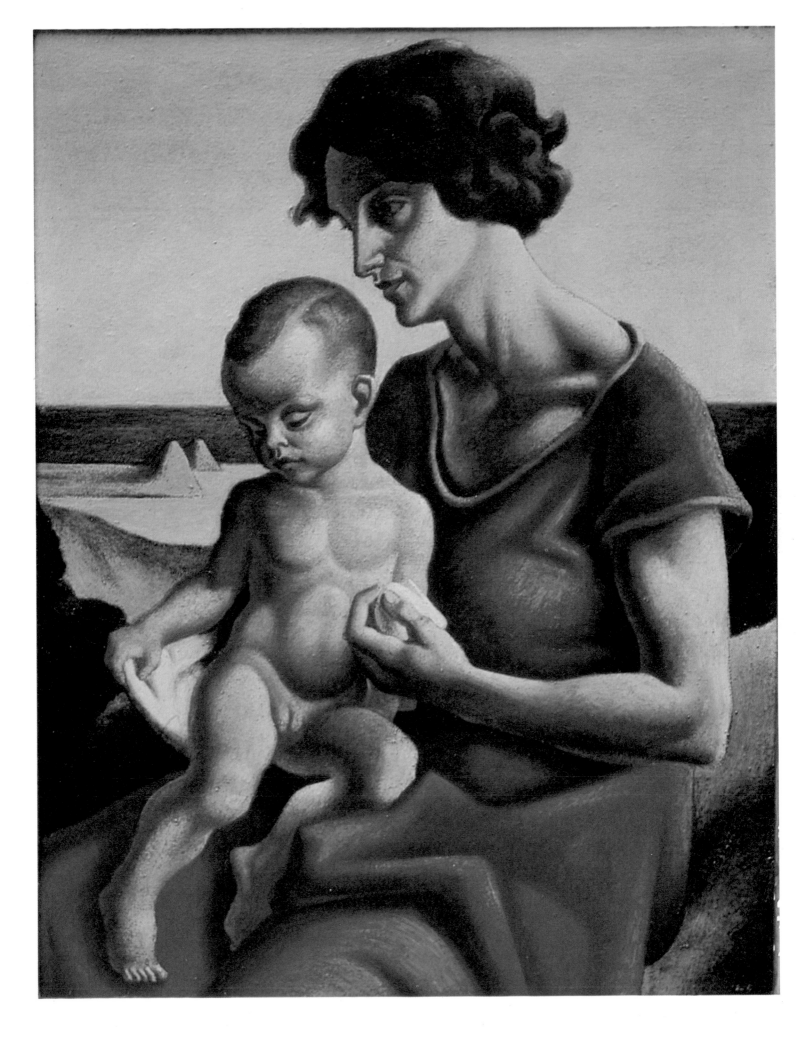

Berthe Morisot (1841–1895)

THE CRADLE

1872, oil on canvas, 21½x18" (55x46cm)

Jeu de Paume, Paris

Berthe Morisot was born in Bourges in 1841, and she studied painting in nearby Lyons with Guichard, who was a student of both Ingres and Delacroix. Then, through Guichard, she met Corot and painted landscapes with him. Later, Berthe and her sister, Edma, were copying Rubens' work in the Louvre. There Berthe met Edouard Manet, who had a great influence on her work. She became his close friend and eventually married his brother, Eugéne. It was Berthe who posed for Manet's painting *The balcony*. She was also a friend of my husband's grandfather, Baron Pellenc.

By 1874, Berthe was in the center of the impressionist movement, and several of her pictures were shown at the famous first exhibition of this new group held that year in Paris in the studio of Nadar, the photographer. From then on she and her sister continued to paint as they pleased, sharing with their fellow rebels the general sarcasm and criticism aroused by their work. Berthe Morisot was a painter at all times—picking up, then putting down her brushes as another would pick up and discard thoughts. To quote her cousin, the great poet Paul Valéry, "Berthe Morisot lives her painting—and paints her life".

The cradle is typical of this ability to seize and record a precious moment from life. It is a portrait of her sister, Edma Pontillon, watching her sleeping baby, Blanche. There is a haunting expression of awe and wonder on the mother's face as she stares through the gauzy transparency of the bassinette curtain. The painting radiates warmth, light, intimacy, and tenderness—all expressed with the sensitivity which is the essence of Impressionism.

BARONESS FRANCES PELLENC

Frances Kier Pellenc

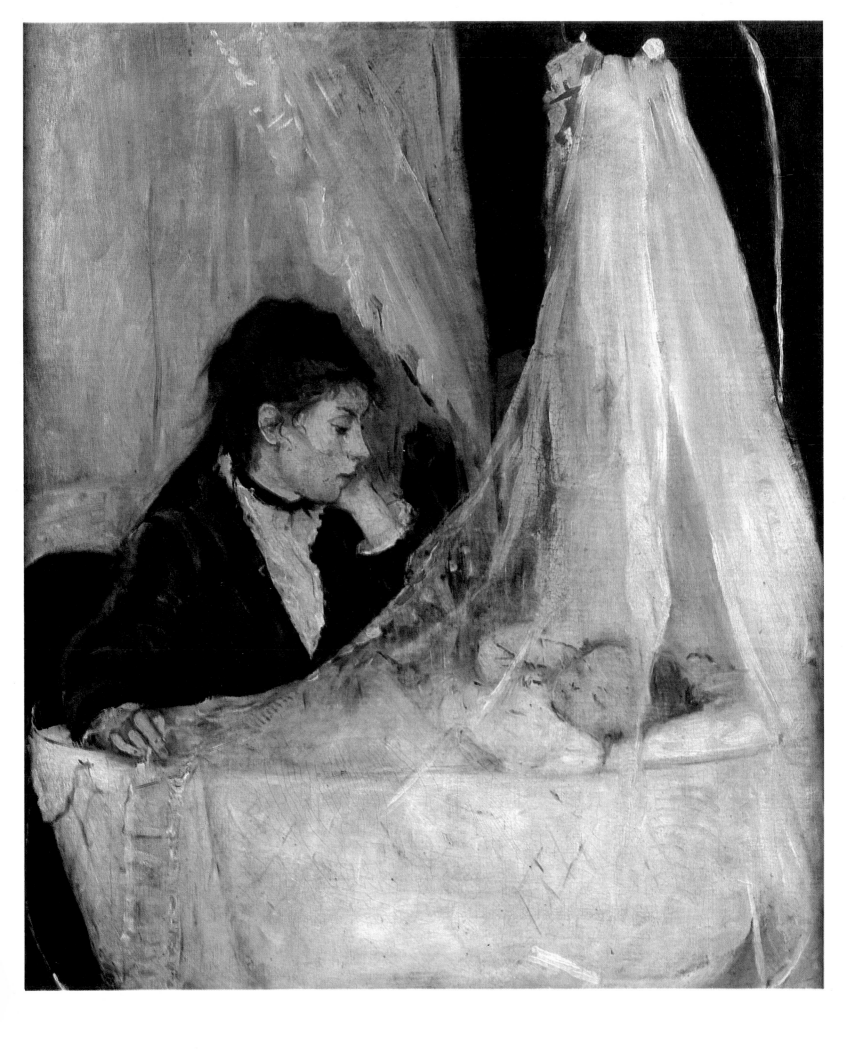

Andrea della Robbia (1435 – 1525)

MADONNA ADORING CHILD

glazed terracotta, 86⅝x59" (220x150cm)

Cathedral, Arezzo, Italy

Like his renowned uncle and mentor, Luca, Andrea della Robbia was born in Florence and died there, thus perpetuating the Florentine ambience of the della Robbia family. Even though the Bottega della Robbia was eventually accused of popularizing Luca's glazed terracotta technique and subject matter almost to the degree of mass production, Andrea nonetheless created a personal style.

In this work we see a very different treatment of the Mother and Child, compared with that of Luca's, or Andrea's, followers. Here there are not the lush garlands of flowers and fruits, the striking azure blue backgrounds setting off the marble-like pristine white of the figures, nor the fresh greens of spring and yellows of sun and flowers. Instead, we find a somber but elegant—one might even say a more sophisticated—treatment or use of color in this architectonically circumscribed composition. A deep, dark, almost prussian blue provides the background, as if it were a night sky painted on a canvas. A deep, rich moss green cradles the Child. The shadows of the off-white glaze of the figures blend subtly with the browns of the cobblestone design of the ground and with the rich earth colors of the elegant marble columns.

In this beautiful altarpiece Andrea presents Mary not as the Queen of Heaven replete with jewels and halo as in many works of the renaissance masters, but as a figure full of expressive tenderness—a mother, barefooted and kneeling humbly before the splendor of her newborn Child.

ELIZABETH JONES

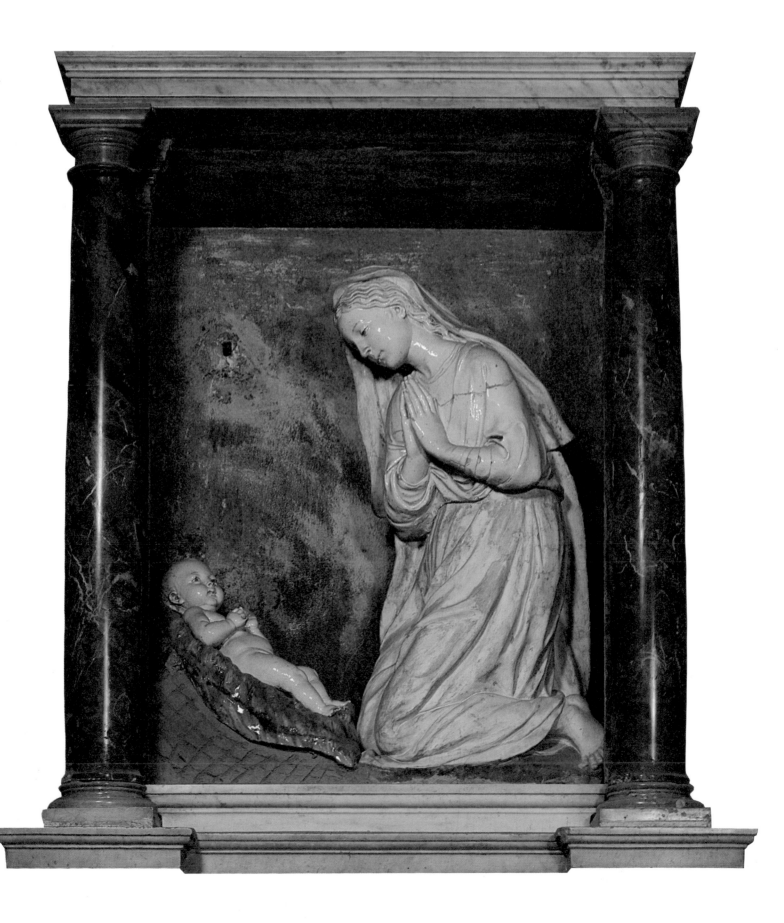

Pierre Bonnard (1867–1947)

THE THREE AGES OF WOMAN

1893, oil on canvas, 18¼x13" (46x33cm)

Collection Natalie Wood Wagner, Beverly Hills, Calif.

FIRST saw this painting by Pierre Bonnard hanging in a room in the Wildenstein Gallery in New York, which was filled with only his work. I did not know then that it was painted when Bonnard, Vuillard, Denis, and others were members of a group called the Nabis (the prophets). I did not know that it showed the son of Claude Terrasse, his mother, and grandmother. I did not know that Claude Terrasse married Bonnard's sister, Andrea. What I *did* know was that it reached for me, and I bought it.

That was ten years ago and I was unmarried, with no children. Yet, all that is in this work of art was familiar to me; without knowing exactly when, how, or why Bonnard painted it, as far as I was concerned, he had painted it just for me.

Afterward, when I traveled a great deal, often living in different countries, this painting always came with me, so that I felt at home wherever I lived.

And now I have my own two children, one still a baby, and my mother often looks at us in this way, as grandmothers have looked at their daughters with their babies from the beginning. So this painting, which captured my own wish, has come true for me.

NATALIE WOOD

Natalie Wood

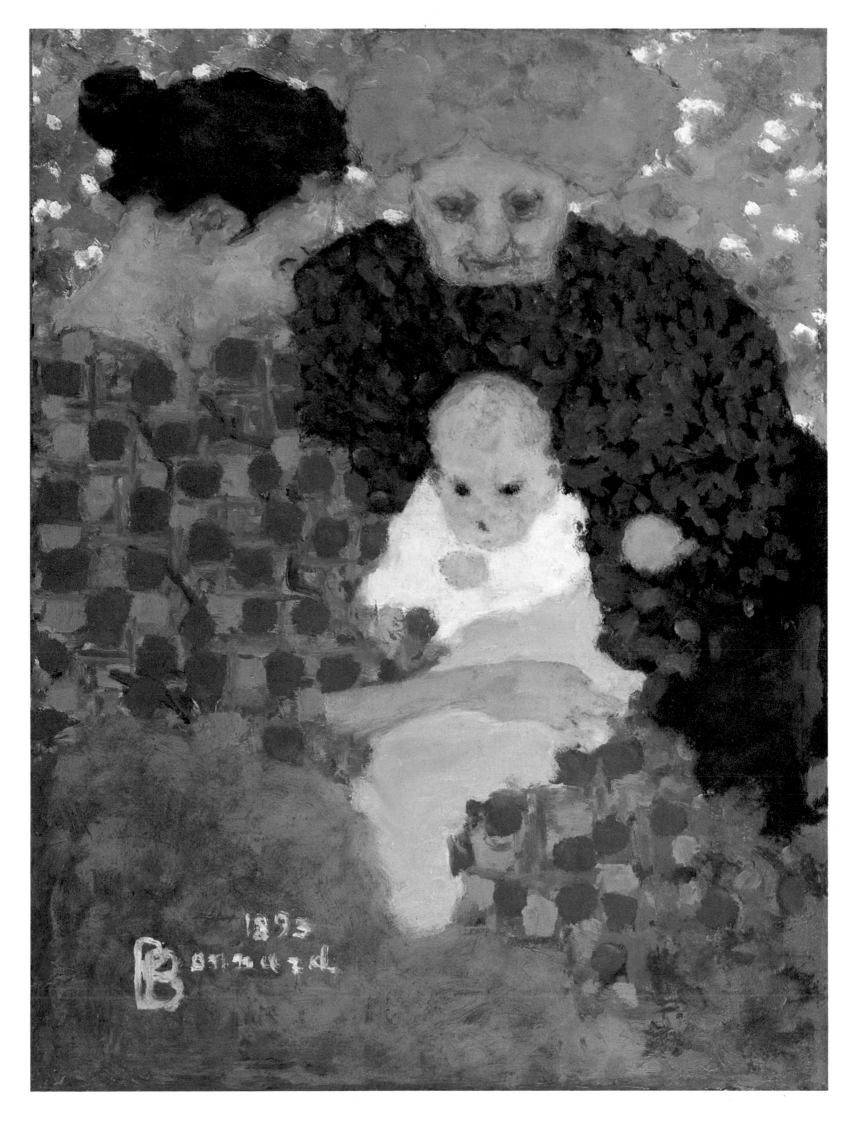

Diego Velázquez (1599 – 1660)

ADORATION OF THE MAGI

1619, oil on canvas, 79⅞x49¼" (203x125cm)

Prado, Madrid

THE three Magi are named Melchior, Gaspar, and Balthazar.

My name is Melchor. I am of Spanish origin. And I have a house in the province of Málaga, not far from Seville, the birthplace of Velázquez.

All reasons for my particular veneration of this painting.

The intensely Spanish ambience, the silver gilt cups of Sevillian workmanship in the hands of the Magi, the Latin cast in the heads of the three Kings as well as the Joseph, and the rich crimsons, blues, and rose of the draperies and doublets bespeak Spain.

But in addition to my obvious bias, the picture draws me particularly because of the alert repose of the principal figure—the Child. The serenity, the contemplation, the strength of the Infant, are quite exceptional.

This is no Babe in swaddling clothes. There is an eternity in the eyes, a calm and strength in the straight little back. And Mary's hands cup him possessively, without lending any support.

Technically, the composition seems almost compressed. A lithograph done by Cayetano Palmaroli shows more of what must have been turned under when framed. In the lithograph, Palmaroli shows that Velázquez gave more space to the figures at the left, and Joseph in his Moorish archway is more visible, adding a balancing element to the overall structure.

The picture hangs in the Prado and is lit by the direct clear light that comes from this extraordinary museum's skylights. But the soul of the painting is the south of Spain, Velázquez's world of Mudejar architecture, Oriental colors and textures, and the noble heads of the Spanish people.

MEL FERRER

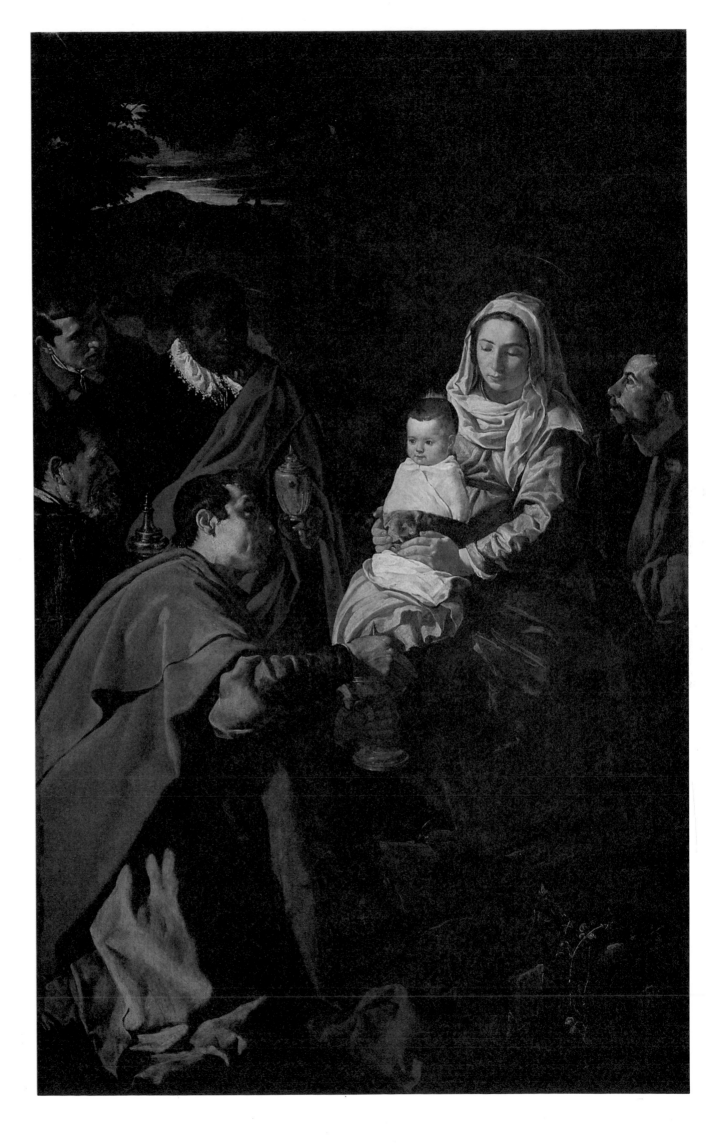

Chaim Gross (b. 1904)

MOTHER PLAYING WITH TWO CHILDREN

1957, bronze, width 24" (61cm)

Collection Mr. and Mrs. Red Grooms, New York

ARTISTS during all centuries have been inspired by the mother-and-child theme because, like art, it is love and it is forever!—for it is the flowering of life! To me, art is love and humanity in all its manifestations. The eternal mother-and-child theme lends itself gracefully and plastically to the creation of sculpture, drawing, and painting of joy and beauty.

Over the years at the beaches of Cape Cod I have observed the movements of mothers and children at play, and was inspired by the variation of form and rhythm of their bodies. I have made hundreds upon hundreds of drawings and watercolors as well as created sculpture in wood, stone, and bronze, of mothers and children—often simplifying or distorting in order to emphasize balance and to dramatize certain major movements, because the immediately sensed rhythm of the body is a vital part of my work. There is a continuous and expressive interplay between the natural bodily movements and the abstract play of line and curves.

Mother playing with two children is one of my happy sculptures. Frequently, while watching a mother caring for a child, I have wondered about the problem of a second child close in age. In this statue I have tried to create an imaginative solution with a harmonious, balanced composition including two children happily at play with their mother.

CHAIM GROSS

CHAIM GROSS'S sculpture is a Love-in-Action excitement that excites me into saying:

> I learned about Love
> and its finer points
> on my Mother's knee
> and other low joints.

DR. SEUSS

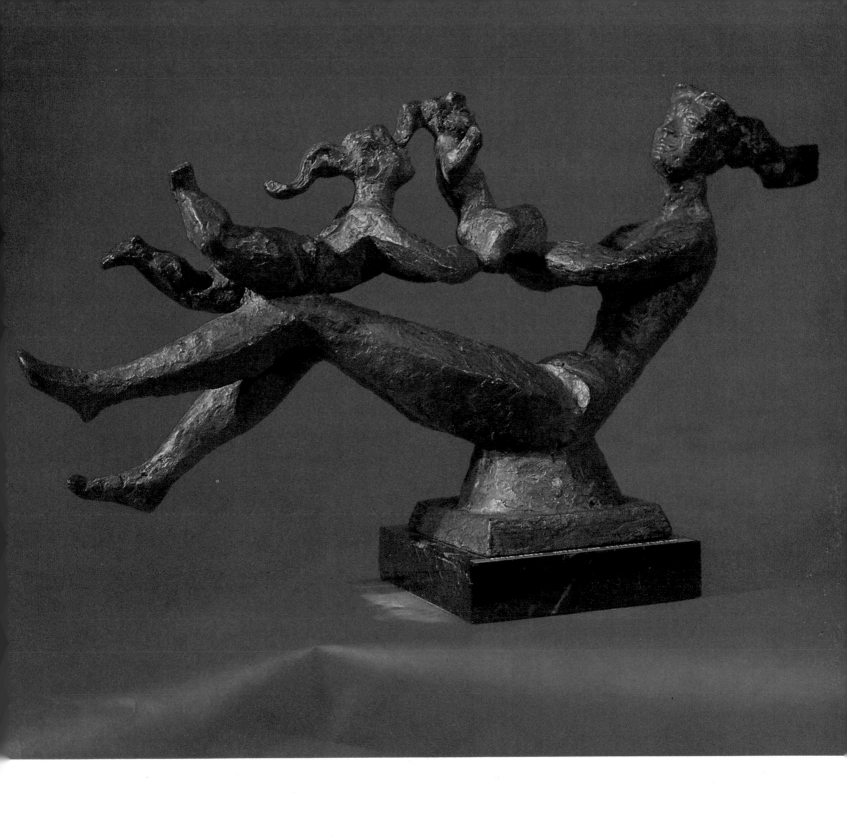

Titian (1490–1576)

MADONNA AND CHILD

c. 1550, oil on canvas, 29³/₄x24⁷/₈" (75.5x63cm)

The National Gallery, London

TITIAN'S *Madonna and Child* might as well have been called "Mona Lisa and Child". Take the Child from her lap, and the face which the Mother bends upon her Babe has in it all of the Mona Lisa's subtle combination of pleasure and foreboding. And foreknowledge? Does the Mother who suckles the Child anticipate for him the cross?

What do the faces of any of the Madonnas reveal when examined with the conscious exclusion of the Child in their arms?

This is, of course, a writer's view of a painting. But the minute a painter entitles his picture *Madonna and Child* he is telling a story; and a viewer must be color and form conscious indeed not to be aware of that story.

The viewer can, this one does, respond to the blues and browns, the flesh tones with so much brown in them, the sculptured plasticity of the folds of the dress—but it is the Mother's face, the apex of the triangle made by the ample curve of the dress over her buttocks and the Child's body on her lap, which holds the eye.

We know the story to come; and on her face that story has already cast its shadow of love and suffering. In the brush that painted this picture there was, in addition to the artist's skill of hand, a heart that understood the human condition and the imprint it leaves on flesh.

JESSAMYN WEST

Dirk Bouts (1415/20 – 1475)

MADONNA AND CHILD

1465, oil on wood panel, 10¼x7¾" (26x20cm)

M. H. de Young Memorial Museum, San Francisco, gift of the Roscoe and Margaret Oakes Foundation

DIRK BOUTS was responsible for numerous innovations in portraiture, still life, and, especially, landscape. His quietly created, subtle revolutions are significant in the development of Naturalism and/or Humanism. For example, although he was hardly the first to paint a portrait, he was the first to portray a man beside a window open to the landscape in which he lived. His idea of nature was broad and deep, and he obviously loved to paint landscape for its own sake. With unprecedented sensibility he painted the robust colors between night and day, the changing light of the passing sun, the flowering of the earth, and the waving motions of the sea. Moreover, he seems to have been the first painter of the Netherlands to populate the landscape with figures in a single perspective. Thanks to Bouts, mankind and the environment started to be thought of as intimately interrelated equals.

The medieval tradition of presenting the Madonna and Child was derived from Byzantine concepts of otherworldliness. The Infant as Savior was often endowed like a miniature man with the miraculous power to hold up symbolic objects and raise his hand in blessing. The Madonna also was usually seen as a distant, abstract goddess. In the more natural styles that preceded Bouts, representations of the Madonna and Child continued to have one or the other facing out at the viewer with superhuman remoteness in their faces and gestures.

Bouts turned his back on the unworldly, rendering images of the divine with which every individual could identify. Instead of a lavishly bejeweled Queen of Heaven holding the Redeemer of Man, we have before us two supremely beautiful human beings—a loving mother and a loving child. They are situated not against a sea of gold, or a field of angels, or a frame of moralizing sculpture; they are bathed by the same natural light that illuminates the simple, solid realism of the tapestry behind them. She wears richly colored but modest garments. Around her head is neither halo nor crown, but a lovely, unpretentious band of pearls. The Madonna and Child do not assert their authority by staring outward. Instead, perhaps for the first time in Northern art, they gaze deeply into each other's eyes, as if sharing the wonder of their common divinity and their common humanity.

F. LANIER GRAHAM

Giovanni Segantini (1859 – 1899)

THE ANGEL OF LIFE

1894, oil on canvas, 108½x83½" (276x212cm)

Gallery of Modern Art, Milan

SEGANTINI has captured in this painting the mood and feeling that Sir James Barrie created when he wrote *Peter Pan*. These two gifted men—the Italian Segantini and the Englishman Barrie—never met, yet their sense of fantasy was remarkably parallel. I had the privilege of playing Peter Pan—and the stardust that Peter sprinkled in the theater is also here in this painting. The mother in the picture could be Wendy, and surely the lost boys are hiding behind her, with Never-Never Land beyond.

Segantini's early work is classically representative. He became a part of the Art Nouveau movement and became very popular in his time. He was absorbed in and repeated the theme of mother-and-child many times with many variations. This one, called *The Angel of Life,* uses the growing, spreading tree to represent nature itself. The tree, symbolically, seems to hold the mother and child in its arms. The delicate blues, grays, and flesh tones are haunting.

I am moved when I see this painting, for it represents the magic of life that I feel.

MARY MARTIN

Anon.

MOTHER AND CHILD

n.d. (South Pacific), painted wood, height 16″ (41cm)

Museum Volkerkunde, Basel

THIS charming figure of a mother and child comes from the islands of the South Pacific, a location dear to me because of the musical show of that name. It seems that it is a unique piece. I'm told that it was found in the Admiralties but it may have come there from somewhere else. According to a friend of mine who knows the region very well, the rather amusing position of the baby on the mother's head is not really like the practice of the Admiralty Islands sea people. However, I understand that the style of carving and the painting in orange-red and white is typical of the Admiralties, so perhaps this was made by some carver with a sense of humor and a desire to break away from conventions. (When I first saw this piece I could not help wondering if the ferocious expression on the mother's face is due to her wanting to "get that man right out of my hair!") Whatever the artist's intentions may have been, he has produced a mother and child that is as intriguing and engaging as the people of that lovely region have always seemed to me.

RICHARD RODGERS

Carlo Crivelli (active 1430—1494)

MADONNA AND CHILD

1490, tempera, 18½x13½" (47x34cm)

The Victoria and Albert Museum, London, James Bequest

THE homely, somewhat petulant little face on this Child is, I find, enchanting—the opposite of the radiant visage one would expect to find in a religious painting of the fifteenth century. I find equally delightful the sophisticated sideways-glancing face of the Mother. There is, in short, an uncannily modern look to this 400-year-old work of Crivelli's, and an uncannily nonreligious look to it as well. One would not be surprised to see this lissome mother stroll into a chic dinner party tonight in London, Paris, or New York, dressed as she is now in her magnificent gold caftan.

Part of this contemporary air comes, I am convinced, from Crivelli's razor-sharp precision as a craftsman and part from his sure sense of the dramatic. (Why else the golden apple held by the Child? *You* may say it symbolizes Eve's temptation; *I* say it shows Crivelli's desire to startle the viewer.) Critic John Canaday put his finger on what I mean: "Crivelli's manner . . . sometimes seems an affectation, yet he remains a fascinating painter".

However, there is more: Christopher Morley once wrote, "A man's mother is so tissued and woven into his life and brain that he can no more describe her than describe the air and sunlight that bless his days". There is an elusive feeling of such unspoken tenderness about this portrayal of the Mother and Child—despite its sophistication.

ELEANOR HARRIS

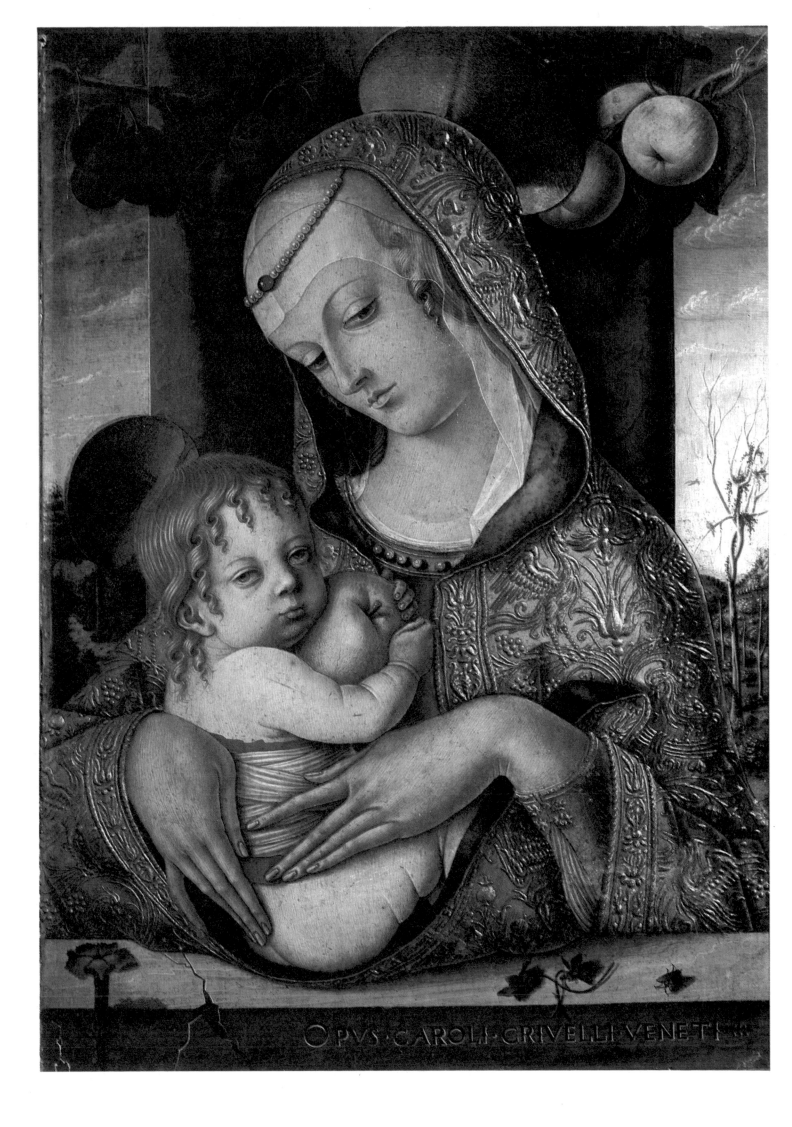

OPVS·CAROLI·CRIVELLI·VENETI·

Henry Moore (b. 1898)

MOTHER AND CHILD WITH CROSSED FEET

1956, bronze and wood, height 10" (25cm)

Collection Mr. and Mrs. Richard Rodgers, New York

THIS beautiful bronze is small in size but heroic in concept. It speaks to me of the selfless love of a mother for her child. The parent is rare and truly blessed who can, without becoming overprotective, encourage the child to grow and develop with self-confidence, who can permit the child to make—and learn from—his own mistakes.

In Henry Moore's *Mother and child with crossed feet* the sculptor has mounted the work with grandeur—on a pinnacle scaled to elevate the figures above the ordinary. The mother's arms encircle the child with love, not touching, not restricting nor possessing, leaving the child free to explore, free to stand on her own—free even to fall, unafraid, knowing that her mother is there, ready to protect her from harm. The child, trusting and secure, reaches out toward her mother, sure of the warmth of her love.

DOROTHY RODGERS

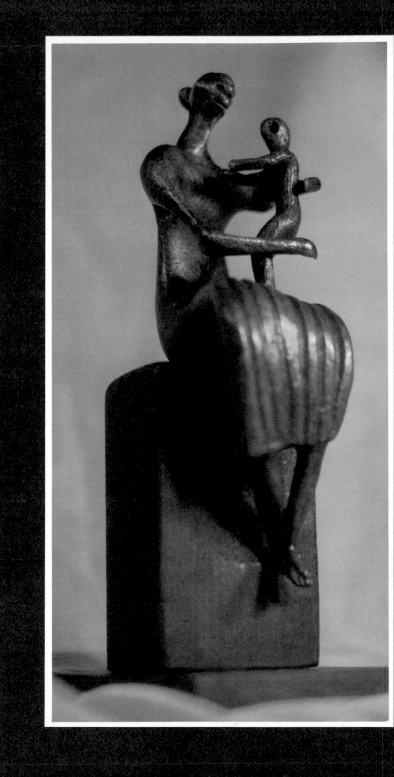

Anon.

MADONNA AND CHILD

12th cent. (French), stained glass, 24'7"x7'10" (750cmx240cm)

Cathedral, Chartres, France

THE origin of the making of glass is so remote as to be lost in legend. But the making of stained-glass windows is a comparatively new art, belonging wholly to the Christian era.

In the lovely Cathedral of Notre Dame at Chartres we marvel, as visitors have marveled for eight centuries, at the uncanny varicolored light, more felt than seen, that seems to float down from the 173 stained-glass windows whose glory has never been matched. For many, the supreme achievement of these windows is "Notre Dame de la Belle Verrière", possibly the most famous window in the world.

This stained-glass Madonna and Child is placed in the south ambulatory between great flanking buttresses, causing cool shadows on its brilliant lighted areas. Rarely is the surface of this window untouched by shadow—even on a sunny day. Charles J. Connick says, "a stained-glass window is the color of the weather. It is at the mercy of light and of all that happens in the path of its light".

The medieval world was aware of the singular nature of the art of stained glass, and its literature tells of the mystical meaning attached to it. It compared light passing through a stained-glass window to the divine Word that transfigured the body of the Virgin. It saw in glass a substance composed of mineral elements rendered transparent by fire, a symbol of the human body made of earthly and perishable matter, but bearing a soul through divine grace.

The light, limpid blue of the Madonna's figure against the more opaque red background, holding her Son upon her knees, crowned by angels, is an unforgettable sight. This work is perhaps nobler than anything Cimabue himself ever painted, enabling us to understand the Madonna's immortal maternity and this childbirth which touched her body no more than the beam of light injures the glass in its passage.

LORETTA YOUNG

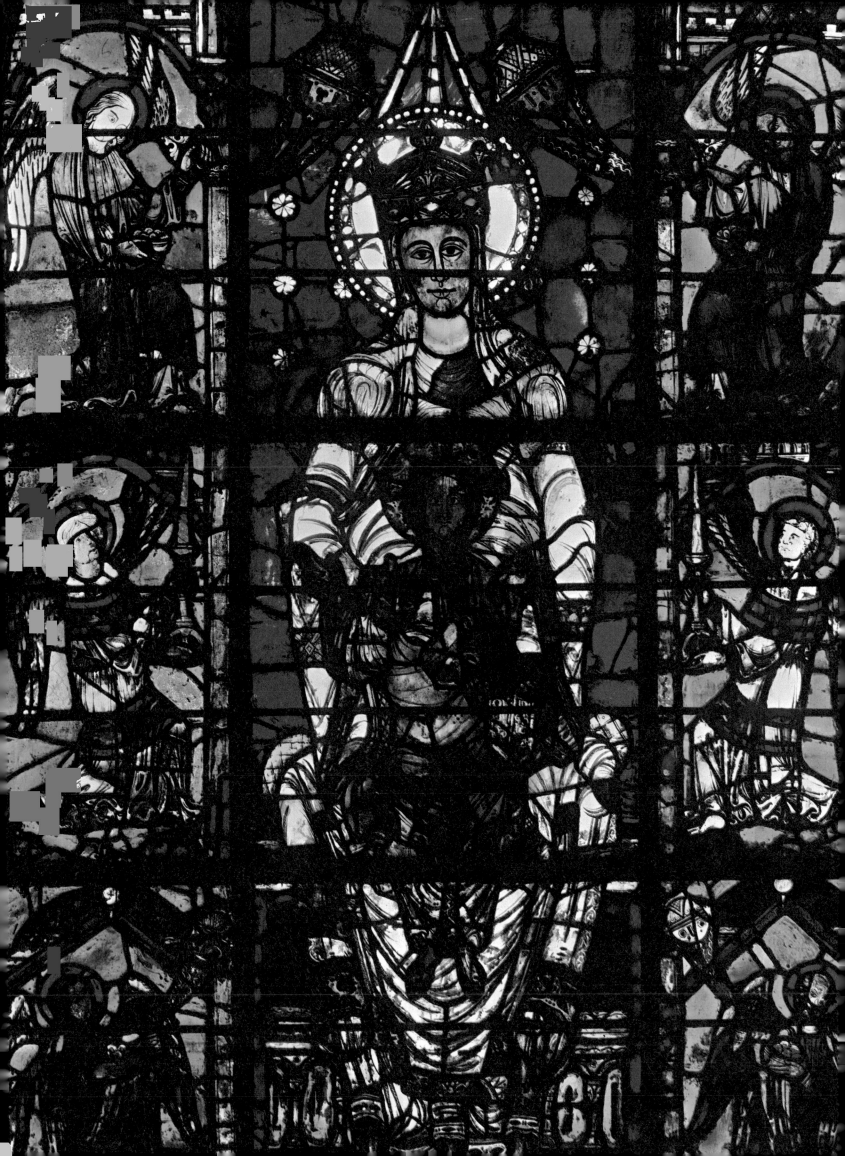

José Orozco (1883 – 1949)

MOTHER AND CHILD

1919, oil on canvas, 31x25" (79x63cm)

Collection Arthur Spitzer, Beverly Hills, Calif.

ART is our only proof of continuity in a life of spirit. When we deny it (as we have en masse and massively) we lose all that gives us a noble concept of human beings.

Orozco is an artist who was especially concerned with what is human. As a Mexican he was never far from the elemental in life, and he painted pictures that reinforced his belief in continuity, survival, and the nobility of the human spirit, like this mother and child.

I envy the Mexican babies carried within a wide scarf around the mother's body as in the painting. When I look into Mexican eyes I wish I had been born there, in the warmth and emotional richness of their nature, with feeling at the core.

ANAÏS NIN

Anon.

MOTHER AND CHILD

6th cent. (Indian), schist, height 30" (76cm)

Los Angeles County Museum of Art, Los Angeles, The Nasli and Alice Heeramaneck Collection

"Where have I come from? Where did you pick me up?" the baby
asked his mother.
"You were hidden in my heart as its desire.
You were the dolls of my childhood games and, when with
clay I made the image of my God every morning, I made and unmade you.
Mystery overwhelms me; you, who belong to all, have become mine.
What magic has snared the world's treasure into my slender arms?"

THERE is a sweetness, a matter-of-fact innocence and play in Hindu poems about babyhood and making love that have no equal in any other language; there is also awe because nowhere in the world are mother and child more reverenced than in India.

To Hindus the sex act is holy, which is why in the great temples there are those couples caught in *maithuna*, the act of love; naked, interlocked, their stone is so vibrant with warm sensuousness that though, like this schist sculpture of mother and child, they are centuries old, they seem living, breathing, he in power and tenderness, she in surrender, selves forgotten in the moment of mating and the deep underlying purpose of fulfillment. It is here that the bride goes to pray, taking offerings of food and incense, a handful of marigolds or scented frangipani flowers that she scatters as she whispers, "Let it be a son".

Girls are welcome too, though not too many: "Another little calamity!" friends will say of a third or fourth daughter because, though little Sita or Janaki is her father's pearl, there is always the one-day formidable expense of a wedding. When the baby is born, honey may be put on its tongue so that it will grow up "sweet in talk". On the name-giving day, lucky names, perhaps seven of them, are written on banyan or banana leaves and a little lamp set near each; the lamp that burns the brightest gives the name. In some families, on the fifth day pen and ink—and a stone from the nearest temple—are put in the birth-room, so that the Unseen Presence, the Creator, can come and write the baby's "karma" on its forehead.

Indian babies are not "brought up" in our sense, seldom scolded, allowed to play—as the baby in the sculpture plays fearlessly with his mother's earring as she smiles; they eat, sleep, grow, live as they will—yet, miraculously, are not spoiled. It is as if those big dark eyes—and words are not as eloquent as an Indian baby's eyes—say confidently, "Even in this land of millions, I am still the 'world's treasure' ".

RUMER GODDEN

Rumer godden

Marie-Louise Vigée-Lebrun (1755 – 1842)

THE ARTIST AND HER DAUGHTER JULIE

1789, oil on canvas, 47⅝x35¾" (121x91cm)

Louvre, Paris

"How dear to our hearts are the scenes of our childhood." How well I remember this marvelous picture by Vigée-Lebrun. It all started in the Black Forest where I was born. Our print of this painting occupied a very special place in our happy home. I used to walk past it every day, and as I grew older, I began to study it more and more. It fascinated me; the pure, tender, protective love of a mother toward her child, and her child's feeling of belonging, revealed in the natural gesture toward her mother. The picture epitomized for me the beauty of motherly love, the unrestrained and unselfish feelings between mother and child.

My boyhood fascination with this portrait led me to find out whatever I could about the artist. She was an extraordinary person. A close friend of Marie Antoinette's, she painted portraits of royalty all over Europe—an exceptional career for a woman in those days. She painted more than a thousand pictures, but only this one stirred within me such happy emotions.

When I decided to leave Germany to join my older brother in America, I felt a great sadness about leaving my family, especially my beautiful mother. To make my departure less painful, the entire family accompanied me to Stuttgart to see me off to the promised land. Before they left, they handed me a package "to open on the boat", they said. The first night out was tempestuous and the ship was being thrown left and right. I felt hopeless and alone; the thought of the ship sinking almost paralyzed me. "If I am going to perish," I thought, "let me first see what's in the package." (I guess I was grasping for my family.) When I saw what was inside, a tremendous warmth and peace overcame me. Here was the picture I loved so much, with a note from my mother which read: "May it always remind you of us and of our great love, and may it also remind you and guide you to be just and loving to your fellow man, especially to mothers and children".

Years later in Paris, as I stood speechless before the original painting in the Louvre, my companion, an old friend, turned to me and said, "Gayelord, that's the original of the picture you have been carrying with you all over the world for the past forty years. Someday you should write a story about it".

GAYELORD HAUSER

Anon.

MESOPANDITISSA

11th cent. (Byzantine), 18x11¼" (46x28cm)

Basilica Santa Maria della Salute, Venice

204

WHAT is a Greek Orthodox icon — the miracle-working kind with a strange black face and a necklace of gold and jewels — doing in Venice? And in the famous church of Santa Maria della Salute whose dome has been immortalized in paintings of Guardi, Corot, Kokoschka, Carlo Carra, and Dufy?

We know that Venice owned the island of Cyprus. But few people are aware that in the fifteenth and sixteenth centuries, in fear of Islam, a strange migration of "Greeks" (Greeks, Cypriots, and Cretans), and later of Serbs, put themselves under the protection of the Most Serene Republic where they were "allowed to practice their old cult". In return, they enriched Venice with a dazzling collection of icons.

Is this one called, also strangely, *La Mesopanditissa* (*She who mediates for peace*) because she was accepted in a church wholly papal and Roman? Is she perhaps from the hand of the Cretan master Michael Damaskinos who actually painted icons in Venice? I know she is Cretan or Cypriot from her red robe and the ocher dress of the Infant.

Everything about this Madonna is strange. And strangest of all is her kinship to that host of curious religious images whose faces suddenly and mysteriously turned black as a prelude to a series of unexplained happenings.

A Spanish folktale describes how the Black Christ of Toledo brought his right hand down from the cross to make a legal deposition for a jilted peasant girl. In Mexico, a black Christ is the patron of thieves and those who pray to him "are never caught". In Poland, Our Lady of Czestochowa, barbaric and beautiful with a black face and necklaces of real coral, has been credited with hundreds of miracles.

And even the most sophisticated twentieth-century observer must admit that the strange Mesopanditissa incarnates one unquestionable miracle. The ecumenical miracle of religious tolerance practiced — at least toward the Eastern Church — in renaissance and present-day Venice. For this alien Lady is so accepted by modern Venetians as their own that they often call her "La Madonna della Salute", as though their famous basilica had been named for her, when actually she came in by the side door!

TONY DUQUETTE

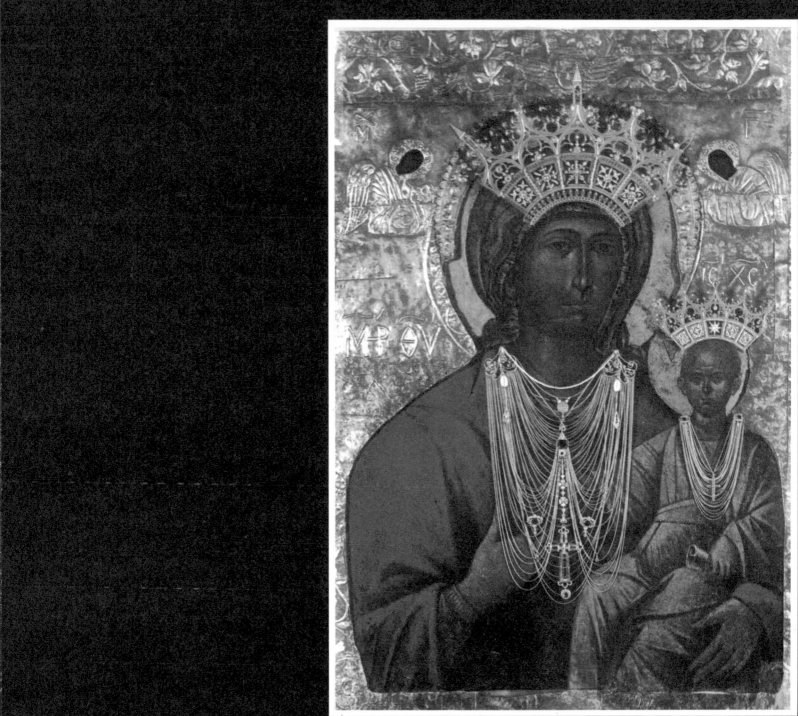

William Dyce (1806–1864)

MADONNA AND CHILD

c. 1860, oil on canvas, 40½x31¾" (103x81cm)

The Tate Gallery, London

DURING the centuries which followed the fall of Rome, warfare and hunting were the main occupations of the barbarian conquerors of Europe: art and learning were perforce restricted to the Church, and it is therefore natural that religious subjects alone should have occupied the minds of artists who toiled in secluded monasteries, producing a flood of imaginative and idealized Madonnas. The coming of the renaissance encouraged a more secular view as artists became aware of the world around them, still perhaps painting and carving the holy Mother and Child, but taking as models the women and babies they saw and often placing them before a background of local scenery. Gradually the spread of learning and the growth of wealth created patrons who demanded domestic scenes and portraiture until, with the arrival of the nineteenth century and the industrial revolution, the flood of Madonnas dwindled to a mere trickle. Of the few later ones that command attention, William Dyce's *Madonna and Child* is a beautiful example: it is also an amusing one, for surely what we see is a portrait of Queen Victoria and the infant Edward VII! The background may well depict the view from the terrace at Balmoral.

It is an old jest that God is an Englishman, but one may suspect that William Dyce had no doubt of it.

Of secular mother-and-child works—if that subject can ever be anything but holy—this twentieth-century sketch by Augustus John in my own collection seems to me the essence of that infinitely intimate relationship. It is reproduced here to contrast—and yet somehow blend—with the formal work of Dyce opposite.

BRIAN AHERNE

Anon.

DEMETER AND KORE

4th cent. (Greek), terracotta, height 8½″ (21.5cm)

Louvre, Paris

THE Greek marbles and few existing bronzes have always over-shadowed the vast number of excellent terracottas, many of which were made from molds in numerous copies. Large-scale terracottas have been used also for architectural adornment, but there are several known pieces which can be considered pure sculpture.

Among these is this Demeter and Kore group. The most famous of the terracottas are the polychromed Tanagra figurines, which are exquisitely delicate, sophisticated, and charming, but this glazed sculpture of the goddess of the cornfield and her daughter has a very strong silhouette, emphasized by the simple forms of the throne-like composition. Even though it is small, it has a monumentality reminiscent of the St. Matthew's *Madonna and Child* by Henry Moore. The group could easily be a study for a large marble sculpture.

There is something rather fascinating about this piece, in that, generally speaking, mother-and-child groups show a tender, affectionate relationship. Here, however, there is a startling austerity and tension, heightened by the mother's totally frontal and static pose. Is it fear or foreboding? Does she know that Kore is to be abducted by Hades and taken to the underworld? She will, in fact, be taken, and be known as Persephone. Though Demeter's daughter will eventually be returned to her, the condition is that Persephone is to spend four months of every year in the underworld as its queen. Knowing this fate makes one feel the more touched by this beautiful sculpture of a mother and her doomed child.

DIMITRI HADZI

Albrecht Altdorfer (c. 1480 – 1538)

MADONNA AND CHILD IN GLORY: Detail

c. 1528, oil on wood panel, 25⅞x16½" (65.7x42cm)

Bavarian State Galleries, Munich

210

By the early sixteenth century, when this painting was made, the Italian masters had already reached the culmination of the renaissance, while the German masters like Albrecht Dürer, Grünewald, Lucas Cranach the Elder, and Albrecht Altdorfer were still holding on to the traditions of the late gothic period.

The motif of the Mother holding the Infant with the long red rosary and his right hand raised in a gesture of blessing is Italian—as can be seen in paintings by Mantegna and Bellini—but in this painting the conception is purely German. The Child is not resting in the Mother's arms; it is presented standing, still a little unsteady, but standing. Not visible in this detail are two angels holding a crown above Mary's head. Here, Mary is no more the simple mother in the stable in Bethlehem, she is the Queen who, in her glory, holds up her divine Child for adoration.

Many of the religious paintings by Albrecht Altdorfer possess an intimate quality which invites one to devout and silent contemplation. And so indeed does this painting of a Mother and her Child.

DR. J. G. PRINCE VON HOHENZOLLERN

Geertgen tot Sint Jans (1455/65 – 1485/95)

TREE OF JESSE

c. 1488, oil on wood panel, 35x23¼" (89x59cm)

Rijksmuseum, Amsterdam

ALTHOUGH it hangs inconspicuously in the same museum with the ultimate masterworks of Rembrandt and Vermeer, this enchanting little picture beguiles the memory because of its unique charm.

The subject is the Tree of Jesse and reveals Jesse's dream, showing the forebears of Christ ensconced, however precariously, in the lacy branches of a genealogical tree which grows out of the folds of the red robe of the sleeping figure of Jesse. Mingling playfulness with piety, the artist places the Madonna in a fanciful setting where she is almost lost in the decorative complexity. But there she is, Child in arms, the crowning ornament atop the topmost bough of this human Christmas tree. She is attended by two child angels and is somewhat smaller and daintier than the more corporeal ancestors so richly garbed for this colorful family picture. Although not one of the faces actually smiles, there is a gaiety that derives from the warm colors and clear patterns of the fabrics, furs, and striped tights that bedeck the *dramatis personae* involved in what appears to be more a merry charade than a biblical event.

It would appear that Geertgen has employed actual models for all but the figure of Mary and the Infant. Using the license of familial resemblance, we discover, as our eye ascends upward, that he has repeated certain faces. The strong side lighting used throughout gives a weight and volume that suggest a carved polychrome relief. This feeling is sustained by the fact that all the figures are held in the plane of the picture, perforated here and there to reveal a courtyard background, which presses against the figures in spite of some attempt at perspective. This treatment conspires to give the effect of an intricate but definite pattern with spatial implications not unlike some abstractions of our own time.

PAUL CLEMENS

Paul L. Clemens

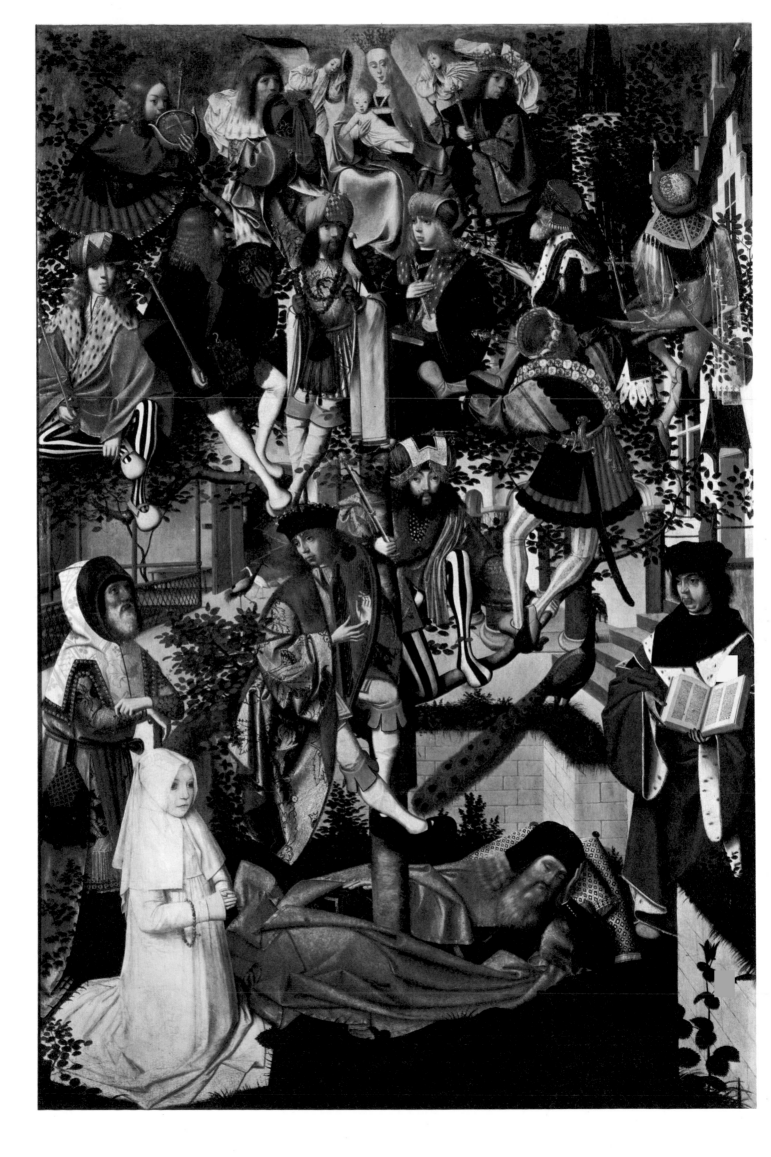

Anon.

MOTHER AND CHILD

c. 2nd cent. B.C. (Luristan), bronze, height 2½" (6cm)

Collection Mr. and Mrs. Eric Azari, Los Angeles

Your eyes
 are they magic
the gazelle itself
 or the hunter
of all creatures
 two black almonds
or the purple
 narcissus?

THIS poem by Jami written in the fifteenth century vividly and visually underlines for me my awareness of the eyes of Persians, the children and mothers of the tribal nomads, the proud warriors, descendants of the Achaemenids, the people from all the corners of this great plateau reaching from Turkey and Iraq in the west, Afghanistan and Pakistan in the east, and the Caucasus and Russia to the north. Their arts and crafts, architecture, music, and especially their long history of ornamentation in stucco, stone, and bronze are constant joys.

This small cast-bronze image of mother and child was worn around the neck as an amulet, probably by a woman to protect herself and her children. Its power emanated from the incised circles on the skirt resembling eyes, which were intended to ward off the "evil eye" from the wearer. Such figurines are generally referred to as "Luristan bronzes", which include a vast number of diverse bronze images found in western Iran and dating from 2700 B.C. to the beginning of the Islamic period. Many are unstratified surface finds, and the cultural sequence of early Iranian bronzes is far from firmly established. This attractive and interesting piece may have been cast at any time during the later part of the Luristan era. About a dozen similar pieces are known from European collections, suggesting that a broad and popular folk religious symbolism had become attached to the mother-and-child figure.

ROLOFF BENY

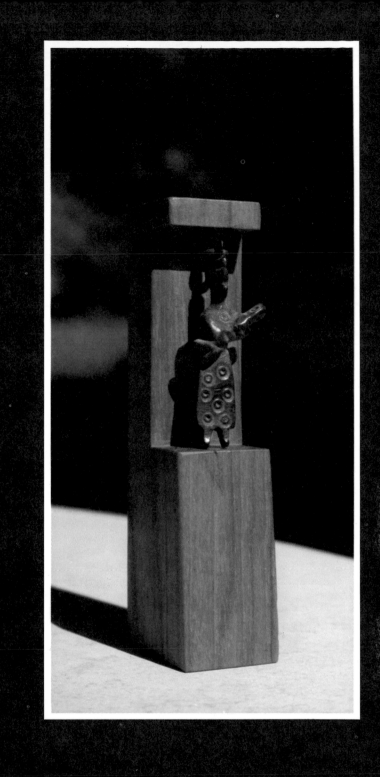

220

PHOTO CREDITS

ABOUT MARY LAWRENCE

Mary Lawrence has lived in the same house since her marriage in
1938 to her husband, the film writer, director, and producer Delmer
Daves. She is mother of three, grandmother of three, and a woman
of many parts. According to her husband, the ancient Greeks may
have foreseen her special attributes when they created the word
entheos (to have the gods within you) which led to our word
enthusiasm. This brio has led her not only to the creation of this
book but to several careers—as an actress, appearing in many plays,
films, and television series; as an interior decorator and pho-
tographer; and into the study of terracotta sculpture, ceramics, and
painting. She grew up in Columbus, Ohio, and was educated at
Columbus School for Girls, Western College for Women, Oxford,
Ohio, and the University of California at Los Angeles. Mary
Lawrence brings her characteristic enthusiasm and energy to her
very extensive traveling and museum-going—activities leading to
other book projects in work.

Library of Congress Cataloging in Publication Data

Main entry under title:
Mother and Child.
 (A Balance House book)
 Includes indexes.
 1. Mothers in art. I. Lawrence, Mary, date
N7632.M67 757'.4 75–11652
ISBN 0–690–00970–4